teach® yourself

art history

teach® yourself

art history
grant pooke and
graham whitham

For UK order enquiries: please contact Bookpoint Ltd, 130 Milton Park, Abingdon, Oxon, OX14 4SB. Telephone: +44 (0) 1235 827720. Fax: +44 (0) 1235 400454. Lines are open 09.00–17.00, Monday to Saturday, with a 24-hour message answering service. Details about our titles and how to order are available at www.teachyourself.co.uk

For USA order enquiries: please contact McGraw-Hill Customer Services, PO Box 545, Blacklick, OH 43004-0545, USA. Telephone: 1-800-722-4726. Fax: 1-614-755-5645.

For Canada order enquiries: please contact McGraw-Hill Ryerson Ltd, 300 Water St, Whitby, Ontario, L1N 9B6, Canada. Telephone: 905 430 5000. Fax: 905 430 5020.

Long renowned as the authoritative source for self-guided learning – with more than 50 million copies sold worldwide – the **teach yourself** series includes over 500 titles in the fields of languages, crafts, hobbies, business, computing and education.

British Library Cataloguing in Publication Data: a catalogue record for this title is available from the British Library.

Library of Congress Catalog Card Number: on file.

First published in UK 2003 by Hodder Education, part of Hachette Livre UK, 338 Euston Road, London, NW1 3BH.

First published in US 2003 by The McGraw-Hill Companies, Inc.

This edition published 2008.

The **teach yourself** name is a registered trade mark of Hodder Headline.

Typeset by Transet Limited, Coventry, England.
Printed in Great Britain for Hodder Education, an Hachette Livre UK Company, 338 Euston Road, London NW1 3BH, by CPI Cox & Wyman, Reading, Berkshire, RG1 8EX.

The publisher has used its best endeavours to ensure that the URLs for external websites referred to in this book are correct and active at the time of going to press. However, the publisher and the author have no responsibility for the websites and can make no guarantee that a site will remain live or that the content will remain relevant, decent or appropriate.

Hachette Livre UK's policy is to use papers that are natural, renewable and recyclable products and made from wood grown in sustainable forests. The logging and manufacturing processes are expected to conform to the environmental regulations of the country of origin.

Impression number 10 9 8 7 6 5 4 3 2 1
Year 2012 2011 2010 2009 2008

v

contents

This is a wonderful 'aide memoire'. It talks to you, not at you – which is very refreshing when 'the Emperor's new clothes' are all the rage.

Kirsty Wark

acknowledgements

Quotations

Chapter 01

pp. 2, 7 Reproduced from *The Story of Art* by E.H. Gombrich, 16th edition © Phaidon Press Ltd. Revised and enlarged 1995. © E.H. Gombrich.

pp. 2, 4 Joseph Beuys extracts from *State of the Art*, Sandy Nairne, Chatto and Windus, 1987. Used by permission of the Random House Group Limited.

p. 10 Charles Marriott quoted in Malcolm Haslam, *William Staite Murray*, Crafts Council, 1984.

pp. 12–13, 21 Friars Bernardo and Francesco quoted in *Painting and Experience in Fifteenth Century Italy: A Primer in the Social History of Pictorial Style* (2nd edition), Michael Baxandall, Oxford University Press, 1972. Reprinted by permission of Oxford University Press.

p. 19 Clement Greenberg 'American-Type Painting' in *Clement Greenberg. The Collected Essays and Criticism, Volume 3*, John O'Brian (editor), University of Chicago Press, 1993. © by Clement Greenberg and John O'Brian.

p. 19 Clement Greenberg, Letter to the Editor of *The Nation*, reprinted in *Clement Greenberg. The Collected Essays and Criticism, Volume 2*, John O'Brian (editor), University of Chicago Press, 1986. © by Clement Greenberg and John O'Brian.

Chapter 02

p. 31 Greenberg quoted in *The Times*, obituary notice, July 1994.

pp. 32, 34 Clement Greenberg 'Modernist Painting' in *Clement Greenberg. The Collected Essays and Criticism, Volume 4*, John O'Brian (editor), University of Chicago Press, 1993 © by Clement Greenberg and John O'Brian.

p. 36 Clement Greenberg 'Complaints of an Art Critic' in *Clement Greenberg. The Collected Essays and Criticism, Volume 4*, John O'Brian (editor), University of Chicago Press, 1993. © by Clement Greenberg and John O'Brian.

Chapter 03

pp. 51–52, 53 Vasari, *Lives of the Artists*, translated by G. Bull, Penguin Books, 1975. © George Bull 1965.

p. 54 Extract from *Jackson Pollock. An American Saga*, S. Naismith and G. White Smith, Barrie and Jenkins, 1989. Used by permission of The Random House Group Limited.

pp. 55–6 Two quotes from R. Heller, *Edvard Munch*, John Murray, 1984.

p. 63 Picasso quoted in F. Frascina, 'Realism and Ideology: an Introduction to Semiotics and Cubism' in C. Harrison *et al.*, *Primitivism, Cubism, Abstraction*, Yale University Press, 1993.

p. 64 M. Blind (translator), *The Journal of Marie Bashkirtseff*, Virago, 1985.

p. 65 T. Garb 'Gender and Representation' in F. Frascina *et al.*, *Modernity and Modernism*, Yale University Press, 1993.

p. 67 R. Parker and G. Pollock, *Old Mistresses*, HarperCollins, 1981.

Chapter 04

p. 79 Smithson quoted from J. Dickie, Travel Section *The Independent on Sunday*, 20 October 2002.

p. 83 D. Bussel, *Sensation – Young British Artists from the Saatchi Collection*, Royal Academy of Arts in association with Thames & Hudson, 1997.

Chapter 05

p. 95 W. H. Wackenrode, *Outpourings from the Heart of an Art-Loving Monk*, 1797, quoted in *Relative Values*, L. Buck and P. Dodd, BBC Books, 1991.

p. 99 H. Langdon, *Art Galleries of the World*, Pallas Athene, 2002.

p. 106 *Guide to the Musée d'Orsay*, Editions de la Réunion des Musées Nationaux, 1987.

p. 107 Picasso quoted in I. Crofton, *A Dictionary of Art Quotations*, Routledge, 1988.

p. 113 R. Hughes, *Nothing if Not Critical*, Harvill, 1990.

Images

- Measurements of two-dimensional work are recorded height before width.
- Measurements for three-dimensional work are recorded height, width and depth.

Plate 1

Caravaggio, *The Supper at Emmaus*, 1601. Oil and egg tempera on canvas: 141 × 196.2 cm. From the National Gallery, London. © National Gallery Collection. By kind permission of the Trustees of the National Gallery, London/Corbis.

Plate 2

Paul Cézanne, *The Grounds of the Château Noir, c.* 1900–1906. Oil on canvas: 90.7 × 71.4 cm. From the National Gallery, London. © National Gallery Collection. By kind permission of the Trustees of the National Gallery, London/Corbis.

Plate 3

El Greco, *Christ Driving the Traders from the Temple, c.* 1600. Oil on canvas: 106.3 × 129.7 cm. From the National Gallery, London. © National Gallery Collection. By kind permission of the Trustees of the National Gallery, London/Corbis.

Plate 4

Grant Wood, American, 1891–1942, *American Gothic*, 1930, Oil on beaver board, 30 11/16 × 25 11/16 in (78 × 65.3 cm) unframed, Friends of American Art Collection, 1930.934, The Art Institute of Chicago. Photography © The Art Institute of Chicago. All rights reserved by the Estate of Nan Wood Graham/Licensed by VAGA, New York, NY.

Plate 5

Mark Rothko, *Untitled, c.* 1951–2. Oil on canvas: 189 × 100.8 cm. From the Tate Modern. Tate London 2003. © 1998 Kate Rothko Prizel and Christopher Rothko ARS, NY and DACS, London 2008.

Plate 6

Isaac Brodsky, *Lenin in Smolny*, 1930. Oil on canvas: 190 × 287 cm. From the Tretyakov Gallery. akg-images.

Plate 7

Berthe Morisot, *Summer's Day*, c.1879. Oil on canvas: 45.7 x 75.2 cm. From the National Gallery, London. © National Gallery Collection. By kind permission of the Trustees of the National Gallery, London/Corbis.

Plate 8

Edvard Munch, *The Sick Child*, 1906–1907. Oil on canvas: 118.5 × 121 cm. From the Tate Modern. Tate London 2008. © Munch Museum/Munch-Ellingsen Group, BONO, Oslo, DACS, London 2008.

Plate 9

Elisabeth Vigée-Lebrun, *Self-Portrait in a Straw Hat*, c. 1782. Oil on canvas: 97.8 × 70.5 cm. National Gallery, London. © National Gallery Collection. By kind permission of the Trustees of the National Gallery, London/Corbis.

Plate 10

Donald Judd, *Untitled*, 1980. Ten steel, aluminium, perspex units. Geoffrey Clements/Corbis/Art. © Judd Foundation Licensed by VAGA, New York/DACS, London 2008.

Plate 11

Carl Andre, *Equivalent VIII*, 1966. Firebricks: 12.7 × 6.85 × 229 cm. From the Tate Modern. Tate London 2003. © Carl Andre/VAGA, New York/DACS, London 2003.

Plate 12

Robert Smithson, *Spiral Jetty*, April 1970. Black rock, salt crystal, earth, red water (algae): length of coil 457 metres on a ten-acre site. Great Salt Lake, Utah, USA. Estate of Robert Smithson. Courtesy James Cohan Gallery, New York. Collection: DIA Center for the Arts, New York. Photo by Gianfranco Gorgoni © Estate of Robert Smithson/DACS, London/VAGA, New York 2008.

Plate 13

Damien Hirst, *Isolated Elements Swimming in the Same Direction for the Purpose of Understanding*, 1991. MDF,

melamine, wood, steel, glass, perspex cases (39), fish (39) and five per cent formaldehyde solution: 183 × 274 × 30.5 cm. © Damien Hirst. Photo: Courtesy Jay Jopling/White Cube, London.

Plate 14

Tracey Emin, *Everyone I Have Slept With 1963–1995*, 1995. Appliquéd tent, mattress and light: 122 × 245 × 215 cm. © Tracey Emin, Photo: Stephen White, Courtesy Jay Jopling/White Cube, London.

Plate 15

Jimoh Buraimoh, *Animals*, 1973. Glass beads and gouache on board: 52 × 138 cm. Collection of Robert Mucchi. © Jimoh Buiramah © Photo: Graham Whitham.

Plate 16

Jimoh Buraimoh, *Animals* (detail). 1973. Glass beads and gouache on board 52 × 138 cm. Collection of Robert Mucchi. © Jimoh Buiramah © Photo: Graham Whitham.

Figure 1, p. 6

Masaccio, *Virgin and Child* (central panel of the Pisa Altarpiece), 1426. Egg tempera on poplar: 135.5 × 73 cm. From the National Gallery, London. © National Gallery Collection. By kind permission of the Trustees of the National Gallery, London/Corbis.

Figure 2, p. 9

William Holman Hunt, *The Light of the World*, c. 1851–1853. Oil on canvas over panel: 125.5 × 59.8 cm. From Keble College, Oxford. akg-images.

Figure 3, p. 10

William Staite Murray, *Persian Garden*, 1931. Stoneware: height 56.1 cm. From the York City Art Gallery, York Museums Trust (York Art Gallery) © William Staite Murray.

Figure 4, p. 33

William-Adolphe Bouguereau, *The Birth of Venus*, 1879. 300 × 215 cm. Oil on canvas: 300 × 218 cm. From the Musée d'Orsay, Paris. akg-images/Erich Lessing.

Figure 5, p. 63

Pablo Picasso, *Les Demoiselles d'Avignon*, 1907. Oil on canvas: 243.9 × 233.7 cm. From the Museum of Modern Art, New York. Institut Amatller d' Arte Hispanic, Barcelona. © Succession Picasso/DACS 2008.

Figure 6, p. 97

National Gallery building, London. © Angelo Hornak/Corbis.

Figure 7, p. 97

Sainsbury Wing, National Gallery, London. Detail of gatepost. © Photo Graham Whitham.

Figure 8, p. 100

Royal Museum of Fine Arts, Brussels, Belgium. © Photo Graham Whitham.

Figure 9, p. 100

Musée d'Orsay, Paris, France. © Photo: Graham Whitham.

Figure 10, p. 101

Museum of Art and Industry, Roubaix, France. © Photo: Graham Whitham.

Figure 11, p. 131

Technique of tempera painting. © Drawing: Graham Whitham.

Figure 12, p. 132

Technique of oil glaze paining. © Drawing: Graham Whitham.

Figure 13, p. 133

Technique of oil painting. © Drawing: Graham Whitham.

Figure 14, p. 135

Technique of watercolour painting. © Drawing: Graham Whitham.

Figure 15, p. 136

Technique of acrylic painting. © Drawing: Graham Whitham.

Figure 16, p. 137

Technique of fresco painting. © Drawing: Graham Whitham.

preface

The authors would like to thank the publishers, including Sue Hart for their support and confidence in this venture. Our thanks also to Catherine Coe, Robert Mucchi, Diana Newall, Denise Robinson, Mary Townsend, Derek Whittaker and to all our students, past and present, with whom we have explored and discussed these ideas and perspectives.

This book is dedicated to:

Rachel Whitham
Barbara & Fred Pooke

introduction

What is art history?

There really is no such thing as art history; there are only *histories* of art. No single way of looking at and interpreting art provides all the answers since there are various methods and approaches to interpretation. For example, we might see the role of art history as a means of communicating factual knowledge, perhaps about the way a work of art was made and the historical circumstances of its production. We may believe that its role is to discover the meanings that works of art had for their original audience, enabling us to think about this in relation to how we see them now. Alternatively, we might believe that art history shows us significant meanings or explains why an artwork might, or might not, have **aesthetic** appeal. In fact, art history can do all these things and more. When we read about art or listen to someone talking about it, we need to understand that we are not getting the whole story. In fact, there is no whole story, just *interpretations* which have evolved as different people have looked, written and spoken about art.

Each interpretation has its own value and adds to our awareness, but alone it will not give a complete understanding and appreciation of art. Even placing several strands or approaches together may not provide a complete overview – such a thing can never exist. You will discover as you read this book that art is not something you can understand in the way you might understand a foreign language or the rules of a card game. To teach yourself art history is not like teaching yourself Spanish or bridge.

We hope that with this book's guidance and with some interest in the images you see, you should be able to more

fully enjoy and understand art, not least because you will have explored the most commonly used and potentially helpful ways of looking. You should also be able to recognize the various approaches used by commentators, critics and art historians when discussing art. This book should both help to provide a better understanding of their interpretations and encourage reflection on your own views. Finally, it is hoped that in reading this short introduction to the subject you will extend and develop your own sense of what makes for an informed response to what you see and visually experience. It has been said that art does not change the world, but art and art history have changed the way we look at the world. This book seeks to offer some introductory perspectives on both. We hope you find it useful.

What this book is about and how to use it

This book is written as an introduction to ways of looking at and interpreting art, and as a primer for the academic discipline of art history. We believe it is suitable for both the general reader interested in understanding and appreciating art, and as an accessible and relevant introduction to students of the subject.

This book can be read in straight chapter order. However, we have organized the sections in such a way that they can also be used flexibly as a basic reference guide. For example, you might come across a particular work of art, style of painting, etc. and may wish to look up a specific section of the book. For this reason, each section can work independently of the others, although we have made cross-references within the book.

The range of objects regarded as art is vast. With the exception of some recent three-dimensional work we have, for the purposes of illustration, restricted ourselves mainly to examples of painting. This in no way should be taken as proof of any artistic preference on the part of the authors or publishers!

Introducing the chapter contents and sections

The first chapter of this book introduces the terms 'art' and 'art history'. It is important to have some awareness of both the range and limits of these terms since, as we shall see, they can mean various things at different times and in different places.

Chapters 02 to 04 explore some of the principal art historical approaches. Chapter 02 considers formalism – looking at and finding meaning in the formal characteristics of works of art such as shape, colour, composition, the materials used and so on.

Chapter 03 is divided into three sections, each of which looks at what we might broadly call the various contexts of art, focusing on history, biography and gender. The thinking here is that in order to understand and appreciate art, we have to know something about how, why, when and where it was produced.

Chapter 04 is about so-called **Postmodern** art and the ways in which art history has adopted different approaches and interpretations. The first section compares and contrasts two examples, which provide a basis for introducing a broad characterization of the term. The second section looks at some more recent examples of art and explores some Postmodern ideas and thinking. The final section discusses an example of contemporary non-Western art, exploring wider issues of interpretation and cultural difference.

Other than seeing reproductions in books, most people experience art in an art museum. The academic study of this area is called **museology**. Where we experience art may influence the way we see, understand and appreciate it, and the three sections in Chapter 05 consider the various ways art has been displayed and presented by curators and galleries.

The final chapter offers more material for teaching yourself art history. It provides information about styles, periods and **genres**, and various painting techniques. It also offers a range of possible information sources (books, periodicals, Internet sites, etc.) and their differing uses and effectiveness.

At the end of the book there is a glossary of art historical terminology cross-referenced to the chapter contents.

Throughout this book, examples are used to illustrate the ideas and approaches discussed and explained. You might think of these as case studies and apply their principles to your own exploration of works of art. There are also suggestions for activities related to particular topics. Please do look at these since they are designed to encourage active learning and engagement with what is being said, which should be a good way to teach yourself.

Please note that glossary terms appear in bold when first mentioned in the text.

01

what is art and what is art history?

In this chapter you will learn:

- some of the differing interpretations and definitions of art
- the changing role and status of art through time
- the historic and ongoing importance of various 'canons' in establishing claims to artistic value
- the part played by academies in influencing how we value and perceive past art and art making.

Section 1 Art: different things in different times and places

The opening line of the Introduction referred to Ernst Gombrich's influential work *The Story of Art*, which begins with this observation: 'There really is no such thing as Art. There are only artists.' Gombrich goes on to explain that art '...may mean very different things in different times and places.' (*The Story of Art*, E. H. Grombrich, Phaidon Press Ltd, 1995.) And this is true. So, even before we look at what art history might be, we should think about how we understand the idea of art itself.

> Please take a minute to consider (and perhaps make a list of) the sort of things you would call art.

To some extent, what you might call art depends on how relaxed an interpretation of the term you take. For example, the twentieth-century German artist Joseph Beuys once said:

> Every human being is an artist...By artists I don't just mean people who produce paintings and sculptures or play the piano, or are composers or writers. For me a nurse is also an artist, or, of course, a doctor or a teacher. A student, too, a young person responsible for his own development. The essence of man is captured in the description 'artist'.
>
> (Extract from *State of the Art*, Sandy Nairne, Chatto and Windus, 1987)

This suggests that anything anyone does might be considered as art. It is a very inclusive and generous interpretation! (We shall return to this in Chapter 04.)

However, if we want to get anywhere with our investigation into what art is, not only will we have to confine ourselves to the visual arts, we will also need to work within commonly agreed boundaries.

> Perhaps you have considered different types of objects you would call art. Now think about the skills themselves, for example, painting, sculpture, printmaking; perhaps the medium used (an oil painting, a marble sculpture, an etching); and even the subject or genre (an oil painting of a landscape, a marble sculpture portrait bust, an abstract etching).

In the Western tradition (that is, Europe and parts of the world significantly influenced by Europe such as the North American continent and Australia), there are commonly accepted disciplines, media and subjects closely associated with our understanding of art. An oil painted landscape, a marble sculpture portrait bust and an abstract etching are all 'art'. At first glance it may seem that art is, on the whole, relatively easy to recognize. But is it?

Is art something displayed in a museum?

While compiling your list, you may have included some things that are not so conventional. For example, did you include a urinal, 120 firebricks, a container of fat or an unmade bed? As well as finding these things in, respectively, gentlemen's toilets, a builder's yard, a kitchen and a teenager's bedroom, they have all been exhibited in galleries and are classified as art. So, could we say that anything displayed in an art museum is art? Or put another way, to what extent do you think this statement is true?

If everything in an art museum can be classed as 'art', where does that leave pottery (or ceramics), jewellery, textiles, glass and other objects that are sometimes displayed? Some may call such things art, but conventionally these would be classified as **craft** or **applied art**.

You may have included pottery, glass and textile pieces in your list and increasingly the distinctions between craft, applied art and art are difficult to make.

However, apart from being different forms or disciplines (pottery as opposed to paintings, jewellery as opposed to sculpture), craft and applied art suggest objects where we might say that the skill in making more directly contributes to their status.

Art can have the attribute of skill but it is also, traditionally, suggestive of greater intellectual or conceptual capacity. Craftsmen and women might find this distinction insulting and challenge it, which probably suggests not only the difficulties in trying to define such terms but also the possibility that the boundaries between craft, applied art and art are really not so clear-cut after all. Nevertheless, the relationship between craft, applied art and art was, as we shall see later, important in establishing the identity of art itself. By labelling some things as craft or applied art, we may think that not everything displayed in an art museum is art. On the other hand, if we look at a particular example, this distinction may be less obvious.

As well as exhibiting paintings, sculptures, drawings and prints, the Louvre in Paris also displays scientific instruments, rugs, armour, cutlery, snuff boxes and more. The French categorize such diverse objects under the catch-all term *objets d'art* (art objects), therefore considering them a form of art. Perhaps we should take the advice given to Alice by the Red Queen in *Through the Looking Glass* (Lewis Carroll, 1872): 'Speak in French when you can't think of the English for a thing.' It would solve our immediate problem!

It is clear that defining art is challenging. Although the contents of an art museum might help us sort out what is art from what is not, it is not a watertight test. But if we agree with what seems to be the French solution, that anything displayed in an art museum is art, surely we cannot agree with the assumption that may follow: that art *must be* something displayed in a museum. Obviously, not all art is exhibited in this way. Outdoor sculpture, sketchbook drawings or a painting hung in your own home are just three examples which would not meet this definition. Therefore, if inclusion in a museum collection is not the only measure for judging what is art, how far can we stretch the meaning of the word?

Art as an inclusive term

Maybe we should return to your list. If you tried to think of as many things as you could, and were relatively liberal in your understanding of 'art', you may have included disciplines such as photography, film and architecture. Many people would classify photography as 'art'. We use the term 'art film' when describing a film which is, arguably, more visually and intellectually stimulating, and usually less popular, than commercial or mainstream movies. We distinguish between structures that are merely building and those we call architecture, the latter supposedly having an aesthetic appeal far greater than the former. It seems that we are nearly back to Joseph Beuys's definition: 'Every human being is an artist' (in Sandy Nairne, *op. cit.*), or at least fast approaching it.

Having followed the discussion so far, you may want to revise your list. Perhaps you feel that you have not been inclusive enough and you want to expand the list to include photography, jewellery, pottery and so forth. However, you may feel that the whole thing is getting out of hand. If we cannot define things, how can we understand them?

> Look once more at your list. How many items are you certain are art?

- It would seem likely that you have included painting. You may have been more specific and listed 'oil painting' and 'watercolour painting', for example. In the Western tradition, it is agreed that painting can be defined as a form of art. However, if we look at a particular example, you might modify your view about some of these conventionally agreed boundaries. For instance, painting was not always considered 'art' in the way we might now understand it.

The changing meaning of art

Masaccio's *Virgin and Child* (Figure 1, p. 6) was painted in about 1426. It was part of an **altarpiece**, a decorated screen in a Christian church. Not all the other panels that comprised the total altarpiece (or **polyptych**) have survived, and those that have are in other museums. Masaccio's altarpiece was created using **tempera** paint on wooden panels (see Chapter 06). One of the altarpiece panels, the *Virgin and Child*, is now displayed in the National Gallery in London, and is viewed by many as an object for aesthetic contemplation. This might be a way of defining its status as art, albeit a restricted one. But, while the painting has aesthetic qualities, these were not its primary attributes for the fifteenth-century congregation of Pisa Cathedral, where the altarpiece was originally housed. For them it was a focus of their religious devotions, as well as being, one assumes, a source of pride and honour for the cathedral and the city. Moreover, the altarpiece was commissioned by an individual, a certain Guiliano di Colino, who no doubt regarded the painting in a similar way to his fellow citizens but also, perhaps, considered it as a gift to God and therefore a contribution to his salvation on the Day of Judgement.

It is possible that some visitors to the National Gallery engage with Masaccio's painting, in spirit at least, as would a citizen of fifteenth-century Pisa, but location and time have undoubtedly changed its meaning. The point is that what is regarded as art nowadays may not have always been art in the way it is now understood. Thus, 'art' can mean different things at different times. If there are difficulties in defining what art is in a culture where art museums, dealers, collectors, connoisseurs and art historians thrive, it would follow that there are even greater difficulties in defining art from cultures where such traditions are less clearly stated or understood.

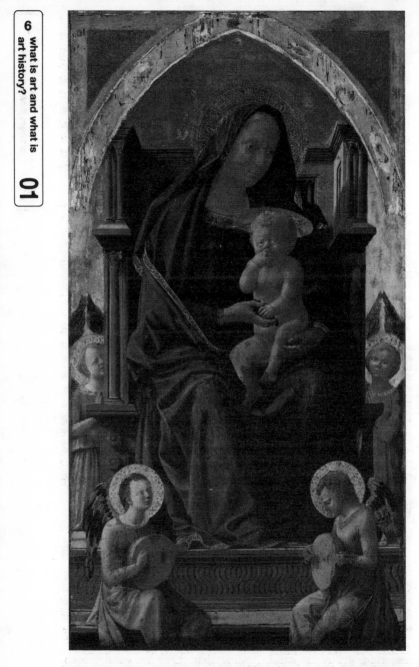

figure 1 Masaccio *Virgin and Child* (central panel of the Pisa Altarpiece) 1426

An Aztec stone sculpture or a wooden mask from Zaire are quite acceptably displayed as art objects in a museum, but for the Aztecs or the Yaka people of Zaire these objects had an important religious and ritualistic purpose. Like Masaccio's altarpiece, when they were made they may have been considered as a form of art but not in the way we would understand it today. Their main purpose, it might be argued, was to serve religion, not provide visual enjoyment. They were not displayed independently of their practical use, as many now are. Their material value was not considered important, but today objects such as Aztec sculpture and Yaka masks are financially valuable in the art market.

Hopefully, it should be clearer that the term 'art' is difficult to define and understand in any precise way. Gombrich's explanation, that it 'may mean very different things in different times and places' (*op. cit.*), provides a starting point to keep in mind. Although not especially helpful when faced with an object about which we might ask the question 'Is this art?', it does underline the fact that there are often several answers, or shades of answers. To sum up so far then:

- distinctions and definitions between art, applied art and craft arose largely from the Western academic tradition of art making
- in the last 100 years or so there has been a systematic questioning of these distinctions, and of some of the values and assumptions which historically underpinned them
- different cultures may have more or less inclusive definitions or understandings of these terms
- some of the definitions and value judgements which we have become accustomed to may have arisen from seeing arts and crafts in very specific contexts and environments (i.e. a gallery or a craft shop)
- what has been given emphasis in art objects has changed not only through time, but according to evolving social, cultural and historical values.

Section 2 Artistic status

Have you ever thought about *why* certain objects are regarded as art and others are not?

When you were deciding what things might be called 'art' or making a list of what you considered to be 'art', did you think

about why paintings are so highly valued, culturally and, frequently, financially?

> Why is a painting, on the whole, given greater cultural status than a pot? Perhaps you could note some reasons why you think this might be.

- One thing that may have occurred to you is that a painting is a unique object while a pot, generally, is not. We may simply tend to give greater value and status to the rare and original, and paintings are 'one-off' objects, each made individually and different from all others. Nevertheless, sometimes they are not quite as unique and exclusive as we might think.

The nineteenth-century English painter William Holman Hunt sometimes made more than one version of a particular subject. His popular *The Light of the World* (Figure 2, p. 9) is in Keble College Chapel, Oxford in England, but a larger version is displayed in St Paul's Cathedral, London. There is also a smaller version in Manchester City Art Gallery. These are neither studies nor preliminary works for a final piece but independent paintings. While not exactly the same, they are very similar.

On the other hand, pots are often mass produced and so not unique, yet some can be 'one-offs'. The British studio potter William Staite Murray put high prices on his work. At his one-man exhibition in 1931, a pot called *Persian Garden* (Figure 3, p. 10) was sold for £126. By comparison, three years later at a sale of Cubist paintings in Chicago, works by Braque, Gris and Léger sold for less than £100 each, and a Picasso for a little over £200. That Murray had priced his pot on a par with painting and, like a painting, given it a title, suggests that he believed it had financial *and* cultural value. These two examples are not typical but they demonstrate that uniqueness is not necessarily a characteristic that separates painting from other forms of artistic endeavour.

When you were thinking about why paintings conventionally have a higher cultural status than pots, you may have felt that a painting is an object to be contemplated whereas a pot is not. We tend to think of pots as functional because we use them in our day-to-day lives. Paintings, on the other hand, are essentially made to be looked at. Therefore, paintings are art because they are something to be admired and thought about. Pots are not art because we use them.

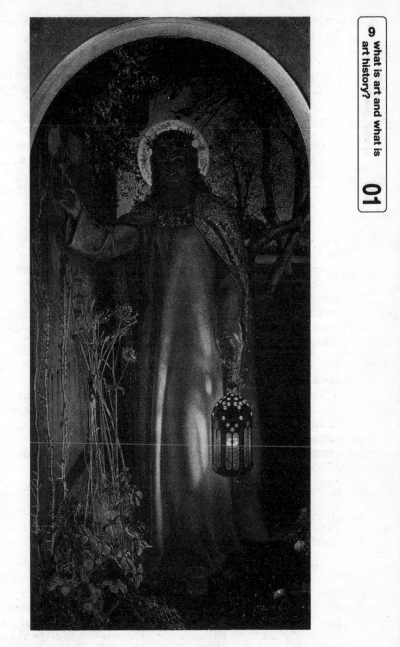

figure 2 William Holman Hunt *The Light of the World* 1851–3, retouched 1858 and 1886

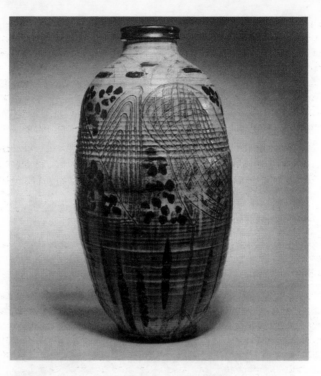

figure 3 William Staite Murray *Persian Garden* 1931

You may have gone further and claimed that painting is more 'artistic', imaginative and creative than pottery. A potter such as William Staite Murray would have denied this. He thought of himself as an artist and felt that his pots were as worthy of attention as any painting.

It seems that his 1930s audience thought so too. A contemporary review of the exhibition at which he sold *Persian Garden* noted:

> Mr Murray carries [the emphasis of the pot] in the direction of sculpture...The emphasis...is upon the aesthetic intention.

> (Charles Marriott quoted in *William Staite Murray*, Malcolm Haslam, Crafts Council, 1984)

The reviewer clearly saw Murray's pottery as a form of art; he associated it with a conventionally accepted artistic activity – sculpture – and a conventionally understood concern for artists and viewers – aesthetics.

You may have listed skill and creativity amongst your reasons for a painting claiming greater cultural status than a pot. Both these ideas are traditionally associated with art. The *Concise Oxford Dictionary* defines art as 'human creative skill or its application.' However, skill and creativity cannot be measured in any precise way and if you thought that making a painting requires more skill and creativity than making a pot, therefore better qualifying it for higher status, do not tell a potter!

The dictionary definition goes on to say that art is 'creative activity...resulting in visual representation.' Painting, at least in the Western tradition, has tended to represent in a **figurative** way, that is imitating three-dimensional forms on a two-dimensional surface. Hunt's *The Light of the World* does this with considerable technical skill.

There are two issues here which may be relevant to the way you explored the question of why a painting is given greater cultural status than a pot:

- First, to represent is not necessarily the same as to resemble. Representation (or re-presentation) does not inevitably require resemblance. An **abstract** painting (one that does not look like anything we might recognize in an everyday sense) does represent. It can represent an idea, thought, philosophy, aesthetic experience or whatever, and it does not have to resemble something to do this.
- Second, technical ability that mimics or follows reality such as that demonstrated in *The Light of the World*, is not necessarily more skilful, creative or generally 'better' than ability that does not mimic reality (as in Murray's pot).

Many people continue to associate resemblance with skill, and skill with art, which would mean that Hunt was more skilful than Murray, and this is absurd. However, despite Murray's attempts to elevate pottery to the status of painting by titling his work and asking a price equivalent to that expected for a painting, the predominant forms of art in the Western tradition were, until relatively recently, painting and the associated discipline of drawing. We might now usefully ask why?

The status of painting

Painting has not always enjoyed the prestige it has now. Until the fifteenth century and the period known as the Renaissance, painting was one of a number of artistic activities, all of which

had relatively equal rank. One way to judge painting's standing is to read contracts made between painters and patrons (clients). For example, in 1485 the friars Bernardo and Francesco of the Spedale degli Innocenti (children's orphanage), Florence, contracted the painter Domenico Ghirlandaio to paint an altarpiece depicting the *Adoration of the Magi*:

> That this day 23 October 1485 the said Francesco commits and entrusts to the said Domenico the painting of a panel which the said Francesco has had made and has provided; the which panel the said Domenico is to make good, that is, to pay for; and he is to colour and paint the said panel all with his own hand in the manner shown in a drawing on paper with those figures and in that manner shown in it; in every particular according to what I, Fra [Friar] Bernardo, think best; not departing from the manner and composition of the said drawing; and he must colour the panel at his own expense with good colours and with powdered gold on such ornaments as demand it...and the blue must be ultramarine of the value about four florins the ounce; and he must have made and delivered complete the said panel within thirty months from today; and he must receive as the price of the panel...115 large florins if it seems to me, the abovesaid Fra Bernardo, that it is worth it; and I can go to whoever I think best for an opinion on its value or workmanship, and if it does not seem to me worth the stated price, he shall receive as much less as I, Fra Bernardo, think good...
>
> (Quoted in *Painting and Experience in Fifteenth Century Italy: A Primer in the Social History of Pictorial Style* (2nd edition), Michael Baxandall, Oxford University Press, 1972)

Having read this extract, what do you think it says about the status of painting? You might think about this in relation to the way we regard paintings nowadays.

That there is a contract at all says much. Unlike today, few paintings in fifteenth-century Italy were made without being commissioned. Yet looking at the contract, it seems that the patrons, the friars Bernardo and Francesco, had a considerable amount of control and that the artist, Domenico, was regarded as a craftsman more than an artist, in the way that title is

understood today. After all, there is little leeway in this contract for imagination, individuality or creative spontaneity.

The patrons want Domenico to paint the picture,

> ...in the manner shown in a drawing on paper with those figures and in that manner shown in it...not departing from the manner and composition of the said drawing.

Bernardo even adds that the work should be painted,

> ...according to what I, Fra Bernardo, think best.

Nonetheless, while Friar Francesco supplies the panel upon which the painting is to be made, the artist Domenico has to pay for it, just as he has to pay for his colours. The contract even states that these should be 'good colours' and that Domenico should use gold and ultramarine blue (ultramarine came from the ground semi-precious stone lapis lazuli and was highly prized).

And finally, the quality of the work is to be judged by the patrons or someone else who will give 'an opinion on its value or workmanship.' If the quality is not to the standard required, the artist Domenico will receive a smaller fee.

This example illustrates that we cannot easily separate the status of the painting from its maker. Although it was always considered that painting required a measure of skill, this did not mean that painters were ranked as more important than other artisans, such as those who made jewellery or weapons. In addition, painters' status was reflected in the fact that they did not have their own **guild** (an association of master craftspeople and tradespeople). In Florence, for example, painters belonged to the Guild of Doctors and Apothecaries, which itself was one of the 14 minor guilds, rather than one of the seven major ones. However, as the fifteenth century progressed, rapid economic growth saw the rise of a merchant class that viewed art as evidence of its taste and refinement. The increased demand for all kinds of art developed most notably in Italy where the status of painting and painters gradually became more elevated.

As early as 1400 the Florentine artist Cennino Cennini argued that painting should be regarded as a **liberal art** and not a mechanical one. Liberal arts such as poetry, discourse, logic and grammar required theory and scholarship; the mechanical arts required practice. Cennini's aspirations were realized, although not entirely, by the middle of the next century. Artists such as Leonardo da Vinci, Raphael, Titian, Michelangelo and, in northern Europe, Albrecht Dürer achieved the sort of

distinction in their own lifetimes previously reserved for the great figures of the liberal arts. Furthermore, the status of painting itself increased.

> Take a minute to think about why the status of painting and painters may have increased. This is a difficult question and there are no firmly established reasons, but you might consider the influence of patronage.

To help you consider this, it may be useful to know that among other important patrons, Leonardo was employed by the King of France; Raphael and Michelangelo produced work for the Popes; and Dürer and Titian worked for the Holy Roman Emperors.

The patrons mentioned were important people and you would be right to assume that their status reflected on the artists they employed and the art they commissioned. Patrons wanted works of art to enhance and confirm their education, good taste and refinement, to advertise their fame, prestige and authority, and to show off their wealth and impress their contemporaries. In order to promote these characteristics, they wanted skilful work with learned themes. Painting was a relatively cheap way of doing this, less costly and quicker than other visual forms such as sculpture, mosaic and tapestry. Paintings could transform the literary into the visual, and more directly and immediately tell a story or communicate a message. Yet while patronage was an important reason why the status of painting and painters grew during the fifteenth and sixteenth centuries, it was not the only one.

Academies

As its status increased, the idea of painting as a mere trade or craft was challenged. During the Renaissance, artists had begun to organize so-called **academies** to informally discuss theoretical and practical issues amongst themselves. The word 'academy', named after Plato's school of philosophy, was used because of its association with an intellectual activity rather than a practical one.

By the later sixteenth century, more formally organized academies had been established, the first in Florence, then in Rome and Milan. As well as challenging the control of guilds, academies proclaimed the status of artists as more than just

craftspeople. An important development that significantly raised the status of painters and painting took place in Paris, France in 1648. Here, painters persuaded the King to support the creation of an academy, which he did. Since this organization had royal approval, its influence, importance and prestige were assured.

The French Royal Academy of Painting and Sculpture held a virtual monopoly over teaching and exhibiting art. Most importantly, the idea that art and taste could be taught and studied according to certain 'laws' or 'rules' was established. For example, the first Director of the Academy, Charles LeBrun, developed a visual system of human expressions and poses which were meant to convey particular emotions. **Composition** and drawing (called 'design') were regarded as the basis of a 'good' painting, and colour was considered as a secondary and less important element. Subject matter was categorized, the most important and prestigious being **history** (which included mythological, religious, literary and historical subjects), descending in importance through portraiture, genre (scenes of everyday life), landscape and still life. The emphasis placed on 'design' and the establishment of a subject **hierarchy** had a huge influence on European painting, which was only challenged in the mid-nineteenth century. The example of the French Royal Academy was imitated in other countries and by 1790 there were over 100 art academies in Europe.

Section 3 What is 'good' painting?

Have you ever considered why some works of art are thought to be 'better' than others?

If we ask this question about a car rather than art, we might be more able to answer because a car has more definite criteria upon which to make our judgements. One car may have more room for passengers than another, it may be cheaper to service, parts easier to obtain, have more economical fuel consumption, have good acceleration or be more comfortable. These reasons are based on personal preference, since things such as fuel consumption or comfort may not be priorities for some people, yet they are commonly accepted criteria for judging the 'quality' of a car. Such specific criteria do not exist for painting. Or do they? The academies put forward the idea that certain subjects were more important than others, and that drawing was more important than colour.

> Look at Caravaggio's *The Supper at Emmaus* (Plate 1) and Cézanne's *The Grounds of the Château Noir* (Plate 2). Which of these two paintings do you think best conforms to academic standards for 'good' art?

The different subjects should suggest that the Caravaggio is a 'better' painting in a purely academic sense because religious subjects had a higher status than landscapes.

However, this is not all. The arrangement of the figures in Caravaggio's painting is carefully planned: the figure of Christ and the table are centrally placed and the other figures are positioned around them. The arrangement of trees and rocks in Cézanne's painting seems less organized.

Also, while Caravaggio uses colour, his painting relies to a large extent on drawing; look at the way he paints the drapery, the objects on the table and facial features, and compare this with the way Cézanne represents leaves, tree trunks and sky. In Cézanne's painting there is hardly any evidence of drawing.

> Now look at Caravaggio's *The Supper at Emmaus* and El Greco's *Christ Driving the Traders from the Temple* (Plate 3). Ask yourself the same question: which of these two paintings do you think best conforms to academic standards for 'good' art?

The subject matter of both paintings is religious and so, in the academic hierarchy, they are equal. The difference between them lies in their compositions and relative reliance on drawing and colour. Again, the Caravaggio fits the bill better. The arrangement of figures and their setting appears less rigidly organized in the El Greco and the colour seems to play a more prominent role, being less 'contained' by the edges of the figures and objects. If you noticed that the poses and facial expressions in both paintings are rather theatrical and that this might demonstrate academic excellence, you should pat yourself on the back! We noted above that the first Director of the French Academy, Charles LeBrun, developed a system of expressions and poses meant to convey particular emotions. Although these two paintings do not conform to this system (since they were painted before it was invented), they illustrate the type of thing LeBrun had in mind. These paintings are looked at more closely in Chapter 02, but for the moment the point being made is that

academies established criteria for painting which distinguished between 'good' and 'not so good'.

Let us return to our analogy of the car. What makes one 'better' than another might be determined by personal reasons rather than specific and 'measurable' ones like fuel consumption or good acceleration. You may prefer a car of a particular shape or colour, and so your judgement about whether one car is better than another is really about personal choice. With paintings the often repeated comment 'I know what I like' is not an informed judgement but an opinion. There is nothing wrong with expressing opinions, but it is worth considering that they are influenced, to a greater or lesser extent, by the customs, conventions and general spirit of the times in which they are made, as well as by the knowledge, experience and perhaps social background of the person expressing the opinion. Therefore, for an educated seventeenth-century viewer, Caravaggio's *The Supper at Emmaus* would more likely be regarded as a 'better' painting than El Greco's *Christ Driving the Traders from the Temple* because it more readily conformed to the conventions of the day (i.e. **academic** taste). A twenty-first-century viewer might be less influenced by academic taste and would probably find it more difficult to judge whether one painting was 'better' than the other.

This section began by asking why some works of art are thought to be 'better' than others. To some extent this has been answered with reference to academies: they established a standard of taste that allowed judgements to be made and influenced opinions. However, academic standards are not necessarily those used today, nor can they be applied to non-Western art. Moreover, they were not applied before the seventeenth century because they did not exist! Finally in this chapter, we want to look at an idea which should help us discover what 'good' art means and, ultimately, what art is.

The canon

The word **canon** comes from the Greek for a carpenter's rule; applied in English it means a standard by which something may be measured. In art, it is used more specifically to signify work acknowledged to be the best example of a culture or a chronological period, a country or region, an individual artist or a subject type. For example, Michelangelo is regarded as the **canonical** figure in Italian art; Picasso the canonical artist of the

twentieth century; Leonardo da Vinci's *Mona Lisa* as a canonical portrait.

There are many canons: the '**modern** canon', the 'canon of French painting', the 'canon of still life painting', but what connects them all is that canonical art is accepted to be, beyond doubt, of the highest quality. If we look back at the example of the academies, we can see that a canon is a *construction*, an artificial standard established by a ruling elite. Charles LeBrun and his fellow academicians declared drawing more important than colour and 'history' subjects more eminent than still life; they established a canon.

It is important to understand the concept of the canon for it not only allows us to talk about 'great' art but about art itself. All the previous discussions about what art is can be simply answered by acknowledging that if it is included in the canon, then it is art. Unfortunately, things are not that simple. The canon is not a fixed concept; works of art pass in and out of it for a variety of reasons.

For example, El Greco's place in the canon came into question in the mid-seventeenth century. He had received many commissions and had been a relatively popular painter in Spain in the sixteenth and early seventeenth centuries (he died in 1614), yet with the Church's shift away from spiritual and mystical images to more realistic ones (Caravaggio represents this tendency), El Greco's work became less popular. The rise of academies and their insistence on drawing over colour further harmed his reputation. It was not until the twentieth century, when his work was re-evaluated as a forerunner of modern art (Picasso's early work was influenced by El Greco's painting), that El Greco's reputation was re-established and he once more became a canonical artist.

The example of El Greco is instructive. It tells us that inclusion in the canon may have nothing to do with skill or aesthetic value. Quite often, inclusion in the canon has more to do with circumstances external to the actual art itself. The reasons why certain artistic disciplines, artists and works of art are considered 'great' are numerous. We have seen this in relation to the status of painting and painters: artists who work for important patrons tend to be regarded as great artists – they are 'canonized'. We can examine one final example to illustrate this.

Please look at Grant Wood's *American Gothic* (Plate 4) and Mark Rothko's *Untitled* (Plate 5).

Both paintings are by American artists and were painted within about 20 years of each other. And there the resemblance ends. One is abstract, the other **figurative**. However, from our point of view the most important difference is that each belongs to a different canon.

Rothko's painting belongs to a style called Abstract Expressionism and we would include it in the 'Modernist canon'. Its abstraction and apparent interest in formal characteristics – in this case colour, shape and surface – make it representative of the type of painting which was promoted by critics and art historians, especially in the 1950s. One of its supporters was the critic Clement Greenberg (to whom we shall return in Chapter 02); he said that Abstract Expressionism was: '"Advanced" art – which is the same thing as ambitious art...' ('American-Type Painting' in *Clement Greenberg. The Collected Essays and Criticism, Volume 3*, John O'Brian (editor), University of Chicago Press, 1993.)

We could say that Wood's painting belongs to the 'popular canon'. Although it was criticized for being a caricature of 'country folk', it became a very popular picture in the United States. Some critics and art historians attacked this type of painting as being anti-modernist partly because the style is reminiscent of fifteenth-century Flemish art rather than mid-twentieth century art. Greenberg wrote that 'Wood was among the notable vulgarizers of our period: they offered us an inferior product under the guise of high art.' (Letter to the Editor of *The Nation*, reprinted in *Clement Greenberg. The Collected Essays and Criticism, Volume 2*, John O'Brian (editor), University of Chicago Press, 1986.)

Whatever we feel about the two paintings, we have to understand that they have each been 'canonized' in their different ways. We can still have opinions about them but the art historical consensus (although not necessarily the popular view) is that Rothko's is a more significant painting than Wood's. The reasons for this have little to do with the works as such. Rothko's painting received much critical support (from the likes of Greenberg, for instance) which was influential in promoting it as 'great' art. This particular painting is now in the Tate Modern in London, a location which itself confers status on work which hangs there. Rothko's paintings continue to be promoted through books, articles and exhibitions. On the other hand, although Wood's painting won a medal when it was exhibited in Chicago in the 1930s, it has remained in the United States, as has all Wood's work and, unlike Rothko's, has never

been as internationally renowned. Also, there have been fewer books, articles and exhibitions featuring Wood's paintings than Rothko's.

Conclusion

This chapter opened by discussing various definitions of art and some of the assumptions (and exclusions) behind their use. The category of art is culturally relative; it has changed over and through time in keeping with perceptions of what is judged to have value. Historically, artists, styles and periods of art have passed into and out of fashion, depending on evolving standards or 'canons', understood as stated and culturally specific benchmarks of quality.

For example, the distinction between craft and fine art is something which can be traced back to the Renaissance and a Western tradition of cultural production. The subsequent status and specialization associated with art practice arose with the academies, those organizations concerned with the regulation and ordering of art and the making and setting of professional standards (a function once undertaken by the old trade and craft guilds).

The motivations for making and commissioning art have also changed through time. Once closely identified with religious patronage and observance, the making of art and its subject matter became increasingly secular with paintings made for the open market, rather than in response to stipulated contract or instruction. Figurative images, those which relate to actual things and objects in the world around us, and those which are abstract and do not, can also be traced back to broader cultural uses and associations which we will explore in the following chapters.

Suggestions for further reading

Diarmuid Costello and Jonathan Vickery (editors), Art: *Key Contemporary Thinkers*, Berg, Oxford and New York, 2007.

Jonathan Harris, *Art History: The Key Concepts*, Routledge, London and New York, 2006.

Chris Murray (editor), *Key Writers on Art: From Antiquity to the Nineteenth Century*, Routledge, London and New York, 2003.

Chris Murray (editor), *Key Writers on Art: The Twentieth Century*, Routledge, London and New York, 2003.

Gill Perry and Colin Cunningham (editors), *Academies, Museums and Canons of Art*, Yale University Press, New Haven and London, in association with The Open University, 1999.

Marcia Pointon, *History of Art: A Student's Handbook*, (4th edition), with assistance from Lucy Peltz, Routledge, London and New York, 1997.

judging by appearances

In this chapter you will learn:
- what formalism means in art and art history
- relevant terminology supported by case studies
- some of the advantages and possible limitations of formalism as a critical approach to art
- what Modernism was and how it has influenced the way we explain and interpret images.

Section 1 Formalism: What it means

As a way of exploring pictures, formalism, as the term implies, looks at the form or appearance of an image rather than content or **narrative**. It suggests that the visual elements which make up a work of art are essential to its meaning since they communicate the thoughts, feelings, ideas, information or whatever else a work of art may be about. Using various examples, this chapter will introduce and explore formalist approaches to paintings, including key terminology as well as considering the advantages and possible pitfalls arising from their use.

In painting, formal visual elements include line, shape, colour and tone, which in turn are affected by the media and techniques employed by the painter. These combine to give us effects such as rhythm, balance, pattern and so on which comprise the composition – the arrangement of lines, shapes and colours we see when we stand in front of a picture. According to the formalist viewpoint, we respond to a work of art – either figurative (one that resembles our visual experience of the world) or abstract (one that does not) – because we consciously or unconsciously respond to its composition or formal arrangement.

Formalism suggests that we ignore subject matter (what is actually going on in the picture) or at least consider it as less significant than the formal qualities. Exploration of a painting's formal elements can certainly help to illustrate its possible meanings or significance. However, as we shall see, when used to look at figurative work this approach has to be related in some degree to subject matter.

As an example, please compare two paintings: Caravaggio's *The Supper at Emmaus* (Plate 1) and El Greco's *Christ Driving the Traders from the Temple* (Plate 3).

> Before reading further, you might want to make a short description of the lines, shapes and colours that you see, and whether you notice any similarities in the two images.

Although painted in different countries, these pictures were made at about the same date and, in some ways, show similar formal characteristics. For instance:

- Both use strong light sources that seem to model or shape the figures, clothes and objects, making them appear three-dimensional, as though they exist in real space.
- Both use **linear perspective**, the system of lines meeting at eye-level, to create the illusion of three-dimensionality. In the Caravaggio it is most noticeable in the right-hand edge of the table; in the El Greco it can be seen in the distant architecture.
- Both use areas of bright colour contrasted with darker, more sombre coloured areas.

As you look at these pictures, you may also notice other similarities. For example, the dramatic poses of some of the figures – the outstretched arms in the Caravaggio, Christ's raised arm and the recoiling figure in the El Greco. However, some of these details we might also associate with the subject matter. This might illustrate the point made above, that with figurative images it is difficult to separate formal exploration of the composition from the actual subject matter. That said, please consider the Caravaggio more closely, seeing whether you can avoid making direct reference to the subject.

Caravaggio: *The Supper at Emmaus*

Caravaggio's painting has what is called a central composition:

- One seated figure is only just off centre, flanked by two others who are positioned lower in the picture area and so form, with their heads, arms and shoulders, an overall triangle of which the central figure's head is the apex.
- However, there is another figure standing to the left that upsets this symmetrical balance.

Other elements support the harmony or relatedness of the composition. For example:

- The edge of the table echoes the triangular arrangement of the figures noted above.
- Reds and whites are arranged across the picture so that there is no distracting accumulation of colour in any one area.

The use of tone (light and shade)

- Tone models the forms, thereby making them appear three-dimensional.
- Tone illuminates what we might think are important features, especially the hands and faces.
- Tone depicts cast shadows, enhancing the illusion of the picture's three-dimensionality.

Colour

- Colour is descriptive, that is not altered by the artist in order to create an effect other than that of a real scene taking place before us.
- Colour is local – not changed by the effects of light or by the reflection of other nearby colours.

The painting technique

- The painting technique is precise and meticulous.
- The edges of forms are sharp and clear, thereby creating a convincing illusion which enhances the scene's reality.

There is much more that might be said about the formal characteristics of this painting. For instance:

- The foreshortening of the figures' arms so that they appear to project into the viewer's space (a similar effect is identifiable with the basket teetering over the edge of the table).
- Light areas set against dark, and vice versa, such as the right-hand figure's head against the background or the shadowed face of the standing figure against the lighter background. This adds to the scene's illusionistic depth, persuading us that the figures exist in actual space.

These points might suggest that Caravaggio wants us to believe, as best we can, that what he has painted is actually happening before our eyes; his use of tonal modelling, linear perspective, detailed rendering, descriptive colour and so forth, support this view. This may help us to understand aspects of the painting to some extent, but we can develop this further.

For example, that the equilibrium or balance of the three seated figures in a triangular arrangement is disrupted by the addition of the standing figure is, in itself, meaningless unless we interpret it in some way.

- Perhaps Caravaggio wanted to make the composition less rigid, even less boring.
- Or perhaps this imbalance in the arrangement was in some way meant to enhance the meaning or effect of the narrative. After all, the two disciples have just realized that the man they are with is Christ, whom they believed to be dead; a stable, balanced composition might convey less effectively a sense of surprise and shock than an imbalanced, asymmetrical arrangement of the figures.
- Also, the use of strong light sources that create dark, contrasting shadows (an effect known as **chiaroscuro**) does

not merely help to create an illusion of reality but adds to the drama of the subject matter.

All this demonstrates that it can be difficult to separate the formal characteristics from the subject matter. In fact, if we do consider formal characteristics independently of the subject, we may reduce its possible meanings and significance. In other words, meaning in some works of art results from the relationship between form and content – between the means used to make the work and what is being depicted.

El Greco: *Christ Driving the Traders from the Temple*

Another look at El Greco's *Christ Driving the Traders from the Temple* may illustrate this point.

- As with *The Supper at Emmaus*, Christ is centrally placed in the picture. Furthermore, his brightly lit garments, strongly lit form and his head framed by the background arch make him the focus of our attention. In short, by employing a series of formal devices, El Greco has left us in no doubt that Christ is the most important figure in the scene.
- The subject is a dramatic one and El Greco has conveyed this in several ways:
 - The poses and gestures of many of the figures suggest movement and even violence.
 - The strong lighting and resulting shadows create a theatrical effect.
 - The awkward perspective of the fallen table in the foreground and the arches in the upper right of the picture produce a disturbing effect.
 - So too do the exaggeration of forms, such as the elongation of Christ's body, the very muscular arms and legs of some of the figures, the inconsistent scale and positioning of the woman carrying the basket at the extreme right and the overall confusion of bodies and limbs.
 - The use of vivid colours, made more so because they are played off against darker and neutral colours, further enhances the drama.
 - And the painting technique used by El Greco, where the brushwork is evident, detail is minimized and the edges of some forms softened – in stark contrast to the detail and sharpness of Caravaggio's painting – contributes to an overall sense of movement.

Therefore, El Greco has used a variety of formal means to convey the violence of the subject. Put another way, the formal characteristics are not there for their own sake but, seen in relationship with the subject, they enhance the picture's meaning.

Yet the meaning of this painting is not merely to convey an image of violence; it is, after all, a religious subject and so we must respond to this fact if we want to experience the work in a more complete way. Moreover, we might need to know something about the circumstances of its commissioning or production, even about El Greco himself. This will take us away from our investigation of formal characteristics and into the realms of the painting's context, which is the subject of Chapter 03. However, we could say that looking at a work like this from only a formalist position may be a limiting experience and one that restricts our understanding. So, we could say that our understanding and appreciation of works of art might be enhanced if we think about them in a number of ways, of which formalism is one.

Cézanne: *The Grounds of the Château Noir*

With the radical changes that took place in painting from the beginning of the twentieth century, formalism became a widespread and influential approach to looking at and making art. Looking at Cézanne's *The Grounds of the Château Noir* (Plate 2), painted at about the turn of the century, we can see why this might be.

Cézanne's work appears less obviously naturalistic than the previous examples by Caravaggio and El Greco. You might see this painting as the representation of a landscape with trees, rocks, sky, etc., but there are several characteristics that, arguably, make the illusion of reality less convincing:

- The actual brushwork and even some areas of unpainted canvas can easily be seen.
- There is no accurate depiction of leaves, tree trunks and rocks, but rather a series of brushstrokes.
- Some of the tree trunks have an outline, something which we do not see in reality.
- There is some attempt to represent depth and distance through the generally warmer foreground colours and cooler background colours, variations in the scale of objects and some use of light and shade. Yet the painting's surface is covered in a dense mass of brushstrokes that deliberately limits any significant illusion of depth and three-dimensionality.

Nevertheless, probably more so than with the Caravaggio and El Greco paintings, we can look at the formal qualities in Cézanne's image to help us to better understand the work.

Colour

This is a major feature of the painting since it describes the subject – green leaves, brown rocks, pale blue sky, etc.; but notice the strange inconsistencies:

- Some small patches of pink on the rocks and, most noticeably, a bright orange area on the rock in the lower foreground. Cézanne may well have seen such colours as he sat in front of this *motif*, as he called his subjects (Cézanne claimed that he usually worked from nature). However, we might speculate that he deliberately changed or orchestrated them in some way to create a particular effect. They do create a certain harmony.
- Some of the greens which describe the leaves are to be found in the rocks; some of the ochres and browns of the rocks can be noted in the trees; the sky, tree trunks and rocks use similar pale greys and blues.
- Warmer colours dominate the lower part of the picture – the foreground of the subject – and cooler and darker colours the upper part – the middle and background. This helps to make the lower part appear closer to us since warm colours advance to the eye and cool colours recede, creating an illusion of depth. But the obvious brushstrokes and lack of detail put deliberate emphasis on the painting's surface, thereby contradicting this visual effect.

Texture/surface

Texture might be tactile, that is actual, or it might be visual – an illusionistic simulation of a tactile surface.

In Caravaggio's *The Supper at Emmaus*, the various textures of hair, skin, cloth, fruit and so forth are illusionistically reproduced so that we know what their surfaces feel like just by looking.

In the Cézanne, the textures of tree trunks, rocks, leaves, earth and sky are all rendered in a similar way. Therefore, the illusion of different surface textures does not exist. What the Cézanne offers in terms of textures is an all over surface of similar brush marks, reminding us that the painting is ultimately a flat surface. More illusionistic pictures like the Caravaggio tend to conceal this.

Line

In two-dimensional rendering, such as drawing and painting, line is used in various ways, but frequently to distinguish the edges of forms. However, line in nature is difficult to find. What appear to be lines, such as the 'lines' between tiles on a kitchen floor, are in fact shadows created by two edges touching each other. Also, objects do not have lines around them; we may notice the edges because their surface is different from their background in some way – different materials, colours, textures or picked out by light.

- Cézanne uses lines in his painting (on the tree trunk at the right-hand side, for example) to show the edge of the object and to separate it from the background. While not a naturalistic effect, it may be that he had to clarify the edges of forms otherwise they would have been lost amongst the wealth of colour harmonies and conspicuous brush marks.

Tone

- Variations in light and shade help to create an illusion of depth, principally the lighter foreground against a darker background.
- Despite a variety of tones within each colour, few individual forms are modelled by light. There is some variation in light and shade on the rocks in the centre of the painting that might persuade us these are three-dimensional, but there is little else in the work to convince us that objects are solid forms which exist in space.

Form

- Cézanne's move away from tonal modelling, i.e. using light to suggest volume and shape, has left us with a painting where the three-dimensionality – solidity of rocks, tree trunks, the mass of foliage – is quite confused and confusing.
- Interestingly, the brushwork and subtle variations in colour tones do give a sense of a world that has mass and weight, if not of its actual appearance.

Perhaps Cézanne's concern is as much about the actual structure and solidity of paint on canvas as it is about the illusionistic rendering of forms. For instance, the darkly painted centre of Cézanne's work seems to represent a solid and tangible distant hillside seen through the trees. Yet isolated from what is around it, this becomes a dense mass of colour and short brushstrokes. This is noticeable if you cover up the bottom third of the painting.

Composition

The arrangement of elements within the rectangle of the picture is far less obviously organized than in, for instance, Caravaggio's *The Supper at Emmaus*:

- Here there is a central figure, table and flanking figures in a pyramidal arrangement, and a standing figure which upsets this formality.
- In the Cézanne there are trees flanking a central area of rocks and a mass of colour and brushwork. A diagonal falls from the middle of the left side to the bottom right corner – a device echoed in the branch in the top right corner and the fallen branch, rock and brushwork at the bottom right.

We might say that Cézanne's painting does not show the visible world in the same way as Caravaggio's *The Supper at Emmaus* or El Greco's *Christ Driving the Traders from the Temple*. Whereas Caravaggio and El Greco use formal characteristics to create relatively convincing illusions of three-dimensional reality on the flat surface of their canvases, Cézanne deliberately draws our attention to painting's formal characteristics.

One tendency of twentieth-century painting has been towards abstract or non-figurative images – pictures that do not appear to look like anything we would come across naturally. We might say that paintings such as *The Grounds of the Château Noir* are seen as the first steps in this journey and Mark Rothko's *Untitled* (Plate 5) is regarded as a point of arrival.

Section 2 Formalism and art history

Some of these artistic experiments in painting at the beginning of the twentieth century, as we have seen in Cézanne's *The Grounds of the Château Noir*, ran parallel with attempts by art historians and art critics to interpret and understand their significance. Some art critics in the early twentieth century came to believe that a formalist interpretation was more relevant for the art of that time. Looking at Cézanne's work they saw a shift away from content (subject matter) as a principal feature of the work to an emphasis on the way it looked and how that was achieved through the formal qualities of line, shape, colour and tone. They argued that a work of art's meaning and significance was embodied in these qualities alone.

Two well-known supporters of this approach were Roger Fry and Clive Bell. Fry believed that the formal qualities of a work of art triggered the response in the viewer. Bell believed that a work of art could provide an emotional reaction in the viewer, something like a religious experience in that it should elevate and even improve us. But both believed that it was the *formal* features rather than subject that mattered. They argued that we have an innate awareness of the qualities of line, colour, shape and tone, and that we respond to them more directly and more genuinely than we do to the subject. According to Bell, the lines, shapes and colours within a picture combine in a certain way to evoke **significant form**. It is the viewer's response to this which, for Bell, is the key to visual experience.

Clement Greenberg and Modernism

A formalist understanding of art was also promoted by the American art critic and writer Clement Greenberg. During the 1940s and 1950s Greenberg supported and helped popularize abstract and **modern** work by Abstract Expressionist painters such as Jackson Pollock and Mark Rothko (see Plate 5). One insightful comment Greenberg made was in 1962 when asked to sum up what he felt to be the key component to art:

> What is the ultimate source of value or quality in art? The answer appears to be: not skill, training, or anything else to do with execution or performance, but on conception alone.

> (Quoted in *The Times*, obituary notice, July 1994)

Like Fry and Bell, Greenberg is here suggesting that it is an artist's imaginative sense expressed through the work that has value and relevance, rather than the subject matter itself. In other words, the 'message' or meaning is in the medium, which is the *real* content. In fact, Greenberg went further than this by saying that while the narrative or subject matter of the image could be of interest, it should play no part in how we aesthetically value or respond to the work. Citing work by French painters like Manet and Cézanne, and the Cubists Braque and Picasso, Greenberg argued that work by the 'best' painters in history could be characterized not by its subject matter but through its forms and technique.

In the light of what has already been said, what do you think Greenberg thought about *figurative* or *naturalistic* art?

- Since Greenberg believed the formal characteristics were most important to a work of art, and that a work's value rested upon this, it would follow that figurative or **naturalistic** art, with its emphasis on content (or subject matter), was not, as he put it, art of quality.

We might begin to explore this further by looking back and comparing Caravaggio's painting (Plate 1) with the painting by Rothko (Plate 5). After reconsidering these images, please reflect upon this further comment by Greenberg:

Whereas one tends to see what is in an Old Master before seeing it as a picture, one sees a Modernist painting as a picture first. This is...the best way of seeing any kind of picture.

('Modernist Painting' in *Clement Greenberg. The Collected Essays and Criticism, Volume 4*, John O'Brian (editor), University of Chicago Press, 1993)

Here Greenberg seems to make a very important distinction. With figurative painting like the Caravaggio we are given the impression, through careful modelling, recession and use of perspective etc., that we are in fact looking through a hole in the wall rather than a flat surface which has been deliberately constructed, of actual or physical depth. Of course, you the viewer know this, but you are asked to suspend your disbelief for the purposes of reading the picture's subject matter. Another example of this is William-Adolphe Bouguereau's *The Birth of Venus* (Figure 4, p. 33). Bouguereau was a nineteenth-century academic painter known for his large mythological and highly figurative, narrative pictures, of which this is one example.

Take a close look at this painting. You might want to make a list of the formal qualities you see, based on the list suggested earlier in the chapter.

As with our descriptions of the paintings by El Greco and Caravaggio, you may have found it difficult to separate form from content. That is, the formal characteristics such as

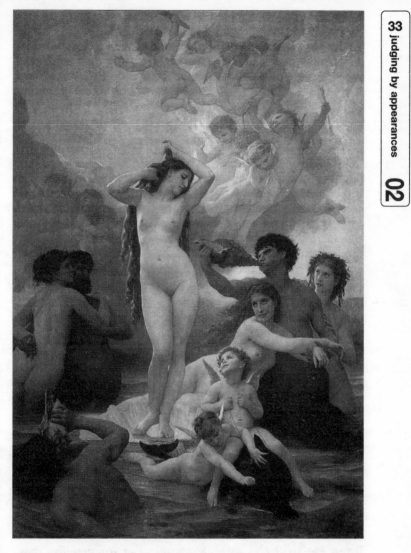

figure 4 William-Adolphe Bouguereau *The Birth of Venus* 1879

composition, tone and line from the subject matter – the gestures and expressions of the figures, their setting and the narrative conveyed. You would probably find the same with the reproductions of Hunt's *The Light of the World* (Figure 2, p. 9) and Brodsky's *Lenin in Smolny* (Plate 6); the latter is looked at more closely in Chapter 03. However, with the Bouguereau, the black and white illustration is fitting since the original has an effect not unlike that of a photograph.

> Why do you think Bouguereau has used an apparently 'photographic' technique here?

Part of the answer, according to Greenberg, can be traced back to the nineteenth century when painters faced an increasingly difficult situation. The commercial success and widespread popularity of the camera gave an accurate likeness at a fraction of the cost of a traditional painting. Although not all nineteenth-century artists represented people, landscape or objects through **mimesis** (literally 'mimicking' reality), many did and, as a result, many saw their livelihoods threatened by this new invention.

One response was for artists to paint **mimetically,** but to choose subjects which were either fantastic or mythological, so combining the apparent techniques of photography (albeit in paint) but with subject matter that only imaginative invention could create. This, aside from interest in the naked female bodies, is one explanation of Bouguereau's painting. But other artists adopted what we now see as a more imaginative and radical solution. For example, the French painter Edouard Manet began to emphasize the physicality of the picture by giving a deliberately unfinished appearance to his paintings. To quote Greenberg: 'Manet's became the first Modernist pictures by virtue of the frankness with which they declared the flat surfaces on which they were painted.' (Clement Greenberg, 'Modernist Painting' in John O'Brian, *op. cit.*)

Greenberg used the word Modernist here to describe those works that made it clear to the viewer they were looking primarily at paint on a flat surface. Manet did not give his paintings the highly illusionistic finish that Bouguereau did and, consequently, the viewer was forced to confront the actual nature of the flat painted surface before anything else – even subject matter or narrative. We can see this in the unfinished surface of numerous Impressionist paintings that has become their trademark. For example, Morisot's *Summer's Day* (Plate 7).

Greenberg's insistence that it was the flatness which contributed to a painting's quality was based on the idea that the two-dimensional nature of painting made it uniquely different from other forms of art. If an artist exploited the unique characteristics of the medium – in the case of painting its flatness – then the resulting work would be well on its way to achieving 'quality'. For Greenberg, the main concern of painting is the way in which the artist uses and applies the medium. Any attempt to suggest a narrative through the use of three-dimensional or illusionistic pictorial space is seen as a needless distraction from the *purity* of the medium. For Greenberg then, the best painting is about the *process* and *technique* of the work rather than its subject matter or narrative.

Conveniently perhaps, you might think this provides a critical justification for American abstract art, which was then much under the cultural spotlight. However, it also allowed Greenberg to 'rewrite' the history of Western painting or canon, to the extent to which he saw the artists of the past as anticipating these important later developments. Greenberg therefore rated painters like El Greco, Rembrandt, Velasquez and Goya because of what he perceived as their attention to the process and medium of painting itself. The best art, according to Greenberg, evolves through what he called *self-criticism* or self-exploration. In other words, it develops through a *dialogue* between the artist and the medium, and by visual reference to the best art which preceded it. As with Fry and Bell, these ideas were based on the belief that a work of art's formal qualities are the primary source of its effect and subsequent appreciation. Fry, Bell, and Greenberg did not dismiss subject matter out of hand, but they did consider it of little or no importance in the evaluation of a picture's quality.

Mark Rothko's *Untitled* (Plate 5) was made as Greenberg was developing his formalist ideas about painting, and it shows the type of work he came to regard as good and important. In effect, Rothko's painting comprises colours, simple shapes with 'blurred' edges, and – vaguely – textured surfaces. While the painting may well have a subject, it is not one that relates to our common visual experience of the world. In other words, it could represent something, but as Greenberg might tell us, this is ultimately something we 'feel' rather than see.

We can now make three interrelated points about this formalist approach:

1 The work may not have a subject as such yet it can still have meaning; subject matter and meaning are not dependent upon each other.
2 The work's meaning is in its colours, shapes and textures – its formal qualities.
3 Meaning resides in the work's aesthetic effect achieved through the manipulation and exploitation of its formal characteristics.

For Greenberg, these three points determined whether art is good or, as he put it, art has 'quality'. So, whatever Rothko's *Untitled* may convey to us, be it an identifiable emotion, some feeling which is less definable, a memory of shapes and colours from some other place or simply a pattern of limited elements, it is the work's *formal* characteristics that do this. Greenberg further insisted that such a work had aesthetic value because it relied on flatness, shape and colour for its 'meaning' – those characteristics particular to painting and not to other art forms such as sculpture, literature, dance and so forth.

We might argue that judgements about aesthetic value (what we think is visually the best) are both culturally determined (arising from widespread notions of value and meaning) and subjective (personal to the individual making the choice). Not so according to Greenberg. In 1967 he wrote:

> Aesthetic judgements are given and contained in the immediate experience of art. They coincide with it; they are not arrived at afterwards through reflection and thought. Aesthetic judgements are also involuntary: you can no more choose whether or not to like a work of art than you can choose to have sugar taste sweet or lemons sour.

> (Clement Greenberg, 'Complaints of an Art Critic' in John O'Brian, *op. cit.*)

Greenberg rated Rothko's painting very highly. Before reading further you might want to think about how you would describe this picture (Plate 5).

How might Greenberg's formalist approach help us to understand art?

- Greenberg's Modernist theory and formalist viewpoints make the actual seeing or experiencing of an image of prime importance – not unreasonable since art history should be about looking!
- Aesthetic judgements (or how we respond to art) are seen as involuntary and instantaneous, they arise from the immediate experience of the painting – it may be difficult even to put them into words.
- Formalism promotes the idea of a work of art on its own (formal) terms. It reminds us that the making of an image is not just (or may not be) the creation of likeness, but rather the exploration of medium for its own sake.
- Formalism provides a way of exploring abstract art which, by definition, may not provide a clear narrative or subject to guide the viewer (we will return to this in Chapter 03 on contextual approaches to art).

What could be the possible limitations and problems with a formalist approach to art?

- Critics have been quick to point out that works of art can be seen in various ways, and that any approach which focuses entirely on process is bound to leave out other meanings or even, perhaps, the specific aim of the artist.
- Formalism can separate images from some of the purposes and motivations that might have caused them to be made in the first place, and in doing so it can limit our understanding because it is *unhistorical*.
- Greenberg's approach may be questioned on the terms of our physiological response to objects. We tend to be culturally conditioned to explore evident meanings (narrative, subject matter) within images before formal or other readings come into play.
- Formalist approaches can result in a limited definition of art. Most of the narrative or subject-based art of the Renaissance and afterwards was written off by Greenberg and some who followed his example.

Conclusion

This chapter has explored and discussed formalist approaches to art. Unsurprisingly, given the emphasis on the particular and highly specific experience of looking, formalist terminology remains influential within the art world. For example, in monographs and catalogues dedicated to the work of an individual artist, formalism provides a vocabulary for extensive visual descriptions of works and their effects on the spectator. In accounting for why and how we respond to art, critics like Bell, Fry and Greenberg made the case for the unique character of art and the aesthetic experience. In doing so, they played an important part in professionalizing and distinguishing art history as an academic discipline at a time when it was often understood as a sub-genre of literature. However, the emphasis on stylistic and technical analysis tended to overlook the broader social, cultural and political contexts in which art was produced and received.

As with any other approach to art, it is important to recognize that formalism and its subsequent and more sophisticated variation through Greenberg's Modernist theory, can be understood historically. That is, such ideas mediate the assumptions and pre-suppositions of their time. Fry and Bell belonged to a generation broadly shaped by the politics of antiquarianism and the legacy of colonialism, associations which influenced not only their choice of art but which determined their world view. Similarly, working at a time when Europe was being superseded in military and economic terms, Greenberg's support of 'home-grown' American abstract painting provided the intellectual justification for his country's cultural hegemony over the art and aspirations of the 'old world'. This is not to moralize or deny the importance of these insights and contributions, but simply to suggest that all approaches to art and art history are not 'value free', but that they communicate broader assumptions about value, meaning and cultural politics which we should question and test in the light of subsequent history and personal experience.

Suggestions for further reading

Mary Acton, *Learning to Look at Paintings*, Routledge, London and New York, 1997.

Clement Greenberg, *The Collected Essays and Criticism: Perception and Judgement, 1939–1944*, (editor), John O'Brian, University of Chicago Press, Chicago and London, 1986.

Clement Greenberg, *The Collected Essays and Criticism: Arrogant Purpose, 1945–1949*, (editor), John O'Brian, University of Chicago Press, Chicago and London, 1988.

Charles Harrison, *Modernism*, Tate Publishing, London, 1997 and Cambridge University Press, Cambridge, 1998.

Alice Goldfarb Marquis, *Art Czar: The Rise and Fall of Clement Greenberg*, Lund Humphries, Aldershot, 2006.

Grant Pooke and Diana Newall, *Art History: The Basics* (Chapter 2), Routledge, London and New York, 2008.

03 looking beyond the picture frame

In this chapter you will learn:
- different contextual approaches to looking at painting and how these can influence interpretation
- what perspectives some biographical and psychologically-based approaches might suggest about images and those who make them
- some of the main assumptions and questions which characterize gendered approaches to art and art history
- how these approaches work in relation to specific case studies.

Section 1 Art in context

In the last chapter we explored formalism as an approach to art which emphasized the way something was depicted, rather than looking at what was being presented (its subject matter). Before moving on, you might find it useful to recall the main points arising from this particular way of looking.

This chapter is divided into three sections, each of which considers a variation of the contextual approach to looking at paintings:

1 The first section will look at approaches that stress the historical and social background or context to images.
2 The second introduces the role of artistic biography and the artist's possible state of mind or psychology, and whether this might be relevant to how we approach or understand images.
3 The third section introduces the issue of gender and sexuality in connection with the subject matter and form of images.

> What might the phrase 'art in context' mean?

As a first step, please take a look at *Lenin in Smolny* (Plate 6) by the Soviet painter, Isaac Brodsky. Assuming some knowledge of history, the title, date and subject should provide us with some clues or prompt questions to ask, even if we are unfamiliar with the specific circumstances of the picture's making.

First, look at the form of the image, that is, the way it has been painted. Recalling the distinction made in Chapter 02, we can certainly say that it is a figurative rather than an abstract painting. In fact, so much so that if glanced at quickly the casual observer might reasonably think it a photograph.

> What effect does this have on us? Or, put another way, why might the painter, assuming he had a choice, have opted for this way of painting?

Before you answer, refresh your memory by looking at Caravaggio's *Supper at Emmaus* (Plate 1). What purpose might be served by attempting to faithfully re-present 'reality'? Using

the various formal elements suggested in Chapter 02 such as line, shape, colour and tone, you might want to write down a quick formalist description of what you see in Brodsky's picture. Nevertheless, in order to think about why Brodsky may have opted for this way of painting, you will probably have to consider more than just the formal aspects of the work.

- You might have thought that Brodsky wanted the viewer to immediately identify the person in it and grasp the situation being presented as soon as it was seen.
- Looked at more closely, the colours are naturalistic and, you might think, have the appearance of an old photograph or even a film still. The angle, light direction and careful use of shadow to define the head of the figure, further enhance this effect. With a fairly high viewing angle, it is almost as if, like a camera lens, we are intruding upon a reflective silence as Lenin sits and writes. As noted, the lines and shapes are crisply drawn and defined but the composition, although clearly thought out, seems somehow off-balance, especially with the empty chair opposite Lenin.

Pre-iconographic analysis

When we describe the formal elements of an image, we are attempting what is called a **pre-iconographic** analysis – literally, what is done before the image. This would include all the aspects (line, colour, tone, etc.) used in the comparison of the El Greco and Caravaggio paintings (see Chapter 02).

> How can we take our exploration of context further with this picture?

To do this we will need some background information which might be connected to the possible symbolism or concealed meanings within the picture. With this, we should be able to identify how the formal aspects might be deliberately designed to convey a deeper meaning which might not be noticeable at first glance.

Vladimir Ilyich Lenin led the Bolshevik Party to power in the 1917 Russian Revolution, thereby creating the first Communist state and the beginning of over 70 years of centralized Communist rule. Following two strokes – the first in 1922, the second in the following year – Lenin lost direct control of power. It was at this time that Grigory Zinoviev and Lev Kemenev

joined with Josef Stalin, Secretary of the Communist Party, to prevent Leon Trotsky, Minister for War and in charge of the Red Army, from seizing power. Lenin died early in 1924 with no clear successor and with many reforms and political changes incomplete. After Lenin's death, Trotsky lost his bid for power and was forced into exile in 1927. Zinoviev and Kamenev then realized that the real threat to their ambitions was Stalin; they were expelled from the Communist Party, leaving Stalin to take charge of the country and create the one-party state that became a feature of Soviet rule. Despite being reinstated into the Party, Zinoviev and Kamenev were tried and executed in 1936.

Isaac Brodsky's portrait of Lenin was painted in 1930, more than six years after Lenin's death. In fact, the year that Brodsky painted the picture, Lenin's embalmed body was interred in a newly built mausoleum in Red Square, Moscow. This begs the question: why a portrait of a dead man?

Iconographic analysis

Let's return to the picture and see if we can find some of the answers to this question in the clues left by the painter. In one sense, this image is full of symbolism: the dust sheets on the slightly antique looking chairs might suggest the passing of time and also of change. The interior is bare and sparse; there is no decoration or overall sense of status or power. Lenin is modestly dressed and informally presented, sitting at a table and writing a speech, perhaps to deliver to the people massed outside. The title of the painting refers to the Smolny Institute which, before the revolution, was a girls' school. At the time of the Revolution, the Bolsheviks needed a temporary base and so chose the Smolny because it was a convenient and relatively central location. The title, therefore, reminds the viewer of this time and, even if not immediately obvious to us, would have been so to many of those who witnessed and lived through the early years of the new regime.

Across from Lenin is an empty chair, a detail which plays a striking part in the overall composition. Perhaps this represents (or symbolizes) the absent partners in the new social experiment that was the Bolshevik revolution. It could possibly represent Karl Marx (the intellectual forefather of the Communist state and the historic figure to whom it was indebted) or, of course, Josef Stalin himself.

When we explore a painting or image and consider the subject matter and whether the various objects or 'motifs' might have a

symbolic or concealed meaning, we are attempting what art historians call an **iconographic** analysis of an image. In other words, we are trying to connect the picture's symbolism or details with wider cultural conventions and possible meanings.

Having suggested that Brodsky's image had a deliberate political meaning or aim, the following piece of the puzzle might now be added. By the late 1920s, Stalin had set about establishing his popularity by various means, one of which was to encourage images not just of himself (often in heroic pose), but also of his predecessor, Lenin. This was to give the impression of business as usual in order to reassure the people that all was in order and going smoothly during what was a time of intense uncertainty and instability. There was even a phrase used at the time, which was probably encouraged by the political regime: 'Stalin is Lenin today.' Brodsky's image, consequently, might be seen as a carefully crafted piece of propaganda or spin, to use the fashionable term. Although commemorating Lenin, it is actually about Stalin, who is absent from the picture but whose presence is suggested by the circumstances of the picture's appearance six years after Lenin's death. Seen in this way, Brodsky's painting is really a political portrait and manifesto which, cynically perhaps, is about a person who is absent from it, not the person depicted in it!

Going back to our earlier stage of pre-iconography, the similarity to a photograph might now be understood. Using the cliché of 'a camera never lies', the style itself suggests something which is or was true, i.e. the close connection between Lenin as the absent 'father' of the Revolution, and Stalin his 'loyal son' who has shown devotion by recording his predecessor's likeness. It should also be mentioned here, that at this time (the late 1920s and 1930s), artists in the Soviet Union came under intense pressure to paint in a figurative rather than an abstract way. The political thinking was that everyday images (often with a political message) would be more useful in educating the people 'appropriately'. Some artists (Brodsky was not among them) refused to do this and their work was simply not exhibited. Others, in the memorable words of one contemporary, 'observed the genre of silence'.

Summing up an iconological analysis

We have just read this image on what art historians call an **iconological** level. That is, we have attempted to connect its imagery or symbolism (its iconography) with a set of broader

historical circumstances and realities; we have attempted to understand what it might mean in relation to its historical context. In fairness, Brodsky's image is probably one of the more challenging examples that we might have chosen. But hopefully it has usefully served to show several things:

- Images may work on more than one level: we may look at them formally, as lines, shapes, colours and tones, etc. or as examples of pre-iconography that are interesting and valid in their own way. In some cases, perhaps like the Cézanne we considered in Chapter 02 (Plate 2), the artist may have wanted to encourage us to see in a particular way. Alternatively, the Caravaggio (Plate 1) is a clear attempt to convey an important message or meaning about Christian resurrection, faith and eternal life, using both formal characteristics and subject matter to do so. Different readings of the picture may place greater stress on the process of painting (its form) as opposed to its subject matter or context.

- In order to understand the context of an image, we must know something about it. Unlike formalism, where, by and large, we can rely on our powers of visual observation, we must also be able to bring or suggest some knowledge to the picture in order to tease out further meanings or explore the artist's intentions (part of the subject of Section 2). This is where art history and historical information more generally can be so helpful since, if carefully used, they should extend and develop our understanding of what is seen and interpreted.

- Images can serve all sorts of purposes and contain multiple meanings. A contextual approach using iconography is one way of engaging with possible meanings, both more obvious and concealed. This approach is associated with the art historian Erwin Panofsky who argued that a three-stage method of describing forms, their symbolism and their subsequent possible meaning (called Panofsky's **trichotomy** – literally three-handed) can help us to explore what we see in a more structured and methodical way.

- Finally, this particular way of investigating the context of an image is probably easier with figurative images, especially where the title gives us clues to the subject matter and possible meanings of the picture. Yet what if the image is abstract like the Rothko (Plate 5) we looked at in Chapter 02?

Does a contextual approach help us here?

Iconographic analysis of abstract painting

In concluding this first section and as an attempt to answer this question, let us return to Rothko's *Untitled* (Plate 5). Since we have already looked at this image from a formalist point of view, we can move on to the second or iconographical stage. What might those large canvases of textured, layered and often luminous curtains of paint suggest to our mind's eye?

From the late 1940s, Mark Rothko started to produce large abstract paintings, a style which, together with that of his colleagues Jackson Pollock, Willem de Kooning, Franz Kline and others, became known as Abstract Expressionism. In these images, Rothko deliberately takes out any aspects of social iconography – that is, any (figurative) reference to the everyday world or subject matter we see around us. A clue to Rothko's intentions is in the early titles he gave to some of his pictures: *Multiform*, *Aquatic Dream*, *Male and Female* are some of the names he used. We might say that these words suggest a different frame of reference; perhaps the forms, shapes and impressions of the natural world and also of free association connected with imagination and fantasy. In fact, the French Surrealists first took up some of these ideas, much influenced by the work of the psychoanalyst Sigmund Freud, and a number of the Surrealists emigrated to the United States where they had a profound influence on American artists such as Rothko.

It has been suggested that at an iconographic level at least, Rothko was attempting to develop a new form of expression or symbolism for a society emerging from the pressures of war and economic austerity. Some of his brooding and mesmeric abstract paintings with their intensely worked and thick **painterly** surfaces might suggest that the role of abstract art was, in part, to suggest the mysteries of nature or at least other ways of seeing and experiencing. Some critics have used the word **sublime** – an experience of such power and grandeur that we cannot give it adequate expression – as one way of approaching these very powerful paintings.

Of course there are different ways to read these and other abstract works. The summary of the ideas of Clement Greenberg offered at the end of Chapter 02 should have given a sense of a formalist way to approach abstract art. However, needless to say, as with Brodsky's painting, we can explore the wider context further in order to delve into the iconology or possible social meanings of this and similar images. But how are we to start?

Further iconographic analysis

For purposes of comparison with the Rothko, look at Plate 4, a figurative painting by another American painter and a contemporary of Rothko, Grant Wood. This fairly well-known image has the title *American Gothic*.

Before going any further, you might want to think about and describe what you see. If you can, ask yourself some questions that you think might help you to understand aspects of the painting's social iconography and subsequent meaning.

Here are some possibilities you might have covered:

- Is the date of the image significant? Can we start to build up a picture of the realities of American country and farming life from this period (the 1930s)?

- Was it commissioned? If not, why might the artist have undertaken it?

- What might we make of the two figures in the picture? How or what might they represent? Are we given any visual clues to their values and ideas by the clothes they wear and the way in which they are presented to us? Does the picture title help or hinder us here?

- How might the style of the painting (figurative) contribute to its meaning or iconology?

Overall, we might say that the image has very carefully presented iconography.

- You will have noticed the whitewashed weatherboard of the Gothic-style house which is placed centrally in the background (given additional emphasis by the apex of the roof which frames and joins the double portrait of the man and woman).

- The austere but formal clothing of the woman suggests perhaps her Sunday best. With the man, we can clearly see the workaday farm denims beneath the dark jacket; the hay fork is held out – almost presented to us. These are people who live by the land in a God-fearing, close-knit rural community and symbolize both hard work and a stable social identity.

- You may also have noticed their faces: both are dour, almost severe. Grant Wood has been called a regionalist or vernacular artist; that is, someone who produces homely and recognizable images which touch upon the essential qualities,

identities and values of a particular location or tradition. In this case, those of the farming communities of the American mid-West in the depression era.

> How does Wood's image help us to understand the meaning or iconology of Rothko's altogether more abstract painting?

Throughout 1930s' America, the figurative style associated with Wood and some of his contemporaries was popular. There were many reasons for this, but in some measure it was due to government-sponsored attempts to encourage accessible and vernacular art forms as a means of creating and forging American social and cultural identity at a time of economic hardship and scarcity. The Works Progress Administration (WPA) was only part of what was a wide range of social, cultural and political measures taken by the Roosevelt government to provide economic support to the US public. Coincidentally, and perhaps naturally enough, there was also a political agenda here. Elsewhere, as we saw with the earlier Brodsky painting (Plate 6), other countries were in the throes of violent economic and social change. The First World War had devastated much of Europe; Germany was expanding and re-arming under Hitler; there were fascist dictatorships in Spain and Italy (Franco and Mussolini); Stalin had held on to power in the Soviet Union. In Britain, a general strike in 1926 resulted in the government putting troops on to the streets in case of an attempted political coup. There had been several attempted revolutions (from the political left and right) throughout Europe in the 1920s. Combined with deteriorating economic conditions underlined by the collapse of the American stock market in 1929, it might not be surprising that figurative styles of art reinforcing what was known and familiar, as well as supporting the political status quo, enjoyed considerable popularity.

Look once more at Rothko's painting (Plate 5). After the Second World War there was an understandable need to escape from some of the earlier (figurative) styles which had been associated not only with the economic problems previously experienced in the United States, but also with styles of painting widely used for propaganda purposes by several countries with totalitarian regimes (including Nazi Germany and Soviet Russia; Brodsky's painting (Plate 6) is an example from the latter). Therefore, many artists were naturally unwilling to return to figuration when it had been so compromised by use in the previous decades.

An iconological or contextual evaluation of Rothko's painting would thus take into account the wider situation when exploring the painting's appearance and presentation. Rothko, as shown in his letters and comments, was keenly aware of the different connotations attached to figurative and abstract art of the time for just these reasons. A new (abstract) American art for a new (post-war) age would be the slogan for the Abstract Expressionists.

Contextual approaches to art: pros and cons

To conclude this section, what can we say about the advantages and challenges arising from a contextual approach which gives emphasis to the historical and social factors behind the making of art?

- In order to extend our understanding of images at an iconographic level (symbolism, for instance, a skull in a still life painting as a sign of mortality or the hourglass symbolizing time passing), we need to have some knowledge of basic cultural conventions. In other words, we need to be able to make the necessary visual connections. Different cultures have varying ways and conventions of making art, so we (the viewer) need some information with which to start.
- At the iconological stage (see pp. 43–6), we may need considerably more background information. As with Brodsky's picture (Plate 6) and Rothko's abstract painting (Plate 5), it can often help if we understand *why* and *when* they were made. Providing this information is what art history is partly about.

Naturally, there are criticisms of some contextual approaches which emphasize the cultural and historical background to images as a basis for exploring and understanding art:

- For example, there can be a danger of overlooking what should be central to the investigation in the first place: the image itself. Notwithstanding all the information we might be able to research later, it is the physical and very real object, sometimes unique or singular, that we have in front of us.
- As mentioned in Chapter 02, some formalist approaches to art history suggest that it is this visual experience which is the

most important basis for understanding and judging art. According to this argument, the examples of historical and social background that we are exploring in this chapter, while of interest in a more general way, cannot really be of any great use in getting to grips with the value and quality of the image itself.

On the opposite side of the fence, the contextual reading would suggest that, in any event, the value and quality of an image is in part socially conditioned, and that we cannot fully understand and evaluate a work unless we work out answers to why and when it was done. Ultimately, these varying approaches are as much about issues of personal interest and judgement as they are about anything else. Hopefully, this section has explored the possibilities which such a contextual approach can open up. However, it might be useful to keep both of these **paradigms,** or ways of seeing in mind when considering any image. Section 2 will explore a contextual approach which stresses the life of the artist and whether this can assist in answering some of the questions explored above.

Section 2 The life of the artist: biography

Giorgio Vasari wrote the first notable history of art. Published in 1550, with an expanded edition written 18 years later, *The Lives of the Artists* was the prototype for many later histories. Its full title, *The Lives of the Most Eminent Painters, Sculptors and Architects* (translated by G. Bull, Penguin, 1975), tells us much about Vasari's intentions.

- First, Vasari's use of the word 'eminent' reflects the changing status of artists during the period in which he was writing (the Renaissance), as discussed in Chapter 01. In fact, his book played a big part in these changes; if something and someone were worth writing about then they must be important!
- Second, Vasari only explores three artistic disciplines: painting, sculpture and architecture, thus ranking them higher than other disciplines such as manuscript illumination or making stained glass.
- Third, he writes about the lives of artists rather than the works of art, or so the title suggests. We could say that this last point establishes Vasari as an art historian who used a contextual approach to the subject. Although not completely true because Vasari made judgements about the quality of

artists' work loosely based upon the sorts of formal characteristics considered in Chapter 02, his *Lives* is based on the idea that biography is the most useful way of understanding art.

We might say that a biographical approach to art history is one that puts the artist at the centre of everything. This may sound obvious since artists create art and it follows that to understand art we need to know about artists. But there is no guarantee of this. As we suggest in this book, the approaches we use with art are as much about personal interest and judgement as they are about anything else. Taking a certain 'position', whether formalist or contextual is, to some extent, how art historians work. For instance, as we saw in Section 1, using knowledge of Russian history helps us to more completely understand Isaac Brodsky's painting of Lenin. Whether it enhances our appreciation is debatable, but some would argue that knowing and understanding more about the contexts of a particular work can develop and enhance our appreciation. Certainly Vasari thought so. His *Lives* is full of biographical information.

Please read the following excerpt from Vasari's *Lives* and think about how biographical detail is used to promote the idea of the artist as a special person. Vasari is writing about the Florentine artist Giotto.

The artist – genius

...this great man, who started life in the year 1276 [in fact he was born about ten years before this] in the village of Vespignano, fourteen miles out in the country from the city of Florence, was the son of a poor peasant farmer called Bodone, who gave him the name Giotto...Bodone used to let him look after some sheep; and while the animals grazed here and there about the farm, the boy, drawn instinctively to the art of design [meaning drawing], was always sketching what he saw in nature, or imagined in his own mind, on stones or on the ground or the sand. One day Cimabue [a Florentine painter born about 1240] was on his way from Florence to Vespignano, where he had some business to attend to, when he came across Giotto who, while the sheep were grazing near by, was drawing one of them by scratching with a slightly pointed stone on a smooth clean piece of rock. And this was before he had received any instruction

except for what he saw in nature itself. Cimabue stopped in astonishment to watch him, and then he asked the boy whether he would like to come and live with him. Giotto answered that if his father agreed he would love to do so. So Cimabue approached Bodone, who was delighted to grant his request and allowed him to take the boy to Florence. After he had gone to live there, helped by his natural talent and helped by Cimabue, in a very short space of time Giotto not only captured his master's own style but also began to draw so ably from life...

(*Lives of the Artists*, translated by G. Bull,
Penguin Books, 1975)

Vasari was writing in the mid-sixteenth century. Giotto died in 1337. In other words, Vasari was writing a little over 200 years after Giotto's death and in a period when documentation was, by our standards, limited. One thing that biographical studies rely upon is documentation. In this case, Vasari's source was the fifteenth-century Florentine artist Lorenzo Ghiberti in whose *Commentaries* the story of Cimabue's discovery of the child-genius Giotto appears. Yet where Ghiberti got the story from is not known; possibly it was a well-known tale since Giotto had become famous in his own lifetime and such stories often surround celebrities.

Whatever the case, it is hard to believe that things happened exactly in this way. Indeed, the first mention of Giotto living in Florence was documented in 1301, 20 years after he was supposedly 'discovered' and apprenticed to Cimabue in the city! And how much Giotto's representation of sheep improved from those childhood beginnings is hard to say; those he painted in Padua's Scrovegni Chapel when he was about 40, are, by modern-day standards, not especially naturalistic. However, the real point of quoting Vasari at some length is not to question the truth of his story or Giotto's ability to draw sheep, but to show how a biographical approach sometimes encourages the idea of the artist-genius. You may have thought this while reading Vasari's account of Giotto: the natural drawing ability and Cimabue's astonishment at the boy's skill, the eagerness with which the boy and his father accept Cimabue's offer, and the rapid development into a great artist.

Vasari's story of natural genius is not unique to Giotto; Picasso's father, himself a painter, was said to have presented his son with his palette and brushes, vowing never to paint again as his

13-year-old offspring's abilities had far outstripped his own. Like Giotto's story, this one is unproven although it makes for a good read. Similar stories of precocious genius exist for artists from Leonardo da Vinci to Andy Warhol. As we saw in Chapter 01, from the Renaissance onwards, the artist came to be seen as not simply a craftsperson but a 'special' person endowed with unique powers of creativity and insight. The writing of artists' biographies, and even autobiographies, not only helped to establish this image of the 'special' person but also greatly contributed to it. Again, we have Vasari to thank for this.

As you read this second extract from Vasari's *Lives*, you will see that he considers this particular artist as a messiah-like figure, sent from God to 'save' us!

> ...the benign ruler of heaven graciously looked down to earth, saw the worthlessness of what was being done, the intense but utterly fruitless studies, and the presumption of men who were farther from true art than night is from day, and resolved to save us from our errors. So he decided to send into the world an artist who would be skilled in each and every craft, whose work alone would teach us how to achieve perfection in design...and how to use right judgements in sculpture and, in architecture, create buildings which would be comfortable and secure, healthy, pleasant to look at, well-proportioned and richly ornamented. Moreover, he determined to give this artist the knowledge of true moral philosophy and the gift of poetic expression, so that everyone might admire and follow him as their perfect exemplar in life, work, and behaviour and in every endeavour, and he would be acclaimed as divine.

(*Lives of the Artists*, translated by G. Bull, *op. cit.*)

Here Vasari was writing about his contemporary Michelangelo, undoubtedly a great artist by any standard; whether he was sent by God 'to save us from our errors' is more debatable. Vasari's essentially biographical approach is not without comment on works of art, but he is sometimes preoccupied with an artist's personality or day-to-day life: Botticelli spending and squandering all he had earned while working in Rome, complaints by Uccello's wife that he stayed up all night studying perspective, and the teenage Filippo Lippi's abduction by Moors.

Although such things may have some bearing on our understanding of art, they are sometimes given an importance disproportionate to their actual artistic significance. Recently, some biographical studies have suggested a fascination with personality rather than art, making their subject appear more like a character in a novel.

Consider this example:

'I'm going to kill myself.'

Tony Smith recognized Jackson Pollock's whisky voice. The late night call was not unusual for Jackson. Even talk of suicide had the air of ritual about it. Yet there was something in Pollock's voice that Smith hadn't heard before, a harder edge that alarmed him. With his ample Irish charm he tried to calm the distant voice, but Pollock was inconsolable. 'Hold on,' Smith finally said. 'I'll be out.' He put down the phone and drove off into the night in the middle of an early spring downpour. It would be hours before he could reach Pollock's house at the eastern end of Long Island – hours in which, knowing Jackson, anything could happen.

(Extract from *Jackson Pollock. An American Saga*, S. Naismith and G. White Smith, Barrie and Jenkins, 1989)

You may have thought that this passage shows an undue concern with Pollock's life and psychological state; there is nothing here to suggest that either Pollock or Tony Smith were artists. Jackson Pollock is not the only artist whose life has been made as significant as his work by art historians and biographers; others include Vincent van Gogh, Henri de Toulouse-Lautrec, Caravaggio, Michelangelo and Andy Warhol.

Biographical interpretation

As shown, a biographical approach to art history can lead to an excessive focus on personality, with the works of art becoming secondary. Moreover, it is worth keeping in mind that biographers often have their own agenda. Vasari, for example, was keen to promote great Florentine artists (he came from nearby Arezzo) at a time when Italy was comprised of independent city states, each keenly aware of their territory and status. It is perhaps no coincidence that Vasari also regarded himself as a gifted artist, conveniently allocating himself a mention in the revised edition of the *Lives*. From an art

historical viewpoint, biographical histories written some time ago may be hampered by limited evidence, and material which could give us a 'bigger picture' which may be unearthed much later. That said, as with Vasari's *Lives*, good accounts can provide a fresh and accessible way of exploring and understanding artists, not just as remote figures but as living and working people. To see how this approach can be used, please look at Plate 8, Edvard Munch's *The Sick Child*.

First, how does the choice of subject strike you? And second, why do you think the artist painted a rather melancholy sick girl?

You might think that illness is an unusual subject for a painting. In some respects it is, although similar paintings were more widespread in late nineteenth and early twentieth-century European art, as we shall see later. However, as to why Munch painted it, you may have thought that it was something he had seen and which had moved him. And you would be right. If we use a biographical approach to interpret this painting, we discover that his father was a physician; this might lead us to speculate that if he had accompanied his father to a hospital or the home of one of his patients, Edvard may have experienced this sort of scene. In fact, some commentators say this image was inspired by such an experience. In 1885, the 22-year-old Munch and his doctor father visited a five-year-old boy who had broken his leg. The boy's sister was grief-stricken and so, it is claimed, we have the sick child transformed from a boy to a girl, and the sorrowful sister reinvented as the woman with her head bowed. Yet *The Sick Child* was more than this. Nine years before this visit, Munch's 15-year-old sister, Sophie, died of tuberculosis and, as one writer put it, 'the sight of Sophie, spitting blood and pleading for her life as she lay in her bed in the children's bedroom was unavoidable.' (*Edvard Munch*, R. Heller, John Murray, 1984.)

The woman with the bowed head in *The Sick Child* is a likeness of Munch's aunt, who looked after the household and the dying Sophie following Munch's mother's death from tuberculosis when Edvard was five years old. The first version of *The Sick Child* (Plate 8 is the fourth version of the painting) was completed in the year Munch and his father visited the boy with the broken leg. This may suggest that while the subject of the painting is the illness and subsequent death of Sophie, the visit

might have aroused powerful memories as Munch was painting the picture.

Of course, this explanation for the evolution of the painting is speculative; we have no proof that Munch was influenced in this way. However, there is evidence from Munch himself that the picture is about his sister's death:

> ...there can be absolutely no question of influence on my *Sick Child* other than the one that wells forth independently from my home. These are pictures of my home and childhood.
>
> (Quoted in R. Heller, *op. cit.*)

Psychological biography

In 1910, Sigmund Freud, the Austrian founder of psycho-analysis, wrote *Leonardo da Vinci and a Memory of his Childhood*. Freud reconstructed the artist's psychological development by drawing on his writings, art works and known adult behaviour. Leonardo had written that he was the son of a peasant woman, to whom his father was not married, but his father later married another woman who became Leonardo's stepmother. Freud concluded that Leonardo had received extreme affection from two mothers and analyzed one of his paintings, *The Madonna and Child with St Anne*, in the light of this. He argued that St Anne, the Madonna's mother, represented for Leonardo his natural mother, and the Madonna herself stood for his stepmother. The enigmatic smile on St Anne's face, Freud claimed, is both envious (of the stepmother) and joyous (of being with her own son). Freud's book is the first of what we might call 'psychobiography', and while we may find his central premise, that an artist's work can be traced back to the experiences of early life, difficult to accept as the principal reason for the way a painting might look, psychobiography can develop and change our understanding and alter our response to what we see.

Look again at Munch's *The Sick Child* in the light of Munch's experience of his dying sister. Now ask yourself why he might have painted this subject.

- You might feel that this image haunted Munch, unsurprisingly given the circumstances of his sister's death.

- You may also have thought that the painting was a kind of exorcism, an attempt to come to terms with a traumatic event from his youth. This psychoanalytic interpretation would seem to have some justification. As well as a number of drawings and prints of *The Sick Child*, Munch painted six oil versions and Plate 8, as previously mentioned, is the fourth of these. He worked on the first for over a year, continually painting, scratching out and repainting. You might see this, together with the repetition of the image throughout his life, as obsessive.

- There is another piece of possibly relevant biographical evidence: throughout his life, Munch kept the chair in which his sister Sophie sat as she died. You can see its high back as a curved shape in the top left of Plate 8, behind the large pillow against which Sophie's head and torso rest.

Biographical and psychobiographical approaches: pros and cons

In order to enhance our awareness of paintings, we may use various approaches or strategies. As shown in Chapter 02, looking at Cézanne's use of colour and brushwork in *The Grounds of the Château Noir* (Plate 2) may support our understanding and appreciation. Earlier in this chapter, we looked at paintings by Brodsky (Plate 6) and Wood (Plate 4), where knowledge of the historical context surrounding the image and reasons why it was painted increased understanding and, arguably, appreciation. As noted previously, the art historical approach we use is often about personal interest and judgement. However, some approaches seem more appropriate for particular works of art than for others.

> For example, how could a biographical or psychobiographical approach assist our understanding and appreciation of Cézanne's *The Grounds of the Château Noir*?

Unlike Munch's *The Sick Child*, there seems little in Cézanne's painting that might relate to his life and psychological state. After all, the painting is a landscape with no obvious

biographical reference. Consequently, you may feel that a biographical approach to this painting is either irrelevant or impossible. Nonetheless, is this true?

The Château Noir was about three miles (4.8 km) east of Aix-en-Provence, Cézanne's home town. In 1887, Cézanne rented space in part of the Château to store his materials and use it as a base for his painting expeditions into the surrounding countryside. Less than a year before, Cézanne's father had died. A banker, he left his three children shares and property and, as a result, Cézanne was for the first time in his life financially independent.

From this biographical evidence, you may think that Cézanne's unconventional style of painting (that is, unconventional for the late nineteenth century) might, in part, be the result of his financial freedom – he did not have to sell his work and so he did not have to paint what people wanted. Although this argument does not really hold true because his painting had always been relatively unconventional, it may be that Cézanne's financial independence encouraged this tendency. It certainly allowed him to live near Aix, a long way from the Parisian art market.

Before his father's death Cézanne had frequently stayed in the capital, but after 1886 he spent most of his time in Provence. Perhaps his newly acquired financial freedom liberated him from having to exhibit or chase after dealers and buyers. Unlike Paris, the south of France did not possess an artistic infrastructure: studios, professional models, dealers and suppliers of art materials. Without this, Cézanne was relatively isolated as a painter and his subjects limited – he tended to paint still lifes, portraits of people he knew and landscapes. Thus, both the subject and style of *The Grounds of the Château Noir* may be in some measure the result of his personal situation after 1886.

We might add some psychoanalysis to this broadly biographical outline. Cézanne's personality was, according to contemporary commentators, laden with anxieties. Allegedly dominated by his father, Cézanne was inhibited and awkward in his relationships with women and, all in all, lacked self-confidence. We might speculate that his solitary expeditions provided him with some solace and reassurance.

You might consider this analysis a less effective way of understanding and appreciating Cézanne's painting than the

formal analysis given in Chapter 02, and you could be right. However, understanding is not finite; we can never completely understand a work of art; there is always more to discover, more to grasp. Nor can our appreciation remain fixed; each time we look at a painting we experience it in a different way simply because we and the situation in which we view it are different. Having read a little about Cézanne's life, we cannot look at his work in exactly the same way as we did before; we know more and this modifies or informs our judgement. To close this section and in view of these ideas, let us return to Munch's *The Sick Child*.

Adding formal and contextual interpretation

We have suggested that Munch's painting is, partially at least, about a childhood experience. In other words, a biographical approach seems to help us a good deal in understanding the painting. However, only considering the work from a biographical position limits meaning and, as a result, is likely to impoverish appreciation. We need to look at a number of things to provide a greater awareness and so a fuller appreciation. As we saw in Chapter 02, one of these might be the meaning which issues from the relationship between form and content. With this in mind, perhaps a formal analysis of his *The Sick Child* would be helpful.

Thinking back to the approaches outlined in Chapter 02, try to make a formal analysis of *The Sick Child*, paying attention to composition, colour and paint application, which seem to be the dominant formal characteristics of the painting.

- The composition, that is the arrangement of elements within the painting, is central and, essentially, vertical.
- Yet what might be more significant to the work's meaning is the way in which the figures dominate. Around them are a number of objects: tables, a curtain, a pillow and chair back. These objects are cropped by the edge of the painting, bringing us, the viewer, closer to the event taking place; we might even say that they draw us in. This is not like Brodsky's painting of Lenin (Plate 6), for example, where we are separated from the subject by an expanse of floor. Munch's composition more intimately involves us in his painting than the composition does in Brodsky's painting.

- Greens and reds dominate the colour of his painting. In addition to creating visual continuity throughout the picture, the colours are used for emotional effect. In combination with the pale yellows and darker colours, we might think they evoke an almost nauseous feeling; at the very least they do not create a comfortable sensation. Neither are they strictly *naturalistic*, as with the Brodsky, possibly suggesting that Munch used colour to do something more than merely describe what the figures and objects looked like.

- The paint has been applied rapidly, in an almost agitated manner, and this too adds to the uncomfortable and emotional effect. Compared to Brodsky's almost detached, 'documentary' application of paint, Munch's is excitable, even impassioned, which reinforces the emotion of the subject.

This formalist analysis extends the biographical interpretation we already have. If we now explore the social context of *The Sick Child* we will have a fuller understanding and, hopefully, a greater appreciation of the picture. When Munch painted the first version of *The Sick Child*, he was living in Christiania (renamed Oslo in 1925) where the majority of the population lived in shabby wooden dwellings without running water and adequate sanitary facilities. In the later years of the nineteenth century, tuberculosis had reached epidemic proportions in the Norwegian capital. Like writers such as Zola, Dostoyevsky, Dickens and Tolstoy, some artists were preoccupied with documenting work, poverty and disease, and the subject of death was not uncommon, especially in Scandinavian art. The Danish painters Michael Ancher and Ejnar Nielsen painted versions of *The Sick Child*, and Munch's fellow countryman and friend, Christian Krohg, also painted a version.

We have built up an understanding of a painting using three relatively independent but interconnected approaches. As a result, our visual awareness is greater and it is possible that we can more fully appreciate the painting. However, as we have already suggested, understanding is not limited; different ways of looking at works of art invariably offer us more.

Section 3 Representing gender

In the 1970s, the rise of feminism radically changed the way we perceived the social and cultural (rather than purely biological) differences – and similarities – between men and women. Art

history was just one of the many academic disciplines which responded to this with a 'gendered' way of looking, asking fundamental, but previously ignored, questions about representation and the exclusions which had hitherto characterized more conventional art history. Or put another way, the making (and discussion) of pictures throughout history appeared to be something principally by men for men.

Look at Bouguereau's *The Birth of Venus* (Figure 4, p. 33).

- You may notice the positioning of Venus in a **contrapposto** pose which shows off her body to the spectator or viewer.
- This picture is naturalistically painted to suggest something which we might actually see, although the title confirms that it is a mythological subject.

John Berger's book, *Ways of Seeing*, (Penguin, 1972) has suggested that images like this mark a crucial difference between representations of women that present them as naked and those that show them as nude. In other words, images which present them as deliberate objects for the **male gaze** (like the Bouguereau) and those that show them as they are, without embellishment or idealization. This may be an oversimplified way of looking, but it does suggest to us that the way that gender (and sexuality) has been represented in art has been very much controlled by the male dominated academies and social hierarchies touched upon in Chapter 01.

In consideration of this, look once more at Munch's *The Sick Child* (Plate 8). Both figures are female; do you think it is possible that Munch consciously excluded male figures from this painting?

- In Section 2 we suggested that the scene probably arose from the artist's memory of a deeply unhappy event. Since Munch's father was a doctor, it may be surprising that he is not the person with the sick child. But to some extent, Munch blamed his father for being unable to save Sophie's life and this may account for his exclusion from the painting.
- On the other hand, it may be that Munch's aunt was simply the person most often at the child's side; probably Munch's father was busy working in his surgery and visiting patients and so less frequently with his daughter.

- You might even feel that Munch's inclusion of a woman, rather than a man, at Sophie's side reinforces the conventional view of women as carers. Of course, as we have already suggested, this may be a social fact; in late nineteenth century, middle-class society, men went to work and women stayed at home. However, it may also be that women are conventionally seen as more compassionate and emotional than men – the pose of the figure at Sophie's side might suggest this.

This last interpretation, however speculative, focuses on one area of interest for those concerned with issues of gender: does the representation of men and women suggest characteristics traditionally or stereotypically associated with the masculine and the feminine? Or, are men and women represented differently in paintings?

With these questions in mind, consider Grant Wood's *American Gothic* (Plate 4).

- You might consider the image to be a conventional interpretation of gender: man dominates and woman is subservient. The male figure is certainly more commanding: he is taller than the woman, stands in front of her and so takes up more space in the picture, and we see more of him (his hand, for instance). Also, he stares at us, whereas she averts her gaze.
- Stereotypical gender roles might apply here. He is the worker and provider, indicated by the workaday denims and pitchfork; she wears a pinafore, white collar and jewellery, which contribute to a definition of her role as wife.

Gender and authorship

This gendered way of 'reading' *American Gothic* develops the social interpretation discussed in Section 1 of this chapter, and it is one of the issues which concerns art historians interested in gender. Another aspect we might deliberate is that of authorship. Did a man or a woman make the painting and can knowing this help our understanding and appreciation? Does it matter?

Please look at Picasso's *Les Demoiselles d'Avignon* (Figure 5, p. 63) and Morisot's *Summer's Day* (Plate 7).

What might tell us that one was painted by a man, the other by a woman?

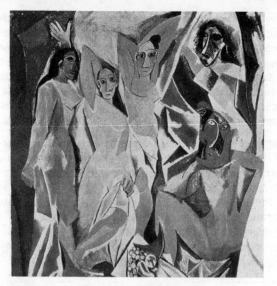

figure 5 Pablo Picasso *Les Demoiselles d'Avignon* 1907

There are no certain characteristics that 'show' masculinity and femininity in painting, but there are some conventional beliefs about both form and content that supposedly identify the artist's gender.

- The content of both paintings is the female figure: in Morisot's work the figures are clothed while in Picasso's they are naked. The female nude is a major subject in Western European art and, with few exceptions, it has always been painted by men.
- With a little research about Picasso's damsels of Avignon we discover that they are prostitutes. Twenty-six years after he painted it, Picasso confirmed this:

Les Demoiselles d'Avignon, how that title irritates me! You know very well that [André] Salmon [poet and art critic] invented it. You know very well that the original title from the beginning had been *The Brothel of Avignon*.

(Quoted in 'Realism and Ideology: an Introduction to Semiotics and Cubism', F. Frascina in *Primitivism, Cubism, Abstraction*, C. Harrison *et al.*, Yale University Press, 1993)

Picasso said that he had originally planned to include men in the painting, clients at the brothel. Yet the finished painting shows the women apparently displaying themselves for these clients. Women exhibiting their naked bodies for the gratification of men might be one way of identifying the artist's gender. However, Morisot's apparently innocuous and amiable scene of two women in a boat seems less obviously identifiable as being by a man or a woman.

- Like Picasso's painting, Morisot's originally had another title – *The Lake in the Bois de Boulogne*. Research reveals that the Bois de Boulogne, a large park on the western edge of Paris refashioned from a former royal forest between 1852–8, was close to the middle-class suburbs where Morisot lived. Therefore, it attracted bourgeois visitors and provided numerous social pleasures: horse riding, skating and boating. The women in Morisot's picture appear to be on one of the boats which took visitors to an island restaurant at the centre of the park's largest lake.

- Unlike men, middle-class women in late nineteenth-century Paris were not free to visit all parts of the city. A respectable middle-class woman like Morisot would not venture into certain parts of Paris, especially alone; this would have meant unwarranted attention by those men whose idea of pleasure was far removed from boating on a lake in the Bois de Boulogne! Consequently, the potential subject matter for women artists was more limited than that of male artists. Furthermore, as the Russian painter Marie Bashkirtseff noted:

> Ah! how women are to be pitied; men are at least free. Absolute independence in every-day life, liberty to come and go...But you will say, 'Why don't you, superior woman as you are, seize this liberty?' It is impossible, for the woman who emancipates herself thus, if young and pretty, is almost tabooed; she becomes singular, conspicuous, and cranky; she is censured, and is, consequently, less free than when respecting those absurd customs.

> (*The Journal of Marie Bashkirtseff*, M. Blind (translator), Virago, 1985)

The Bois de Boulogne was one of the 'safe' and respectable environments and Morisot made the most of it, although even here the subject is not a woman alone.

One final point about the content of these paintings. In addition to who is represented, art historians concerned with gender are also interested in how the physical and social setting for the figures might influence our interpretation.

- Morisot's painting is set in nature, albeit an artificial lake in the Bois de Boulogne. Women are traditionally associated with nature, which itself is conventionally understood as female – Mother Nature. Men are customarily associated with culture and, while Picasso's subject is not culture in the sense of refined and intellectual achievement, it is culture in a wider sense: the customs of a people – in other words, what we do.

The form paintings take can also be associated with gender:

- When Morisot exhibited with the Impressionists, one critic noted the 'delicacy' of her paintings, a characteristic associated with femininity. The short brushstrokes which, another critic remarked, create 'a gracious mobile surface'. 'Gracious', being another feminine characteristic, was applied not only to Morisot's work but also to Impressionism in general.
- Moreover, the Impressionists' emphasis on colour over drawing (essentially meaning the use of line) identified their work as 'feminine'.

Colour plays '...the role of sentiment; submissive to drawing as sentiment should be submissive to reason, it adds charm, expression and grace.' (Quoted in 'Gender and representation', T. Garb in *Modernity and Modernism*, F. Frascina *et al.*, Yale University Press, 1993.) If you substitute the word 'colour' for 'woman', 'drawing' for 'man', and 'she' for 'it', you can see how the above quotation offers a stereotypical view of gender.

> Take another look at Picasso's *Les Demoiselles d'Avignon* (Figure 5, p. 63). How might the technique be described as 'masculine'?

- There are no 'delicate' brushstrokes here, little 'charm and grace', the edges of forms are hard and angular.
- Neither is there a concern for colour over drawing. Conventionally, this adds up to a 'masculine' technique and presents quite a different impression than Morisot's painting.

Gendered self-portraiture

Knowing whether a painting was made by a man or a woman can influence our understanding, in much the same way that knowing about historical context or the life of the artist may ultimately extend our awareness. To take this a little further, we will consider whether our own gender as a viewer affects the way we look at paintings. For this, we will explore one final example.

> Please look at Elisabeth Vigée-Lebrun's *Self-Portrait in a Straw Hat* (Plate 9). Describe what you see and, bearing in mind that the issue in this section is gender, make a few comments on what you think about how the subject is represented. In order to do this, you may want to make a few notes.

- You might have noted the central positioning and frontal pose of the figure, her hat and dress, the palette and brushes, the gesture of her right hand, her gaze fixed on you, the background sky, and the accomplished technique.

Yet how much of this can be related to a gendered approach and does it alter our response to the picture?

- Palette and brushes are attributes which suggest the profession of painter. Self-portraits by men range from the artist represented as a gentleman, in fine clothes and surrounded by his possessions, or the intellectual figure with attributes such as a desk, books, pen and paper, to a working painter in a studio. However, self-portraits by women more frequently refer to the profession of artist than do those by men. Until relatively recently, the social status of women was lower than that of men; while some women became artists, it was judged to be a 'masculine' profession and so a woman had much more to prove than her male counterpart.
- Self-portraits could be used as a form of publicity where potential patrons could see, at first-hand, the artist's skills. If a woman painted herself working at an **easel**, or at least with the tools of her trade, as Vigée-Lebrun's picture does, a prospective (male) patron might be more convinced of her abilities.

- Many self-portraits by women show the artist not dressed for working in the studio. We might, as some commentators have remarked, see paintings like this as the artist offering herself to the male patron as a woman as well as a painter; this could be the case with Vigée-Lebrun's picture.

 She offers herself as a beautiful object to be looked at, enjoyed and admired...A woman artist was acceptable in the eighteenth century but by very different criteria than those applied to men. She was acceptable only in so far as her person, her public persona conformed to the current notions of Woman, not artist.

 (*Old Mistresses*, R. Parker and G. Pollock,
 HarperCollins, 1981)

- You may think that Vigée-Lebrun has represented herself 'as a beautiful object to be looked at, enjoyed and admired.' Perhaps for a male viewer, the direct gaze, bare neck, the fall of the hair, slightly parted lips and beckoning right hand give the painting a sensual dimension.

- Although Vigée-Lebrun's painting might be seen in this way, some biographical detail could provide us with a slightly different view. Elisabeth Vigée-Lebrun was admitted to the French Royal Academy in 1783, one of only four women allowed membership (the Academy was a male-dominated institution and, as such, mirrored the lower social status of women in general). She was not only an artist but also a wife and mother, having married a successful art dealer in 1776, and painted a number of self-portraits in which she includes her daughter, thereby establishing a maternal role.

- *Self-Portrait in a Straw Hat* was, according to Vigée-Lebrun's own account, inspired by seeing Rubens's painting of Susanna Fourment, known as *The Straw Hat* (now in the National Gallery, London). Vigée-Lebrun's painting might be, in part at least, an attempt to follow the techniques of someone she regarded as a great painter and so prove herself as a great artist, rather than displaying herself as a beautiful woman.

- While some contemporary critics noted the painting's allure for the male viewer, others admired the technique for its own sake and also commented that the painting was a good likeness. Furthermore, Vigée-Lebrun's loose costume and unpowdered hair was a style she promoted against the prevailing fashion and was not, necessarily, an enticement for

the male viewer. Compared to the Rubens' portrait which inspired her, Vigée-Lebrun's painting is less overtly sexually alluring, not least because Rubens painted his model in a dress that reveals her breasts and cleavage.

These differing interpretations of Vigée-Lebrun's painting should reinforce a truth that we have stressed throughout: art history is a discipline concerned with interpretation. Sometimes this is based on our emotions and sensations when we look at art; sometimes it relies on knowledge and understanding of a work's context; often it is a combination of both. Approaches to art which give specific attention to questions and contexts of gender have crucially redefined the scope and nature not just of art history, but of many other disciplines. To conclude this section, here are some of the questions which gendered approaches to earlier forms and methods of art history may give specific attention, especially in relation to older examples of art practice where forms of discrimination were both more institutionalized and embedded:

- What was the context of the image's production and that of the artist who made it? (i.e. historically, what opportunities were practically available to the artist?)
- What was the critical response to the artist's work or **oeuvre** generally? For example, is it possible to recognize differences of treatment between artists on the basis of perceptions of gender, rather than on qualitative differences between the work produced? If so, what do the language and tone of these responses tell us about cultural and social mores regarding sexuality and expectations of women more generally?
- How are issues of class and ethnicity addressed in the examples of art studied? Are there comparisons with male contemporaries in the scope and approach of the work undertaken?
- Are there patterns of patronage which suggest differences of treatment and perception? How have these changed through time, both specifically and generally?

Conclusion

This chapter has taken an introductory look at how issues of context, biography and gender can be used to situate and explore particular examples of art. When we discuss the context in which an image or art practice was undertaken, we typically frame broader questions about the intention, origin, character

and influence of what we are looking at. Additionally, all art which is produced externalizes and projects particular cultural assumptions and values, some of which may be explicit, others tacit or concealed.

However, it is important to recognize that works of art should not be reduced to simple 'euphemisms' of context, but rather that they should be considered as complex and indirect expressions of ideas, influences, values and connections. For example, in the case of Brodsky's painting of *Lenin in Smolny*, the political and social context of an emergent one-party state and its associated 'cult of personality' should be taken into account in attempting to describe the iconography or symbolism of the work. Similarly, when we look at paintings like Morisot's *Summer's Day* or Vigée-Lebrun's *Self Portrait in a Straw Hat*, it is important to recognize the constraints, expectations and elisions which are encoded within such representations. That is, the painters of both images were working within social and cultural contexts in which women were widely objectified by the male gaze and the assumptions of patriarchy. What did it mean to be a professional or middle-class woman in France either in the Third Republic or under the monarchy of Louis XVI? To what extent can (or should?) we see such representations as personal, if coded, expressions of highly gendered experience?

The psychoanalytical insights arising from Freudian and post-Freudian thinking have also influenced art history as they have other academic areas and subjects. Although we should perhaps be wary of arbitrarily imposing contemporary ideas and judgements onto readings of the past, the stated or possible motivations behind human creativity in its broadest sense is nevertheless a seductive interest within art and art history. To what extent can or should we 'read' personality, motivation and intention behind art, whether the examples chosen are figurative, abstract or conceptual? Should we rely upon the conscious or stated beliefs and assertions of artists about their own work, where known, or should we take a more sceptical and dispassionate distance and only trust the evidence of our own eyes and personal intuition?

Suggestions for further reading

Laurie Schneider Adams, *Art and Psychoanalysis*, Icon Editions, New York, 1993.

Emma Barker, Nick Webb, and Kim Woods (editors), *The Changing Status of the Artist*, Yale University Press, New Haven and London, in association with The Open University, 1999.

Anne D'Alleva, *Methods and Theories of Art History* (Chapter 3), Laurence King, London, 2005.

Jonathan Harris, *The New Art History: A Critical Introduction*, Routledge, London and New York, 2001.

Gill Perry (editor), *Gender and Art*, Yale University Press, New Haven and London, in association with The Open University, 1999.

Grant Pooke and Diana Newall, *Art History. The Basics* (Chapter 6), Routledge, London and New York, 2008.

Griselda Pollock, *Vision and Difference: Feminism, Femininity and Histories of Art*, Routledge, London and New York, 2003.

04

art today: contemporary ways of looking

In this chapter you will learn:
- the contexts, origins and some of the meanings associated with Postmodernism
- some of the principal characteristics of Postmodern art and art history with reference to relevant case studies
- about the Institutional Theory of Art, an influential and widely used approach to contemporary art and aesthetics
- some of the main issues and debates associated with looking at non-Western art practice and what this might tell us about assumptions of cultural value and identity.

Section 1 Where to start?

Two questions often asked by people faced with examples of contemporary or Postmodern art are:

- What does it mean?
- Why is it art?

Some notable British examples have included an unmade bed, bisected animals in formaldehyde, the use of elephant dung, a light going on and off, the systematic dismantling of an artist's SAAB car and an absent oak tree. Since much art practice from the 1960s onwards has covered a wide range of experimental forms and approaches which have become increasingly mainstream, including land and body art, performance work, video installations, etc., these questions might be timely ones to revisit.

This chapter will start by describing and comparing some examples of art practice from the 1960s and 1970s. This will introduce the idea of the Postmodern, since the term is often used as a catch-all when describing artistic and cultural changes in general since the 1960s. We will briefly look at the impact of Postmodernism on art history before considering one influential approach to evaluating art – the so-called 'Institutional Theory'. The final section will explore the issue of 'difference' by looking at one example of non-Western art and how historic and more contemporary responses to it might shed light on wider issues of artistic value and cultural diversity.

Let us start by looking at *Untitled* (Plate 10) by the American artist, Donald Judd.

How might you describe this work of art? Think about the ways in which it differs from the works of art you have referred to in previous chapters.

- Clearly this work is not a two-dimensional painting like many of the examples we have seen so far, although parts of it are coloured. However, we can say it is sculptural since it is a three-dimensional structure with an open form; despite the geometrical shapes and arrangement, we can look through it because of the regularly spaced voids.
- Perhaps you noticed that it is made from metal and prefabricated. Judd carefully arranged ten identical units

constructed from aluminium, coloured Perspex and steel which are positioned to project out from the gallery wall at regular intervals with each unit separated by spaces the same size and volume as the individual sections. You may also have noted it is repetitive and lacks variety.

- As an abstract composition (or 'construction') similar to Rothko's work (Plate 5), it is not illusionistic or mimetic.

Although originally trained as a painter, Judd increasingly experimented with commercially available materials like metals, woods, plastics and resins and, by the mid-1960s, he was routinely referring to his works as 'objects' rather than 'sculptures'.

Before we explore Judd's work further, consider the abstract work *Equivalent VIII* (Plate 11) by another American artist, Carl Andre. Andre's title stems from the fact that it was created as one of eight pieces originally presented as a group in an exhibition. Chapter 05 explores this example in relation to its status as art, but for now we can consider its formal characteristics (as discussed in Chapter 02) compared to Judd's work.

What similarities does *Equivalent VIII* share with Judd's *Untitled*?

- Like *Untitled*, Andre's work is made from repeated commercial or industrial materials, in this case 120 uniformly sized firebricks arranged in a rectangular format on the gallery floor.
- There is no frame or plinth; we see and experience the work *in situ*, as it is.
- Unlike the polished metallic surfaces of Judd's *Untitled*, up close we can see subtle variations in the colour and texture of individual bricks that change according to the time of the day or the direction of the gallery lighting and positioning. Describing this and similar works, Andre once said that it was necessary that materials should be able to speak for themselves.
- Unlike Judd's work, the materials used in making *Equivalent VIII* have not been altered from their original state but simply rearranged and placed within a gallery space. As a result, do we look at these previously non-artistic objects differently? Carl Andre clearly felt that we should.

Cultural criticism of Modernism

Art historians and critics classify these works as Minimalist. This refers to a way of making and exhibiting art from everyday materials which are not usually seen as 'artistic'. Minimalist works also frequently use simple, repetitive shapes and forms (as opposed to individual, complex and detailed ones), and they are non-illusionistic (they do not portray a human figure, a still life, or some other subject). Along with the work of Pop artists like Andy Warhol, Roy Lichtenstein and Richard Hamilton, Minimalism was among the first **avant-garde** movements to challenge the dominance of painting as the major form of visual art. By the 1950s, a movement such as Abstract Expressionism, although radical in its approach to conventional subject matter, still continued using traditional painting media on a two-dimensional surface (see Plate 5).

A younger generation of artists in Britain, Europe and the United States became increasingly critical of abstract paintings and the whole approach to art as something which had to be a definite size, made from particular materials, and exhibited as a financial or cultural end product in galleries and museums, both commercial and public. Connected with this was a deep hostility from artists like Andre and Judd, along with many others, towards the critical theories of Modernism (see Chapter 02) which were increasingly seen as elitist and outdated. In fact, we could say that there was a reaction against any fixed and approved idea of what art was or should be. This, in turn, fed an appetite for more radical approaches to both the making and defining of 'art', resulting in a range of activities. Performance and land art, video and installation works, and body and kinetic (or moving) art were seen as more accessible and relevant to the later twentieth century. (That some of the works which set out to challenge the status quo were seen by many observers as no less complex and confusing is a point to be noted in passing here!)

Yet these radical, far-reaching developments were not just a result of artists reacting to what had gone before since it could be reasonably said that this probably describes all previous artistic changes. What was different about the 1960s, so it has been argued, was that the developed world witnessed the start of a series of spectacular social and economic global transformations which gathered pace in the following decades and which profoundly reshaped a whole range of cultural ideas and assumptions, with art and art history only one part of the bigger picture.

We now identify this as a shift from Modernity to Postmodernity and, while there may be limited agreement on precisely what the Postmodern is, we can say that at least in relation to art some of its characteristics can be traced to the post-war decades of the 1960s and 1970s. However, some critics put its origins much earlier, suggesting that the French artist Marcel Duchamp clearly anticipated the 'anything goes' attitude to cultural values, which has characterized Post-modernity, with his **readymades**. The most famous of these is *Fountain*, a urinal intended to be exhibited as art in 1917. Nevertheless, there is generally agreement that Postmodernism resulted from the larger changes that radically transformed our world in the 1960s and 1970s. By identifying these changes we are returning to the art historical approach discussed in Chapter 03 – the historical and social contexts in which art is made. The formal analysis of Judd's *Untitled* and Andre's *Equivalent VIII* made earlier only seems to go so far in understanding contemporary or Postmodern art. Works like these, and many made since, are often interpreted in relation to a wider context.

The contexts of Postmodernism

If we take an overview of the last 30 or so years of the twentieth century, we see that political and cultural debates, which had previously tended to see class as the major basis for social and economic change, began to embrace more complex ideas of gender, ethnicity and sexuality (the 'sexual revolution' of the 1960s and 1970s might be seen as one part of this wider questioning process). Western philosophy started to question established belief systems such as Marxism, organized religion, male dominance and white racial authority, Freudianism, Enlightenment reason, and political ideas like communism and capitalism, all of which once claimed they had the 'answers' to human problems. One French philosopher, Jean-François Lyotard, described the 'death' of these so-called 'grand-narratives' and a greater public scepticism as part of the new world view.

The challenge to these once universally accepted beliefs, with their supposedly certain answers, was called Postmodernism, a sensibility or way of seeing that identified with the uncertain, ephemeral, fragmentary and chaotic character of our world. In disbelieving any of these **hegemonic** or dominant ways of understanding, Postmodernism also encouraged a greater awareness of social, sexual and ethnic diversity; ecological and environmental issues; and corporate control, mass media and

consumerism. All in all, Postmodernism stood for a more sceptical, critical and insecure view of the world.

Section 2 Postmodernism and art histories

At the start of this book we suggested that there is no single art history, but in reality *histories* of art or different ways of looking and responding to what we see. In the same way, if Postmodernism can be understood as anything, it is as a state of mind or contemporary sensibility which, positively seen, encourages a more inclusive way of looking.

In 1967, the French theorist Roland Barthes famously announced the 'death of the author'. Although Barthes was thinking of literary 'texts', images can be explored in a similar way. He was suggesting that there is no reason to advantage one way of looking at something over another. For example, your interpretation of a painting may be no less valid than that of your neighbour, that expressed in a book about art or that claimed by the artist. Barthes was arguing that 'texts', or in our case, pictures, can have various meanings and interpretations, some of which may not even have been intended by their creators or authors.

This is not to say that we should ignore the views or feelings which may have created a painting by Mark Rothko or an 'object' by Donald Judd, but simply that there is no monopoly on how we should experience or respond to what we see. Some Modernist critics like Clement Greenberg saw this view as part of a 'crisis of cultural authority', threatening the cultural status quo and a green light for bad taste and **kitsch**, but it might also be seen as making objects, ideas and images more accessible in order to be more widely shared and enjoyed.

Barthes was not the only theorist whose views shaped our attitude to the Postmodern. Another French thinker, Jean Baudrillard, famously noted that the Gulf War never happened. By that he meant the spectacle of smart bombs and devastation was seen by most of us through the medium of television as a *simulated* experience. For Baudrillard, this 'hyper-reality' has become the medium through which we see not only examples of art (usually through reproduction in books, posters, postcards, CDs and so on), but also one which increasingly describes the nature of our social experience and interaction. Some of

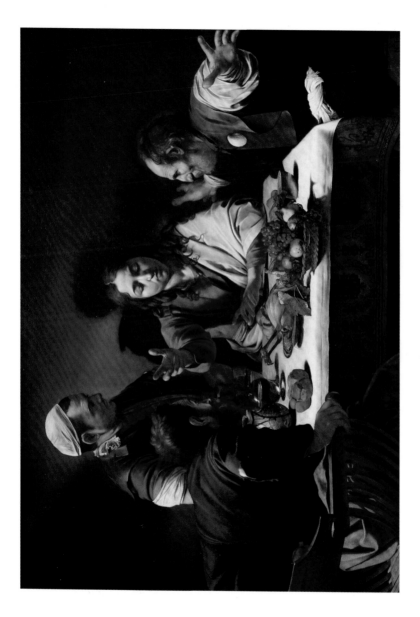

plate 1: Caravaggio *The Supper at Emmaus c.* 1596–1602

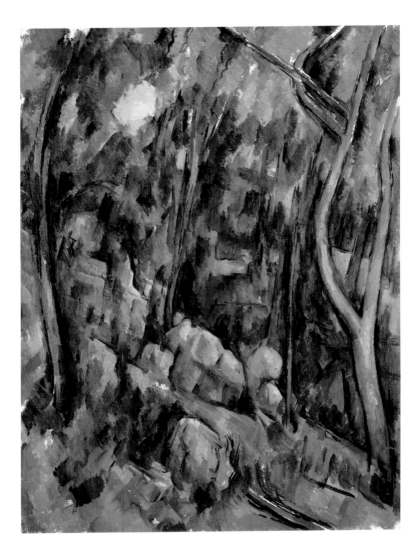

plate 2: Paul Cézanne *The Grounds of the Château Noir c.* 1900

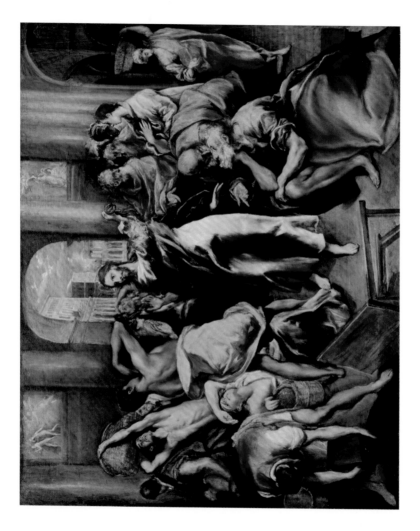

plate 3: El Greco *Christ Driving the Traders from the Temple c.* 1600

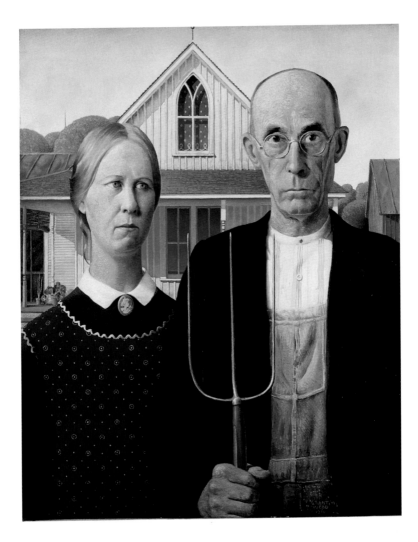

plate 4: Grant Wood *American Gothic* 1930

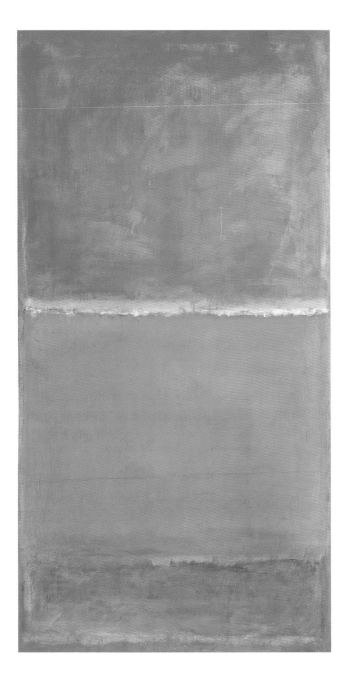

plate 5: Mark Rothko *Untitled c.* 1951–2

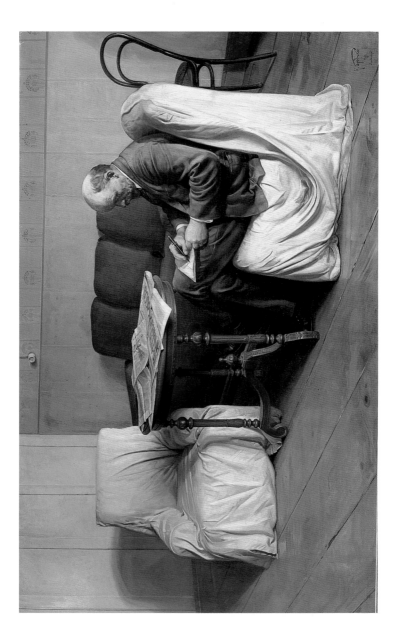

plate 6: Isaac Brodsky *Lenin in Smolny* 1930

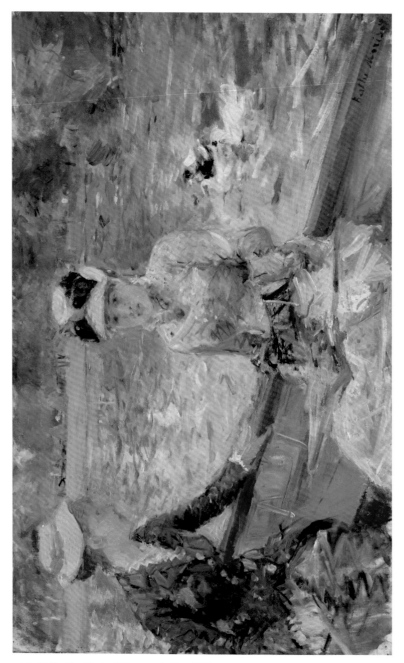

plate 7: Berthe Morisot *Summer's Day* 1879

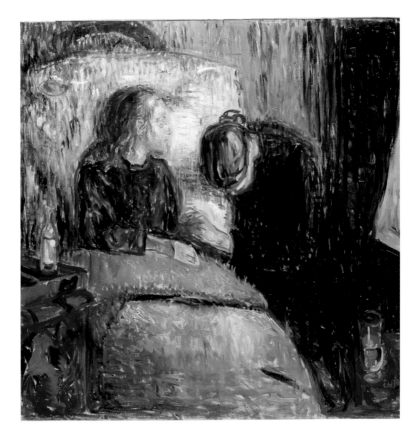

plate 8: Edvard Munch *The Sick Child* 1907

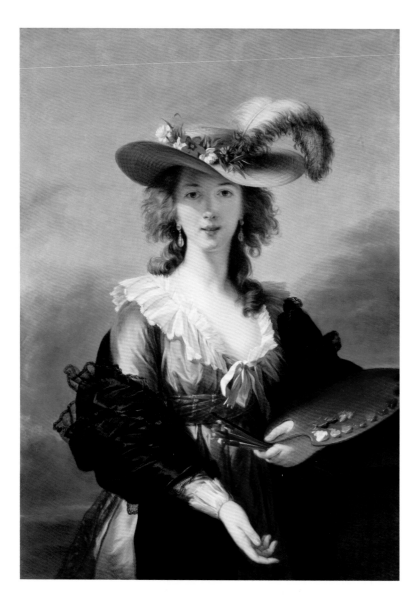

plate 9: Elisabeth Vigée-Lebrun *Self Portrait in a Straw Hat c.* 1782

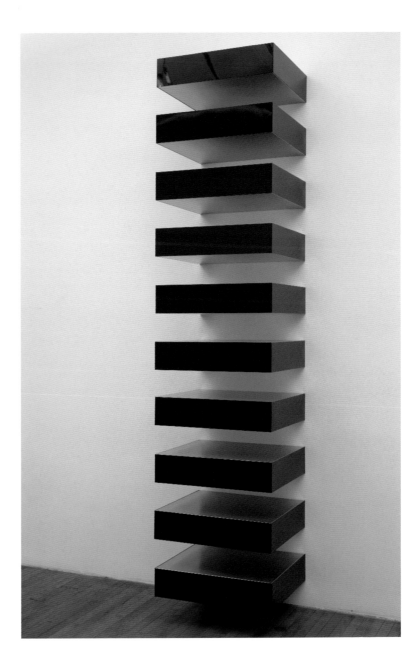

plate 10: Donald Judd *Untitled* 1980

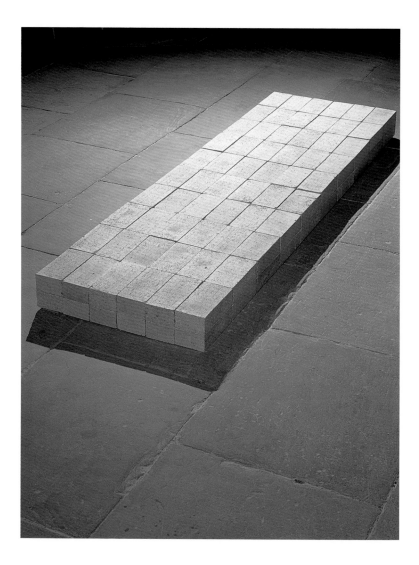

plate 11: Carl Andre *Equivalent VIII* 1966

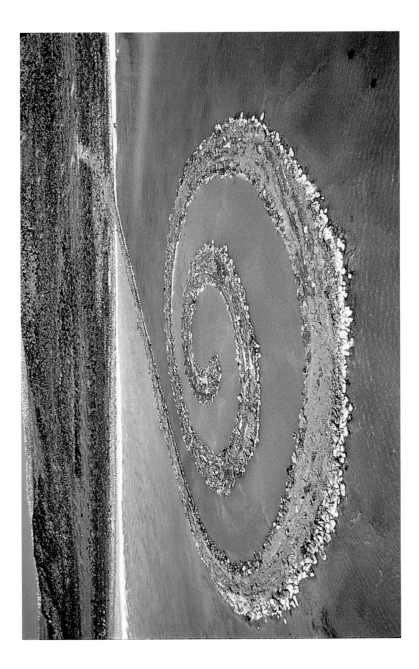

plate 12: Robert Smithson *Spiral Jetty* 1970

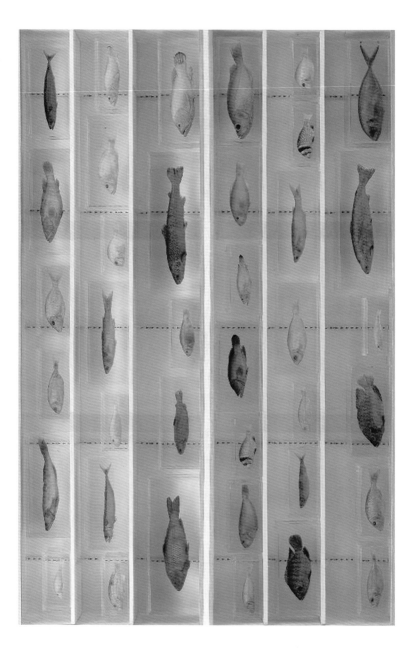

plate 13: Damien Hirst *Isolated Elements Swimming in the Same Direction for the Purpose of Understanding* 1991

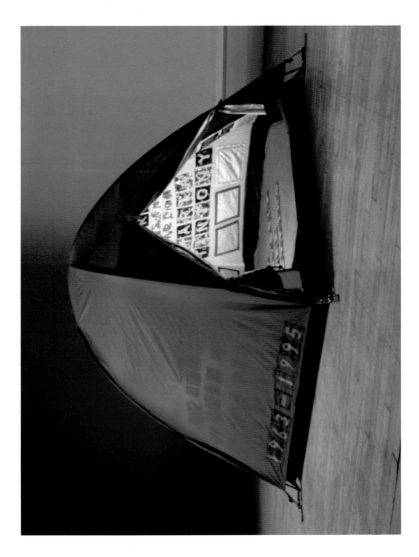

plate 14: Tracey Emin *Everyone I have Slept With 1963–1995* 1995

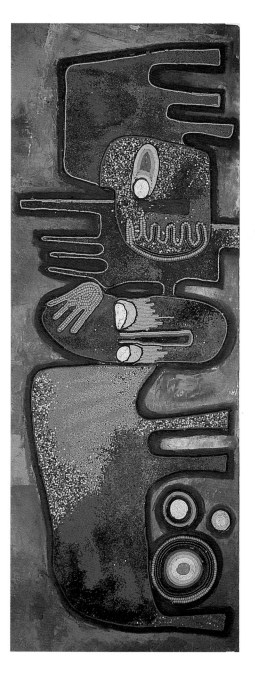

plate 15: Jimoh Buraimoh *Animals* 1973

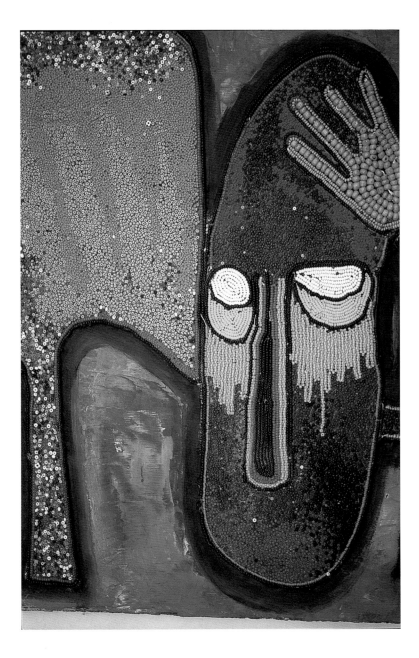

Plate 16: Jimoh Buraimoh *Animals* (detail) 1973

Baudrillard's insights are suggested in the work of artists like Andy Warhol, Roy Lichtenstein and, more recently, Jeff Koons. They have all produced images that directly reflect the notion of art as a commodity from the world of everyday consumer objects; their images parody, imitate or ironically refer to other images and, as such, are seen as especially symptomatic of Postmodern culture which continually recycles and re-fashions.

Discussing these changes, the art critic and philosopher Arthur Danto announced the 'end of art'. By this he did not mean that art was finished, but that the traditional cultural ideas that had underpinned Modern art (beliefs in social progress, commitment to certain ideals, a belief in art's capacity to enlighten and improve the viewer, etc.) had given way to cultural relativism (values being equal but different), the pragmatic demands of marketing and the needs of sponsors and institutions. For example, for some sceptical observers in the 1980s, the art market on both sides of the Atlantic was *the* forum that decided artistic quality and value, rather than the intrinsic merits or otherwise of the images on offer.

The above outline does simplify some complex issues, but we can say that many Postmodern artists of the 1960s and 1970s were, in various ways, attempting to grapple with some of the changes in cultural value and in the resulting status of both art and art making. In doing so, they were looking for new artistic forms, uncompromised by the past, with which to express these fresh ideas and perspectives. Parallel to this process was the start of what has been called the 'new art history': the reaction to and adoption of some of the feminist, psychoanalytic and political ideas that have been introduced elsewhere in this book. These developments are ongoing; although cultural pundits may now talk about post-feminism or deconstruction, these evolving paradigms would not have been thinkable without the earlier legacy of the 1960s.

> Look again at Judd's and Andre's work, bearing in mind some of the points just mentioned. Can you see these images differently?

It is difficult to relate an abstract work of art with wider social issues but you could see both Judd's and Andre's use of 'non-art' materials, the simple repeated forms without the complexity of more conventional sculpture, and the move away from the individual artistic skill of making, as refusing to conform to past ideas and as a response to a new, Postmodern sensibility.

Taking this further, both Judd and Andre claimed that their work carried a political message. This is difficult to believe by simply looking at *Untitled* and *Equivalent VIII*, although because the works do not conform to traditional ideas about what art is, this might be associated with a refusal to conform in a political and social way. In other words, by making unconventional art, artists might also be stating their hostility to wider social and political conventions.

Following this brief survey of some of the art of the period, we can explore two further examples of how artists tackled some of these big issues. First, consider the photograph of Robert Smithson's *Spiral Jetty* (Plate 12).

> You might take time to note down your initial thoughts on what you see. How and in what ways might this work challenge or depart from some of the more conventional ideas of art making?

- The coiled earthwork was over 1,476 ft (450 m) long and made from mud, rocks, salt-crystals, water and originally covered a ten-acre (four hectare) site at Rozel Point, Great Salt Lake, Utah in the United States.
- Its construction, which started in Spring 1970, involved the movement of over 6,500 tons of material, with the site itself acquired on a rolling 20-year lease from Utah's Land Board. Smithson, who was killed in a plane accident while surveying another site for a possible land art installation, had passionate beliefs about ecology and the role and responsibility of art in contemporary culture.

In brief, *Spiral Jetty*:

- uses 'non-art' materials
- is far larger than we expect art to be
- is outside and not in a gallery or museum
- does not display those skills and even interests we traditionally associate with works of art.

> If we see this example as typical of the wide range of art experimentation of the 1960s and 1970s, can we make some links between the cultural and social changes we have identified as Postmodern and the *Spiral Jetty's* format, size and use of materials?

Some points that may have occurred to you might be that:

- The work's size prevents it from being seen or viewed in any museum or gallery space, and clearly it was not intended to be. This might question the role of the museum or gallery as the sole arbiter of 'great' art. Yet while Smithson loathed the New York art establishment, photographs signed by him were sold to interested collectors.

- The spiral or coil might suggest an organic, natural shape, but can equally be seen as an abstract design with no such connection. Like the work of Andre and Judd, we are viewing a novel design albeit one using natural materials rather than industrial or commercial ones.

- The use of materials is not only unconventional, they are natural. However, they are shaped with the help of contractors using earth-moving machines.

- We might ask how long this work was intended to last in its original form, given the changes of time. We usually expect a work of art to last forever but by 1972 *Spiral Jetty* was underwater. Although the water level went down again more recently, the earthwork's rocks are now bleached white by the salt crystals.

Given Smithson's much publicized views on ecology and politics, it seems fair to say that serious points are being made here about nature and the real value and meaning of art. Discussing his huge land artwork, Smithson once described it as a 'traffic jam of symbolic references.' (Quoted from *The Independent on Sunday*, J. Dickie, Travel Section, 20 October 2002.)

We might add then that *Spiral Jetty* is as much about the process of making art as it is a finished product to be admired, if in fact we can even say this of a structure which by its nature is constantly changing. One of Smithson's themes was 'entropy' – the gradual slowing down and decline of all natural phenomena. This land art example might be as much about movement, displacement and change as it is about redefining the meaning, symbolism and place of art in a radically changing world.

An interim summary

This is a good time to summarize the chapter so far. We started by looking at two key questions about modern art. The first was a general one about why so many seemingly unconventional materials and approaches appeared when they did.

We suggested that a series of deep-seated global and cultural developments began to change the context in which artists worked. This, in turn, encouraged the exploration of different forms and materials as one means of responding to a radically changing social and cultural environment. Inevitably, we are generalizing about a far more complex set of changes and issues, but Postmodern artistic fashions can be related to the differing contexts of the times. So, when we approach contemporary art, whether in museums, books or on television, we should think carefully about *why* artists use and adapt the forms they do and *how* these differ from previous or perhaps more 'conventional' ways of art making. These questions should at least provide a start to teasing out other meanings.

Our second question of 'why is it art?' is equally important. Aesthetics, that is how we respond to art and its effect on our senses, is generally related to ideas about beauty and taste which are then associated with art's cultural value. It follows that attempts at suggesting theories and meanings for art are essentially aesthetic questions.

The Institutional Theory of Art

As you will have gathered, there is no agreement on what art is, let alone whether it is good or bad! However, for modern art there is one popular and widespread approach to consider. The 'Institutional Theory of Art' bypasses questions about aesthetics, good and bad art or art as a response to wider social and historical conditions. Its supporters claim it is the most straightforward and pragmatic way of understanding a wide range of art practice, including Andre's *Equivalent VIII*, Smithson's *Spiral Jetty* and other examples given in this and the following section. Its critics are less generous!

The Institutional Theory of Art has two basic propositions:

1 For any object to be art, it must be a form which has in some way been changed by human agency or effort.
2 The resulting object must have been shown in a museum, gallery or exhibition context.

To illustrate this, please look at Damien Hirst's *Isolated Elements Swimming in the Same Direction for the Purpose of Understanding* (Plate 13).

As a first step, perhaps you could note down what you see.

- Hirst's work comprises MDF (medium density fibreboard) shelving which holds perspex cases containing a single fresh or seawater fish in formaldehyde solution. As such, the work appears to meet the first criterion of the Institutional Theory of Art. The fish have been re-presented in a preserving solution as part of what might be seen as a modern polyptych, or a many sectioned display case. Arguably, not only has this process changed how we see the objects themselves but it also raises wider issues about gallery display and meaning (the subject of Chapter 05).
- Hirst's work also meets the second criterion of the Institutional Theory. Since its display as part of the Royal Academy's 1997 exhibition, *Sensation – Young British Artists from the Saatchi Collection*, it has become an example of so-called 'Brit Art' by a major and established artist.

> What does the Institutional Theory fail to tell us about Hirst's work?

- This theory only tells us that it is art, but since this is given such a wide definition it might not be telling us very much. It does not deal with whether it is good or bad art. Nevertheless, some would claim that this is not a relevant question to ask; art may not be something that we should judge as good or bad. After all, what criteria determine what is good and bad? And if criteria are decided, can they be applied to all works of art?

> What does the Institutional Theory tell us about Hirst's work and about art in general?

- It certainly gives a baseline for identifying as art the amazing variety of objects, performances and practice which have become an increasing feature of Postmodern culture over the past 40 years or so. For instance, Smithson's *Spiral Jetty* and Hirst's *Isolated Elements Swimming in the Same Direction for the Purpose of Understanding*.
- It recognizes that what may be important in the creative process is not simply that 'art' conforms to a preset and conventional picture or sculpture format, but that it can communicate and have meaning in *many* and *complex* ways, and that we should keep an open mind on how this might and can be done.

- The Institutional Theory does identity the powerful part played by museums and galleries (both public and private) in promoting modern and contemporary art, and in the actual forming of cultural status and value. The early reputation of many 'young British artists' (yBas) in the 1990s was connected, rightly or wrongly, with the reputation of the leading collector and buyer of contemporary art, Charles Saatchi, who might be said to have recognized the originality and power of many of their works.
- Lastly, this theory takes us away from discussions on 'whether' something is art, to what it might be saying and how it might be doing this. This moves the debate on to what makes something interesting, meaningful and rewarding rather than a somewhat pointless argument about whether we should call it art or not.

To illustrate this, this section concludes by looking at another well-known example of Brit Art, Tracey Emin's *Everyone I Have Slept With 1963–1995* (Plate 14).

Consider this work and think about how the use of materials and forms affect how we respond.

Looking back at some of the observations made earlier about Postmodern art, do you notice any similarities with the earlier approaches of Judd, Andre and Smithson?

- Emin's choice of materials is certainly 'softer' (a tent appliquéd with various names) but perhaps no less innovative than those of Judd, Andre and Smithson.
- Like Hirst's work, it is an installation, but one which adapts a functional object (a small tent) to an artistic statement. We discussed this earlier in relation to Carl Andre's use of bricks for *Equivalent VIII*. Both examples meet the criteria of the Institutional Theory – objects have been adapted, changed and then shown within a museum, gallery or exhibition space.

Now look again at Emin's work. What meanings might you take from it?

The work has been described as providing an 'archaeology of variously intimate relationships within a 'confessional' shelter', (*Sensation – Young British Artists from the Saatchi Collection*, D. Bussel, Royal Academy of Arts in association with Thames & Hudson, 1997).

The appliqué designs depict the names of the artist's bedmates – from close family to sexual partners and the unborn child she aborted.

- In mixing both public statement and private, biographical confession, Emin has arguably crafted an interesting, meaningful and powerful image. Her use of techniques and materials, conventionally associated with craft and gender, might suggest a contemporary and personal re-exploration of those ideas about the historical differences between **fine art** and craft considered in Chapters 01 and 03.

Conclusion

To sum up, all the examples discussed in this chapter are in some way 'conceptual' – they are partially about ideas which revise, extend and question conventional definitions of art as something fixed and definite. Smithson's *Spiral Jetty* even challenges our expectations about where we can see art. Part of their value is in the process or thought that has gone into their making and exhibition. If Postmodernism means anything in relation to art and art history, it suggests there are more relaxed boundaries about what art is, should be and even how it might be discussed and experienced.

Also, in all these examples, the onus or responsibility for teasing out meanings from the image (as a kind of visual 'text') is placed *on you, the viewer*. As a spectator, you are being asked to respond to what you see. Unlike some of the Modernist ideas outlined in Chapter 02, Postmodernism may be seen as non-prescriptive. Although Chapter 05 looks in more detail at how art is presented in galleries, one point we can make here is that exhibition spaces are increasingly sensitive to this interaction. For instance, London's Tate Modern at Bankside has adopted a thematic approach to displaying its permanent collection – a deliberate attempt to encourage a thoughtful comparison and contrast to differing genres and media of art, rather than rehearsing a fixed and predetermined collection of 'great works' from the last century for audiences to view uncritically. With this and similar displays comes the tacit responsibility that *your* considered response as a viewer of images helps to shape their value, status and ultimate meaning.

Section 3 Seeing difference: non-Western art

So far in this chapter we have introduced the Postmodern and some of the attitudes and ideas with which it is associated. Postmodernity suggests a more inclusive approach to making and defining art, and to wider values and ideas about global change and cultural awareness. One way in which this is apparent is in a challenge to the **Eurocentric** monopoly that had previously covered a whole range of activities and beliefs of which art was just one. This in turn has led to a questioning of not only how we valued past art but also what framed wider attitudes to pre-colonial cultures, be they African, Mesoamerican, Native American, Islamic or whoever. In this section we will look at one example of non-Western art, discussing differences of form and purpose as well as considering how this affects our reading of Western art practices and values.

> Examine Jimoh Buraimoh's *Animals*, main image (Plate 15) and detail (Plate 16).

Buraimoh, a contemporary artist associated with the Oshogbo School in Nigeria, has used a conventional painting technique combined with an unconventional (for Western European art, not Nigerian art) use of beads glued to a wooden panel **support**. The overall effect is a mosaic-like surface appearance. Using beads was a practice associated with the Yoruba people for gifts destined for the king, although they were usually sewn on to cloth; Buraimoh's use of glue and panel is, therefore, a modification of the traditional technique.

> Please try to give a formal description of Plate 15. How would you describe the shapes, colours, texture and composition of the piece?

- The shapes are relatively simple, combining curved and angular forms.
- The strong, bold forms and colours draw our eyes across the picture space to the mask and the flanking forms, suggestive of grazing animals.
- The beads, stuck closely together, give a textured surface, a kind of granulated effect. The texture of the painted areas, although not the colour, contrasts with this.

- The compositional arrangement of shapes is balanced: the central mask-like face, flanked by the 'animal' forms.
- Generally, the work is decorative and patterned with reds, browns, yellows, blues, greens and ochres. The dark blue painted band around the shapes of what we suppose to be animals, a mask and other forms, distinguishes the 'objects' from the background while, at the same time, closing and bringing forward the **picture plane**. There is, consequently, little illusionistic depth in the picture and the image is flattened.

By describing works of art in this way we are suggesting that this is an initial way of understanding them. Let us take the process a stage further.

Would you see this as *abstract* or *figurative*, or perhaps a mixture of the two?

- The forms are not figurative but we can recognize a mask or face and a hand, an animal shape at the left and, possibly, another animal shape to the right. However, some shapes – the circles and the form with vertical elements immediately to the right of the mask – do not seem to be related to observable reality, or images we might see in the world.
- Although the image is not figurative, neither is it fully abstract.
- As with the forms, the colours are not figurative either.
- The flattened forms, with their dark blue outlines, do not present an illusion of depth or three-dimensionality, and so add to the abstract and decorative character of the work.

Having described Buraimoh's work in a formal way and attempted to pigeonhole it as figurative or abstract, it may have occurred to you that we are classifying it in relation to Western art practice and not necessarily contemporary African or, specifically, Nigerian art. In one sense, this may not be surprising since the Western tradition remains one widely used in the formal analysis of images.

Nevertheless, to continue this approach and take our analysis of Buraimoh's work further, we might consider that in previous chapters we have sometimes described images as belonging to various genres or types such as portraiture, history painting, still

life, landscape and so forth. Yet Buraimoh's piece does not seem to fit any of these and here our use of Western conventions for art may have reached a dead end. Genres are largely Western European inventions, many of which stem from the rise of the academies in the seventeenth and eighteenth centuries (see Chapter 01). These values were (and are) entirely arbitrary and yet their cultural familiarity may encourage us to see them as natural and given. Postmodern accounts of art and cultural histories question these Eurocentric ways of looking, suggesting that we should and must approach previously marginalized pre- and post-colonial cultures on their own terms, and not through hegemonic Western ideas and values.

Let us return to Buraimoh's image. Since it is partly abstract we cannot easily assume the artist's intention. But should this prevent us from responding to the image in other ways? In Chapter 02, we saw another abstract work by Mark Rothko (Plate 5), a canonical figure within the Modernist tradition.

What similarities and differences do you notice between the work of Buraimoh and that of Rothko?

- Of course, one is oil paint on canvas and so firmly of the Western artistic tradition; the paint and beads on wooden panel is not of that tradition.
- We can say that both are abstract, although in varying degrees. The Rothko does not seem to resemble anything we might come across or see and so, to use the art historian Charles Harrison's terminology, it is an example of 'strong' abstraction. On the other hand, Buraimoh's image is an example of 'weak' abstraction: although the forms are simplified or 'stylized' we can make out approximations to animals and other natural objects.
- With both, we are probably less concerned with narrative or any possible action and more with the processes and textures of the works themselves (the formal elements) and how we respond to them.
- From first glance, neither suggests any of the genres (portraiture, landscape, still life, etc.) that have been historically so important within Western academic painting. Yet in both cases, we are asked to respond to them differently.

We discussed the Modernist context to Rothko's painting in Chapter 02 and it was suggested that abstract painting moved away from the literal storytelling characteristic of earlier art. However, Buraimoh's work deliberately references earlier Nigerian traditions of gift giving by using beads as part of the medium. In doing so, Buraimoh draws attention to the values and meanings attached to making art in his own country's pre-colonial history. For example, throughout the African continent, images and sculptures had various functions. In addition to representing natural objects, image making served a range of decorative, functional, and religious purposes. The idea that an image should merely capture a 'likeness', and be judged accordingly, is largely wedded to the Western (academic) tradition of picture making. Therefore, in responding to what we see, it is important to respect and engage with cultural difference, to find out the varying conventions and motivations behind making images and their presentation. This, it has been argued, is a Postmodernist rather than Modernist attitude.

The non-Western canon and art history

This more inclusive (or Postmodernist) way of looking was different from widespread views and attitudes prevalent in the nineteenth and early twentieth centuries. To understand how these ideas worked, please look again at Picasso's *Les Demoiselles d'Avignon* (Figure 5, p. 63). We previously explored this in relation to ideas about Modernism but the image became a powerful example of how some Western avant-garde artists reacted to the discovery of so-called 'primitive' non-Western cultures.

Do you notice any stylistic similarities and differences between Picasso's painting and Buraimoh's Oshogbo piece?

- In both examples, we might compare the use of simplified or stylized outlines and shapes. The figures in Picasso's picture have angular faces which seem to resemble masks whereas in Buraimoh's work there are more curved and, arguably, less aggressive shapes.
- We recognize that the shapes in the Picasso represent human bodies, but they do so by approximation. In Buraimoh's picture, some of the shapes less obviously represent identifiable natural objects.

- The colours and shading in *Les Demoiselles* are harsh and arbitrary; in Buraimoh's picture the colours are bright and the shading relatively subtle, an effect created by mixing the coloured beads (see Plate 16).

- Neither work attempts to create convincing pictorial depth, recession or the three-dimensionality of forms, but by using beads which stand proud of the flat picture surface, Buraimoh's image has *real* three-dimensionality. Arguably, the African artist is not confined to conventional Western categories of painting and sculpture; his work begins to transcend these categories. Interestingly, Picasso's invention of **collage** in about 1912 suggests a similar disregard for this convention.

'Primitive' art, that is non-Western art especially from Africa, the Pacific and Central America, had a significant impact on Western avant-garde art in the early years of the twentieth century. Figure 5 (p. 63) is one example of this.

Why do you think some Western artists were interested in so-called 'primitive' art?

- The expansion of colonial power and international trade throughout the nineteenth and early twentieth centuries opened up large parts of Asia, the Pacific, Africa and the Far East. In doing so, Western countries like Britain, France, Belgium, Germany and the United States created dependent colonies. Such colonialism included inherent ideas of Empire, and Darwinian views of human development and progress: that Western nations were somehow superior to non-Western ones, and that Westerners were at a more advanced stage of development than indigenous peoples in the colonies.

- One result of colonialism was an influx of carvings, sculptures, ivories, masks and textiles, which found their way not only into artists' studios but also into ethnographic and anthropological collections. These were established in many European cities to cater to an increasing public interest in the 'exotic' and the 'primitive'. Removed from their original context and purpose, these artefacts were often exhibited in the equivalent of museum curiosity cabinets as examples of pre-civilized, or 'primitive', human development. The word 'primitive', literally meaning 'primary in time', was often used negatively as a basis for comparing the apparently sophisticated (academic) and figurative Western art forms

with non-Western objects which, by comparison, were seen as simplified and basic.

- As mentioned in Chapter 01, the Western selection of painting as a higher art form arose from the writings of artists such as Vasari and Leonardo in the sixteenth century. This placed painting at the apex of artistic achievement, with sculpture and design generally accorded lower status. Ironically, many of the 'primitive' art objects on display in ethnographic and anthropological collections actually belonged to highly sophisticated and continuous visual traditions, which in some cases stretched back thousands of years. Depending on their place and culture of origin, such objects served not only widespread decorative purposes but frequently had commemorative and ritualistic uses. These non-Western objects were, therefore, categorized as fundamentally 'different' from those of the Western academic tradition, so underlining the cultural status and value they were given by mainstream opinion.

- Many avant-garde artists like Gauguin, Picasso, Braque, Matisse and Modigliani believed that such difference gave to 'primitive' art objects an authenticity of form which they began to use in their own work. In these avant-garde circles, 'primitive' styles symbolized an alternative to Western industrialization and commercial values. An influential study published in 1908 (*Abstraction & Empathy*) by the German writer Wilhelm Worringer appeared to support these ideas. Worringer associated naturalistic art with periods of social and cultural stability and the angular, stylized forms of non-Western art with periods of social upheaval and unrest. In the early years of the twentieth century, avant-garde Modernist artists were consequently able to use these 'primitive' styles as a new means of exploring the process of painting and art making, and as a symbolic criticism of Western materialism at a time of intense technological and social change.

As you may have guessed, both these historical perceptions of non-Western art were stereotypical. On the one hand, images and artefacts were avidly collected as if to reassure colonial ethnographers and anthropologists of the superior value of Western art and its visual traditions, and in this sense non-Western cultures were seen as the 'other' – something outside European values and understanding. On the other hand, avant-garde artists, while possibly more appreciative of the formal and decorative qualities of these images, nevertheless, used Western colonial assumptions of the 'primitive' as a justification for the apparent naturalness and 'authenticity' of their own work.

Conclusion

We have concluded this chapter by looking at one example of non-Western art as a means of making some distinctions in relation to interpretation and history. In recent decades, the accelerating effects of globalization, and the legacy of post-colonialism, have underlined the extent to which we can only meaningfully talk of *art histories*, rather than a singular, Western tradition, even if such a model has been dominant or hegemonic in the past.

The questions which art historians must increasingly ask relate to the differing perspectives, histories and interactions of peoples across the world. The historical and racial boundaries and perceptions of 'difference' which have characterized Western history have also determined its cultural and artistic categories. These in turn have made socially and historically specific claims to value and identity which have previously been taken for granted.

Just as Postmodernism has questioned older ways of making and defining art, as well as issues of gender, politics and ethnicity, the post-colonial world situates art and the realm of the aesthetic as properly global activities, rather than the preserves of the developed or 'first world'. At a time of increasing global stress and conflict, it may be timely to remind ourselves of these interdependencies and histories.

Suggestions for further reading

Steven Connor (editor), *The Cambridge Companion to Postmodernism*, Cambridge University Press, Cambridge, 2004.

Eleanor Heartney, *Postmodernism*, Cambridge University Press and Tate Publishing, 2001.

David Hopkins, *After Modern Art 1945–2000*, Oxford University Press, 2000.

Amelia Jones (editor), *A Companion to Contemporary Art Since 1945*, Blackwell, Malden, MA and Oxford, 2006.

Catherine King (editor), *Views of Difference: Different Views of Art*, Yale University Press, New Haven and London, in association with The Open University, 1999.

Gillian Perry and Paul Wood (editors), *Themes in Contemporary Art*, Yale University Press in association with the Open University, New Haven CT and London, 2004.

Brandon Taylor, *Art Today*, Laurence King Publishing, London, 2004.

Glenn Ward, *Postmodernism* (revised edition), Hodder & Stoughton, 2003.

05

art in museums and galleries: spectacle and display

In this chapter you will learn:
- the meaning and importance of museology in the exploration of art
- how the presentation and arrangement of art objects in museums and exhibition spaces may influence our perceptions and responses
- the changing nature of museums and the strategies they may employ to variously canonize the art which is presented
- how so-called 'blockbuster' shows contribute to debates on value and meaning in museums and exhibition spaces.

Section 1 The art museum experience

In recent years museology, the role of museums and the way they display art, has become an important part of art history. For the curators, who organize and arrange art displays, museology is not only essential to what they do but also relevant to the way we, as museum visitors, look at and understand art.

However, before we take this further, it is worth thinking about why we visit art museums and galleries. There may be many reasons, even as simple as using the café or sheltering from the rain! Yet most of us probably go to see 'great', or canonical, works of art, especially the case with the current fashion for 'blockbuster' exhibitions on both sides of the Atlantic. Visiting an art museum is not usually an everyday event for most people and canonical art is more frequently seen in reproduction: in books and magazines, on postcards, posters, television, video, CD Rom, DVD and the Internet. But seeing art in reproduction is, for a wide variety of reasons, an experience dissimilar to seeing it in a museum.

Original works and reproductions

Take a look at any of the colour reproductions of paintings in this book, or think about copies of familiar images which you have seen in magazines, postcards or books. How do they differ from the original? Perhaps you could make a list of the points arising.

You might have noted that:

- the size of the work is not the same as the actual painting
- the colour, detail and surface texture of the reproduction is not absolutely faithful to the original
- the original often has a frame which is not reproduced.

So, in thinking about the differences between experiencing the original and experiencing a reproduction, you might have come to the conclusion that the gallery or art museum is superior. But is this necessarily true?

Can you think of any drawbacks to seeing paintings in an art museum and any advantages of looking at reproductions?

- You may have experienced an art museum as a crowded place, which can distract you from looking at the works. Visit the Louvre in Paris at almost any time of year and just try to see Leonardo's *Mona Lisa*!
- You may also have thought about the way works of art are displayed. Sometimes paintings are hung high on a wall and they are difficult to see, or mounted behind glass where reflections can interfere with your view.
- Also, because paintings are financially valuable objects, you are not allowed to get too close to them and this could interfere with your appreciation.
- Looking at a reproduction may have disadvantages but you can look at it again and again; looking at the real thing repeatedly requires the effort of one or more journeys.
- Information about works of art is limited to labels and display boards in art museums; a book can tell you much more. Of course, you can read a book about a painting while standing in front of it, but is this a useful way to either look or read?

Despite these disadvantages, we might still feel that art museums and galleries are the best places to look at art. In 1936, the philosopher and critic Walter Benjamin argued that works of art have an 'aura', by which he meant they have a unique and original quality which we somehow 'sense' when in their presence. We certainly do not react in this way to a reproduction. Perhaps the best way to view art is alongside other works and in an atmosphere sympathetic to contemplation; this might seem better than flicking through an art book in a library, for example. If we accept Benjamin's idea, we might decide that we visit art museums to 'experience' art in a way that is impossible when looking at reproductions.

Nevertheless, this 'experience' is not a simple or straightforward one. We have already seen that our response to individual artworks can be diverse, from one which is immediate, perhaps suggested by a work of art's formal characteristics, to one which places it in relation to historical and social circumstances. Moreover, as we have seen from the previous chapters, these different approaches or perspectives provide interpretations which may give a work of art various or even conflicting meanings.

The museum environment

Just as we have suggested that art historians might encourage a particular way of viewing art, art museums can do something

similar. We may see this as a form of manipulation or meditation which encourages us to understand artworks in a particular way and, in one sense, this is true, but no deception is intended here. As you will have realized, there is no such thing as a 'correct' interpretation or complete understanding; different interpretations contribute to a more detailed understanding rather than a completely comprehensive one. However, when we see art displays in museums and galleries we might be forgiven for thinking that these are 'correct' interpretations. This is because art museums have a status and air of authority; we tend to experience them as special places because they house what we believe to be the best examples of creativity and 'high culture'. When we visit museums this idea consciously or unconsciously influences us. In 1995, the American art historian Carol Duncan wrote that visiting a museum was akin to a kind of ceremony – she called it a ritual. To some extent we are expected to experience a sense of awe, reverence and even spirituality in the presence of works of art but, Duncan argued, this is encouraged by the setting – the building itself and the display format.

The idea of displaying art in museums and galleries does not go back very far. Private individuals and institutions, such as the Church and universities, have collected art since the Renaissance, but museums and galleries as we now understand them were not established until the eighteenth century. They perceived their role as preserving objects of aesthetic beauty and to 'educate' visitors by exposure to them. In 1797, the German writer Wilhelm Wackenrode noted:

> A picture gallery...should be a temple where in silent and unspeaking humility and inspiring solitude, one may admire artists as the highest among mortals.

> (*Outpourings from the Heart of an Art-Loving Monk*, 1797, quoted in *Relative Values*, L. Buck and P. Dodd, BBC Books, 1991)

For Wackenrode, an art museum was a shrine where visitors paid homage to 'god-like' artists and, if we feel as he did, it is not surprising that we experience a sense of admiration when visiting these institutions. Even if we do not exactly experience this, the realization that we are in the presence of unique objects which are culturally and financially valuable, affects our response. In fact, even before we go inside some museums, the building itself sets the 'tone'. The architecture of the London and Washington D.C. National Galleries or New York City's Metropolitan Museum of Art suggests that of ancient classical temples, which clearly echo Wackenrode's ideas.

The art museum as a temple was the typical architectural interpretation from the early nineteenth century.

- Munich's Glyptothek, the first public sculpture gallery, was opened in 1834 and its façade is a nineteenth-century version of a Greek temple.
- The Altes Museum in Berlin, another nineteenth-century building, has a rotunda based on Rome's most famous temple, the Pantheon.

These grand settings encourage a reverent atmosphere for contemplating and appreciating what we are persuaded can only be 'great' art. Therefore, architectural setting both outside and inside museums plays an important role in the way we think about and interpret art. The National Gallery's Sainsbury Wing in London is another example of this. The original extension design was criticized by H.R.H. Prince Charles, resulting in the selection of a new proposal.

> Please look at Figure 6, opposite, which shows the original London National Gallery building of the 1830s at the right of the picture, and the Sainsbury Wing, opened in 1991, at the left. In what ways are these buildings similar and different?

You will see a number of likenesses:

- The height of each building is about the same.
- Each is comprised of angular shapes with classical features such as pilasters or applied columns on the building's façade.

There are also important differences:

- To the careful observer, the pilasters on the Sainsbury Wing are not arranged regularly, and they do not even appear to support the entablature above, as they do in the older building.
- The balustrade, which runs above the entablature on the 1830s' building, is only briefly hinted at on top of the Sainsbury Wing.
- If you look carefully at Figure 7, opposite, you will see that some details of the newer building are not classical at all but based on Egyptian motifs!

> Now you could ask yourself why the Sainsbury Wing was designed to look like the original building, but not exactly like it.

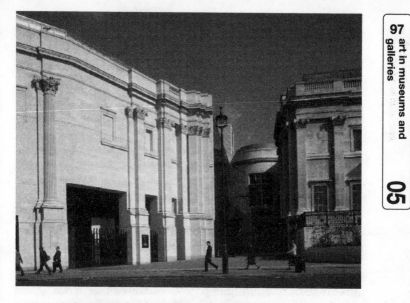

figure 6 National Gallery, London, United Kingdom

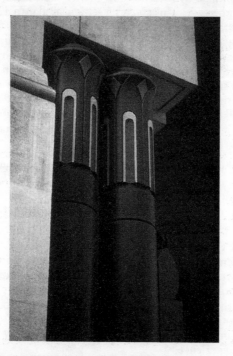

figure 7 National Gallery, London, detail of gatepost

- Among H.R.H. Prince Charles's criticisms of the original proposal was its different styling to the original building, and this influenced the choice of the present design. However, in the light of the suggested connection with the classical style for museum buildings, you might have felt that this style was still fitting in 1991.

- However, given that the present design is an unorthodox interpretation of the classical style, you might think that this was a way of saying the building is both traditional and modern. It would probably help to know that the Sainsbury Wing displays paintings from around the period of the Renaissance which was, in Italy at least, a time when there was an interest in the reinterpretation of classical forms and themes. Perhaps a reinterpretation of classical architecture for the Sainsbury Wing exterior seems appropriate for such a collection.

How does this help our understanding of the art inside the Sainsbury Wing? The building's classical appearance might suggest the appropriate reverential mood, although probably as influential on our attitude to the paintings themselves is the interior design. In the Sainsbury Wing, the top-lit galleries have pale grey walls with dark grey arched entrances, some with columns either side. This creates a setting similar to a Renaissance church by the fifteenth-century Florentine architect Brunelleschi. Since many of the paintings in this part of the museum are Italian altarpieces, we might say that the interior design is an appropriate environment and one sympathetic to contemplation. Yet not all the works in the Sainsbury Wing are Italian; some are Flemish, others German. For these, the connection with a Brunelleschi church might be less relevant. But more than any historical reference, it is the interior's quiet, contemplative atmosphere that probably affects our response to the paintings.

The Sainsbury Wing, with its modern mix of Renaissance and nineteenth-century classical architecture, might persuade us that art is something we should approach with some reverence. However, visiting a museum or gallery of more obviously modern design can also provide a special experience.

New York City's Museum of Modern Art (MoMA) was the first museum entirely devoted to late nineteenth- and twentieth-century art. Originally built in 1939, the building itself is modern, with no reference to classical architecture, but in its own way the MoMA is as temple-like as the Sainsbury Wing or the Glyptothek. Redesigned by architect Yoshio Taniguchi and reopened in 2004, the MoMA's displays exemplify the modern museum experience.

- Works are exhibited in uniformly lit galleries and open spaces, with plain walls and wooden or neutral coloured stone floors.
- The paintings are hung with plenty of space between them so that another work in view does not disturb the viewing experience.
- The labels are discreet and uniform in size, colour and typeface.

In 1976, the critic Brian O'Doherty coined the term 'the white cube' for this kind of gallery presentation, associating it with a sense of aestheticism, which puts the emphasis on the uniqueness of the visual experience, with everything in the gallery space arranged to enhance this without distraction.

We might see such settings as the modern equivalent of the temple-like museum. Our response is perhaps as reverent as it would be if we were in the classical settings of the Picture Gallery of Old Masters in Dresden or Madrid's Prado. However, art museum architecture does not always communicate this sense of homage and worship, as shown by some more recent museums.

London's Tate Modern is a converted brick power station and, although its size might overwhelm us, the architecture adds less to a sense of respect for the works of art and more to a sense of awe at the building's sheer scale. The decision to convert Bankside Power Station into an art museum was made for sound economic reasons but, at the same time, the Tate Modern has benefited from this unique architecture because it enhances visitor experience.

Let us return to the point that started this chapter: why we visit art museums. While there may be many reasons, we suggested that the main one was to see works of art. Yet the architecture of the museum itself is an important experience for some visitors and Tate Modern may be an example of this. But it may not always be a positive experience for those who want to look at the exhibits. For example, one writer said of the Solomon R. Guggenheim Museum in New York City: 'The pictures are overwhelmed by the beauty of Frank Lloyd Wright's building...' (*Art Galleries of the World*, H. Langdon, Pallas Athene, 2002.)

Look at Figures 8, 9 and 10 (pp. 100–101) and consider the relationship of the sculpture you can see in each picture with the surrounding architecture. In view of what we have been discussing, you might want to think about the significance of the architecture to the exhibits.

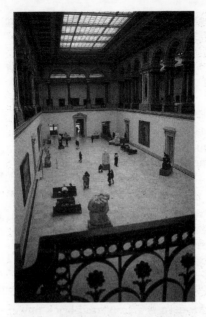

figure 8 Royal Museum of Fine Arts, Brussels, Belgium

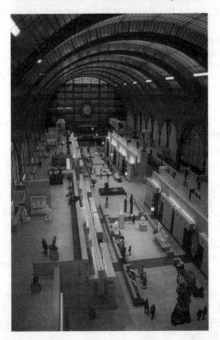

figure 9 Musée d'Orsay, Paris, France

figure 10 Museum of Art and Industry, Roubaix, France

- The Royal Museum of Fine Arts in Brussels, Belgium (Figure 8), has a few sculptures in a spacious central area and the setting does not seem to impose on the art. However, the classically detailed doors on the ground and upper floor arcades echo Wackenrode's image of the museum as a temple, providing a quiet, dignified and, perhaps scholarly environment.

- On the other hand, the sculpture in the photograph of the Orsay Museum in Paris (Figure 9) is difficult to locate; some of it is freestanding, like that in the central lower aisle, and some set against panels, as you can see towards the middle of the left side of the picture.

- In the Museum of Art and Industry at Roubaix (Figure 10), near Lille in France, the sculpture is clearly displayed either side of a rectangular pool.

The architecture of the Orsay and Roubaix is not classical; indeed, before the Orsay was a museum it was a railway station and the building at Roubaix was a swimming pool (it is still

called La Piscine). The conversions of railway station and swimming pool created more complex interiors although the original use of each building is apparent, especially at Roubaix where part of the pool remains and the changing rooms either side are now galleries. At the Orsay, the angular stone structures flanking the central aisle (which was once the railway track) are galleries but designed in a different style to the original architecture. The museum's curators and the French authorities wanted this – quite the opposite position to H.R.H. Prince Charles's objections to the original design for the Sainsbury Wing.

Whether the architecture of the Brussels Royal Museum is more suitable for viewing art than that of the Orsay or La Piscine is a matter of choice. However, the striking architecture of the French museums competes with the exhibits for the visitor's attention, inevitably affecting our gallery experience.

The museum experience as 'spectacle'

More recently, some art museums have begun competing with other attractions. According to several critics, their main aim is increasingly geared both to education *and* entertainment or 'infotainment'. The architecture of the Orsay and La Piscine, like that of the Pompidou Centre in Paris, the Bilbao Guggenheim Museum in Spain, and the Groninger Museum in the Netherlands, becomes as much a part of the visitor's experience as viewing the works of art themselves. We might understand this better if we consider the following:

- The distinction between education and entertainment is not as clear as it was. In part, this is a consequence of increased leisure time and the subsequent proliferation of ready-made entertainment, largely a result of new technology. In these circumstances, the separation of the art museum experience from the entertainment experience has become problematic, if not blatantly futile.

- As places that rely on visitors for their economic survival, museums are in competition with the publicity, promotion and hype of consumerism and other forms of mass entertainment.

- Since a number of art museums were created as catalysts for economic regeneration of often run-down and deprived urban areas – the Bilbao Guggenheim in Spain, the Lowry Centre and the Baltic Centre for Contemporary Art in north-west and north-east England respectively, are examples of this – attracting visitors becomes a matter of economic necessity.

Given these contexts, it is hardly surprising that art museums have, in varying degrees, become less like shrines to culture and more like entertainment centres. Some art museums, once considered spaces for contemplation, now seduce and beguile visitors through their architecture and their displays. 'Spectacle' is the term often used to describe this process, suggesting a visual experience similar to that of a staged media performance or a leisure-time product, rather than a serious engagement with art as an aesthetic and enlightening experience. Carsten Höller's artwork *Test Site*, exhibited at Tate Modern in 2006, might illustrate this. Three slides were constructed from the upper levels of the gallery to the lower turbine hall, with visitors able to make a rapid and, it seemed, precarious descent. The work evoked helter-skelters and playgrounds and was, in one sense, entertainment, begging the question: what distinguishes a theme park ride from an art exhibit? It is difficult to see how Höller's work was not spectacle – the visual spectacle of watching people on the slides and the 'spectacular' experience of the sliders themselves.

In competing with other attractions, art museums have found it necessary to provide more than just the 'art experience' or the specificity of engagement typically associated with it.

> An art museum café or restaurant may provide a valuable service, as may the museum shop, but how might they relate to the idea of 'spectacle'?

Apart from providing a service, on site cafés, restaurants and shops have nothing to do with seeing art objects but they do raise museum revenue and, arguably, encourage visitors by supporting a more 'inclusive' experience. Perhaps when London's Victoria and Albert Museum (V&A) pitched itself as 'An ace caff – with quite a nice museum attached' in the 1980s, things had gone too far. Was a café the reason why people visited art museums? Yet what is more important here is that the V&A felt it necessary to advertise itself at all.

More than the café, the museum shop directly advertises the museum through its merchandise. Much of this may have no direct connection with art other than pictures from the collection reproduced on T-shirts, key rings, coffee mugs and anything else thought 'appropriate'. How often have you noticed that museum shops are frequently more crowded than the galleries themselves? You might reason from this that art is just an excuse for buying and has become part of the 'spectacle'

of contemporary consumer culture. To some extent this is borne out by New York's Metropolitan Museum of Art and Paris's Louvre.

- In New York, the intent visitor looking at artefacts in display cases can fail to distinguish between the museum and the shop, which sells reproductions of the Museum's artefacts, displaying and labelling them in a similar way to that used in the museum itself. Furthermore, the shopping area is not always clearly distinguishable from the exhibition areas, allowing the visitor absorbed in looking at exhibits to wander inadvertently into the shop. This blurring of boundaries between the museum experience and the shopping experience is further supported by the Metropolitan's website, which introduces its retail outlet as 'The Fine Art of Shopping'.

- In Paris, additions made to the Louvre not only include an entrance topped by a glass pyramid with a vast atrium beneath, but also direct access to the museum from the Metro and an underground shopping mall – the museum and shopping experiences deftly combined.

Displaying art

So far we have explored how the architectural setting of museums and galleries can be related to wider social issues of education, entertainment and consumption, and economic revitalization, and how these things influence our approach to the works displayed. But it is the direct contact with art, rather than its immediate environment, that probably has the most meaningful and durable influence. We can say that both the ways and methods that museums and galleries use to display their collections are decisive in the way we interpret and engage with art.

> Why are certain works of art selected for display in a museum or gallery?

Any art museum collection and its development depend on several factors, including:

- its history, benefactors and purchasing policy
- what exhibiting space it has available
- the personal interests of curators

- the directors' aims and those of others who govern the museum
- funds available for purchasing, donations and bequests.

This means that what you see in a museum is rarely the result of impartial artistic choice. In choosing artworks for display, museums give them the status of 'greatness' or, as noted in Chapter 01, they canonize art. Some images may already be canonical before the museum acquires them, in which case their addition to the collection may reflect this. But if the work of art does not already have such status, exhibiting it can help things along.

To explore this, let us return to the Orsay Museum in Paris which exhibits works of art made between the mid-nineteenth century and the early twentieth century. French art of this period has always been considered important, especially that of the Impressionists. Nevertheless, while the Orsay exhibits canonical work, including Impressionist paintings, it also displays works previously excluded from the canon, for instance paintings by so-called **Salon** artists such as William-Adolph Bouguereau (see Figure 4, p. 33). By exhibiting these, the museum both challenges the existing canon and suggests that it should include the likes of Bouguereau. For the viewer this may be confusing:

- Does Bouguereau's work have the artistic importance we give to other work shown, such as that of Monet?
- Should we be looking at paintings as aesthetically significant objects or as 'historical documents'?
- Or is Bouguereau included because his painting is meant to convey some other meaning?

> How do the displays in art museums influence the way we interpret individual works of art?

If Bouguereau's painting is not seen as canonical, then its inclusion in the displays of a prestigious museum must be for another reason. The painting is exhibited in the opulent setting of the Orsay's restored ballroom. We know that Bouguereau was an artist admired by the Parisian upper middle class in the nineteenth century, the same class that frequented the lavish ballroom. We might therefore be expected to find historical and social meaning rather than aesthetic meaning in the painting. In other words, the painting may not simply be displayed for its

artistic merits but more because it is a 'document' representing an aspect of epoch of French history and society.

All museums classify and categorize their collections, a task usually undertaken by directors, curators and designers. As visitors to art museums, we should be aware of these essentially *artificial* arrangements and how they influence the way we view, appreciate and find meaning in works of art. The Bouguereau example might suggest that the Orsay's displays place artworks in their historical context, which is reinforced by the so-called 'Dossiers' that the Orsay's catalogue describes as:

> ...displays [which] are all focused on different artistic themes, their goal is to broaden the cultural field to include music, literature, the press, etc.

> (*Guide to the Musée d'Orsay*, Editions de la Réunion des Musées Nationaux, 1987)

In consequence, the museum's arrangement of paintings is loosely chronological, enabling us to follow the history of French art from the mid-nineteenth century to the First World War. All this might indicate that the classification of exhibits is based on an historical rather than an artistic basis, and that as visitors we should expect the Orsay to be as much an encounter with cultural history as an aesthetic experience. With this in mind, we might look at individual works as 'historical documents' and not just great works of art. Yet is it as simple as this?

Despite the basic chronological arrangement of exhibits, the Orsay displays the work of some artists in its own discrete space. Courbet, Cézanne, van Gogh, Toulouse-Lautrec and pastels by Degas all have separate galleries. These images seem to have special status when viewed in a room of their own, isolated from the work of others. On this basis, we might, therefore, make conscious or unconscious judgements that certain works have greater artistic merit than others. Alternatively, some of the work on the museum's middle level is neither chronologically arranged nor considered to be canonical; both apply to Bouguereau's picture, which is exhibited here. (The middle level of the Orsay is the final part of the 'tour' suggested by the guidebook and, unless you know your way around, it is quite difficult to depart from this prescribed route.) The Orsay is a vast museum with thousands of exhibits and by the time the visitor reaches this final stage, exhaustion has probably set in. Can we assume that supposedly aesthetically inferior works are displayed at this point because it attracts fewer, and less alert, visitors?

Arranging the collection

Picasso was once recorded as saying, 'Museums are just a lot of lies.' (Quoted in *A Dictionary of Art Quotations*, I. Crofton, Routledge, 1988.)

> Considering the way art museums display their collections, what do you think Picasso might have meant?

- Perhaps Picasso was criticizing the way museums help to establish artistic canons which, as we saw in Chapter 01, are invented standards of taste.
- Also, depending on any museum's holdings, it can only present a limited 'story of art', and Picasso might be saying this is far from the truth.

By circumstance and necessity, museum displays do not always provide the complex and diverse art historical narratives that the works might deserve. Instead, they display exhibits in convenient categories. For instance, a museum such as St Petersburg's Hermitage exhibits its collections in national schools: French painting, Italian painting and so on. Others, such as the MoMA in New York and London's National Gallery, use essentially chronological arrangements. These displays have the advantage of showing artistic development but they cannot easily make comparisons with works from different periods. Comparison of two paintings of the female nude made at different times, for instance Picasso's *Les Demoiselles d'Avignon* (Figure 5, p. 63) and Bouguereau's *Birth of Venus* (Figure 4, p. 33), convey quite different meanings from those arising from comparing two paintings by artists working during the same period.

London's Tate Modern has arranged its collection to encourage such comparisons with thematic rather than chronological displays. Poetry and Dream, Material Gestures, Idea and Object, and States of Flux are the four 'themed' areas of display at Tate Modern. These are broad enough to allow work of different periods and by different artists to be exhibited together, thereby encouraging viewers to 'create' their own story of art, rather than follow a single prescribed story (see Chapter 04).

Picasso's comment asks us to reassess the role and responsibilities of art museums; it begs the question whether there is a correct and 'truthful' way of displaying art. For some

artworks, a museum is an appropriate setting but for others it is artificial, as, for example, with paintings made for specific locations, such as Figure 1 (p. 6). Not only is this altarpiece no longer in its original church setting, its various parts are now in different museums. What we see in London is only part of the whole work. With this painting, Picasso's claim might begin to ring true.

However, we must not forget that art can mean different things to different ages. Unlike our Renaissance predecessors, we can understand and appreciate Masaccio's painting in a museum; it is no longer experienced exclusively as a religious object but valued more for its aesthetic and historical significance. Thus, we might think that instead of museums being 'a lot of lies', it might be fairer to describe them as places that *exhibit and present different truths*. An understanding of how displays present *a* truth, rather than *the* truth, should enhance the rewarding experience of looking at art.

Section 2 The art exhibition and the 'blockbuster' show

Section 1 suggested that the museum setting and the way artworks are displayed could convey particular meanings and so influence our interpretation. With temporary exhibitions, as opposed to permanent collections, this is more so!

While there have always been specially created exhibitions, in recent years most of the major art museums have organized and exhibited temporary shows. These focus on particular aspects of art: an individual artist, group or movement, a precise period of time, a theme such as landscape or a particular medium such as drawing. By bringing together works from different collections, unfamiliar and sometimes fresh interpretations can be considered in ways impossible if the works were seen independently and in their original locations.

There are many exhibition types and we might view each differently, sometimes simply because of their locations and motives. For example, large international shows, like the Venice Biennale in Italy, present art in national pavilions where it is difficult to disassociate the exhibits from the nationality of their makers, and this may influence our judgements and interpretations. On the other hand, we probably view exhibitions differently when organized in a public museum,

such as Amsterdam's Rijksmuseum or the Philadelphia Museum of Art, where they seem to play an accepted role in the museum's programme of events. Equally, exhibitions held at prestigious venues like London's Royal Academy of Arts, often reflect the institution's status, which might also colour our appraisal of the work itself, just as exhibitions supported by the National Endowment for the Arts, the Arts Council or British Council may have a comparable authority that influences our opinions. Similarly, exhibitions in commercial galleries might be seen in another way, since it can be difficult to disassociate them from financial value and business interests.

Perhaps more than permanent collections, temporary shows need to be approached with an awareness that certain beliefs and values are consciously or unconsciously being made. Put another way, any exhibition will convey ideas and opinions that influence the way we understand and appreciate art: *there is no such thing as a neutral or value-free presentation of art.*

What's in a name?

Even before we enter an exhibition, its title might persuade us to look at the work in a particular way. *The Genius of Venice 1500–1600* and *Sensation – Young British Artists from the Saatchi Collection*, both held at the Royal Academy, London, in 1983 and 1997 respectively, and *Jackson Pollock: Defining the Heroic* held at the Museum of Fine Arts, Houston, Texas in 1996, and *The Triumph of Painting*, held at the Saatchi Gallery in London in 2005, are all titles of temporary exhibitions.

> How do you think these titles might influence our attitude or approach to the exhibitions?

- The title of the Royal Academy's 1983 show suggests that the art of sixteenth-century Venice is the product of exceptional creative power, a period of genius in fact. This might be true but the title makes a significant contribution to our expectations and so possibly prejudiced the way the exhibition was approached.
- Similarly, the title *Sensation* suggests that we should expect something exciting and, by implication, controversial. This proved to be the case, but how far was it encouraged by the title?

- The Jackson Pollock exhibition presented the idea that the artist and/or his art were heroic, a word often associated with courage and bravery, but here it is more likely to be connected with bold and outstanding achievements. The exhibition's organizers probably consciously evoked the various shades of meanings of 'heroic'.

- The Triumph of Painting was organized at a time when other forms of art – installations, video, performance and so on – seemed to dominate the contemporary art scene and painting was no longer regarded as the pre-eminent artistic form. The title of the Saatchi exhibition appeared to redress this, promoting painting as once more of paramount significance and intimating that it had overcome its rivals. Visitors were being presented with the idea that painting was 'back', whether it was or not.

In all these cases, the titles might influence our approach to the exhibitions, providing us with some preconceived ideas about how to look at the exhibits.

Selecting exhibits

Nonetheless, titles only go so far in suggesting an exhibition might be promoting a particular 'line' or approach. The selection of exhibits, formats and displays play a significant part in our understanding and interpretation. To a large extent, what is included in an exhibition depends upon what the organizers want to include. As such, an exhibition is an artificial grouping which influences the way we view, appreciate and situate meaning. In 1987, London's Royal Academy staged *British Art of the Twentieth Century: The Modern Movement*, which included 13 works by David Bomberg, more than any other painter in the exhibition. Did this identify Bomberg as a more significant artist than others hitherto considered more canonical, such as Walter Sickert, who had 12 pictures in the show, Francis Bacon, who had eight, or David Hockney, with only four? Or was this a legitimate attempt to give Bomberg the canonical status he did not previously enjoy?

As well as organizer and curatorial choice, what exhibitions include is also dependent on what is available. It may not be possible to borrow certain works for a particular show. The 1991 *Georges Seurat* exhibition held at the Grand Palais in Paris was a major show but without the artist's major paintings. The Art Institute in Chicago, the Kröller-Müller Museum at Otterlo

in the Netherlands, and London's National Gallery did not lend important works by the artist, resulting in one newspaper commenting that the show was more remarkable for what wasn't there than what was. As well as the unavailability of works, rising market prices and more mundane considerations such as insurance and shipment costs have to be considered. One of the more unusual episodes came at the end of 2007 when the staging of an exhibition of French and Russian art from St Petersburg was put in jeopardy. Russian officials were concerned that the paintings, many of which had been confiscated from collectors by the Bolsheviks after the 1917 revolution, might be subject to claims by the collectors' heirs or by companies trying to seize Russian assets as part of historical lawsuits. The British government stepped in and rushed through legislation that safeguarded the paintings whilst they were being shown at London's Royal Academy.

Displaying exhibits

Like permanent collections, exhibitions need some form of arrangement and categorization to give them meaning. We should be aware as visitors that professional curators, just like us, are people with preferences and opinions, which essentially decide the form an exhibition will take; their decisions about content, organization and display will ultimately convey a particular way of interpreting works of art. Exhibitions of individual artists tend to be organized chronologically. A show such as *Renoir*, held in London, Paris and Boston in the mid-1980s, presented the French artist's work in a series of galleries and traced its evolution from his earliest paintings, made in the 1860s, to his last works of about 1919. This encouraged visitors to interpret and appreciate against the context of Renoir's developing style and variations in subject matter.

On the other hand, the Paris show of the nineteenth-century artist Gustave Courbet, held in France and the United States in 2007–8, was chronologically and thematically organized. The exhibition opened with the artist's early work and closed with his last paintings, encouraging visitors to identify the artist's evolving style. However, throughout his career Courbet painted a number of themes again and again, notably landscapes and nudes, examples of which were displayed together so that visitors were encouraged to compare them. Overall, this exhibition put emphasis on the historical contexts of Courbet's paintings, with sections of the show devoted to 'The Modern

Temptation', which considered his influence on other, younger painters such as the Impressionists, and 'Courbet and the Commune', looking at the artist's involvement with political events after the Franco-Prussian War.

The desire for curators to contextualize art exhibitions is understandable; as we saw in Chapter 03, interpretation and appreciation of works of art can benefit from contextual knowledge. Equally, context can serve to deflect attention from the aesthetic value of the works; perhaps this was in the mind of the organizers of *1900 Art at the Crossroads*, held in London and then New York in 2000, a survey of art made around the beginning of the last century. The exhibits were displayed thematically in separate galleries: portraits, the city, rural scenes, religion, and so forth. This placed less emphasis on the chronology and nationality of the works and gave more importance to the way similar themes were represented by different artists; this probably persuaded visitors to look more closely at the works themselves than to fit them into an art historical context.

The question of historical context is further illustrated in two London exhibitions from the early 1990s: the Royal Academy's *Pop Art* and the Barbican Art Gallery's *The Sixties. Art Scene in London*. Both these exhibitions displayed work form the 1960s, but were organized in quite different ways, thereby encouraging differing interpretations. The Royal Academy's show arranged exhibits by nationality: American, British and European. Displayed in separate galleries, the Pop Art movement was presented as three independent but parallel developments. The *Art Scene in London* show organized exhibits more thematically: galleries were labelled 'Dissent 1958–63', 'A New London 1959–63', 'Bodies and Gender 1958–67', etc. This presented 1950s' and 1960s' art in London, including Pop Art, as an interconnected sequence of themes, with some artists represented in more than one of the galleries. Although the Barbican exhibition was only concerned with art in London, while the Royal Academy show spanned two continents, work by artists like Peter Blake and David Hockney was displayed in both shows. In the Royal Academy's *Pop Art* exhibition, paintings by Blake and Hockney were hung with other paintings by their British Pop Art contemporaries. In the Barbican's *Sixties* show their work was displayed alongside 1960s posters, photographs, magazines, newspapers and record sleeves. In this way, the Academy's show presented art only in the context of other art, whereas in the Barbican exhibition art was placed in

a broader cultural and social setting. For visitors, appreciating and interpreting a David Hockney painting only in relation to other paintings was probably different from seeing it in relation to paintings, posters, record covers, etc.

The examples of the *Pop Art* and *The Sixties* shows demonstrate how exhibitions can follow certain art historical viewpoints, the former looking at the art objects themselves, the latter presenting them as part of the wider social and cultural background. A contextual approach was also used in *Goya and the Spirit of the Enlightenment*, organized in the late 1980s by museums in the United States and Spain. As the title suggests, the exhibition's aim was to explore the canonical Spanish artist as a man of his times. Goya lived during a period when parts of Spanish society were beginning to embrace French ideas about philosophy, learning, politics and culture. His paintings, drawings and prints reflected these Enlightenment ideas but he was also influenced by humankind's irrational and illogical actions. In Goya's Spain, this showed itself in superstitions and people's inhumanity to each other. Such an approach to art is contextual and *Goya and the Spirit of the Enlightenment*, probably even more so than the Barbican's *The Sixties*, was consciously planned to present the works of art in this way. Visitors to the Goya exhibition may have been persuaded that the interpretation with which they were presented was an influential and persuasive one; the critic Robert Hughes certainly thought so:

> When I first saw the show in Boston I wanted to accept the Enlightenment view of Goya wholeheartedly, because it promised a way out of earlier stereotypes of the artist. It enables us to reread many of his images...

(*Nothing if Not Critical*, Harvill, 1990)

How might Robert Hughes's comments suggest the exhibition was successful?

- Hughes suggests that seeing the exhibition altered an existing interpretation of Goya's work and this might be seen as a way of measuring its success. His comments make it clear that we can be persuaded by an exhibition's particular approach but it is also important that we do not lose sight of other approaches which might also allow us insight.

However, with exhibitions it is often difficult to do this; the organization and arrangement of exhibits to promote a particular 'reading' can be extremely compelling. With larger exhibitions, this is emphasized by the related publicity and promotion. These so-called 'blockbuster' shows are accompanied by posters, press advertising, and critical reviews in newspapers, journals and related television programmes and sometimes even reduced ticket prices are offered. All this adds to a 'must see' effect where visiting the exhibition becomes a status symbol. Consequently, blockbuster shows are usually crowded and the experience might seem closer to a theme park than an art museum, all of which influences our understanding and appreciation of the works on display.

Section 3 Museums and exhibitions: other meanings

This chapter's final section develops some of the ideas about art museums mentioned earlier which are not directly connected with display and exhibitions but nevertheless affect our understanding of art. Like other institutions, art museums have responded to the demands of marketing, consumerism and greater use of technology. When we visit art galleries or museums we not only look at the images themselves but are able to develop awareness by using portable audio guides and touch screen computers.

What do you think are the advantages and disadvantages of using audio guides and computers in art museums?

- You may feel that audio guides and computers can improve our understanding and appreciation of art. In one sense they replace books which, as noted above, have the advantage of providing information extending that given on labels and display boards.
- Audio guides give visitors information as they stand in front of the works of art; computers, as in the Micro Gallery of London's National Gallery, provide easily accessible, immediate and on-site information to those wanting further data or background.
- However, you might feel that using such technology diverts attention from the contemplation of the exhibits themselves.

In fact, you may think that visiting some art museums is no longer the quiet and reflective experience it was once claimed to be.

With leisure and entertainment increasingly influential in our society, many museums offer visitors an experience beyond looking at the exhibits: restaurants and cafés, book and gift shops, a members' room, special open evenings and private views, concerts and other events staged in the galleries and, as we have seen, museum buildings providing an appropriately spectacular setting.

Some museums now promote themselves as brands or products: in the press, through television programmes, publishing their own books and magazines and endorsing merchandise sold in their shops. London's Tate Gallery even organizes its own award, the Turner Prize, which is presented as a small-scale Oscar ceremony attracting not only art lovers, curators and dealers, but also celebrities.

A major feature of museum marketing is sponsorship. Funding is a concern for all museums because state sponsorship and individual donations by wealthy patrons have declined. Businesses and corporations now financially support exhibitions and donate money to museums. In return, the company name is promoted and some may have galleries named after them.

> You might like to think how the museum 'experience', as described above, has influenced your response to works of art.

- One result of all this has been a considerable increase in visitor numbers to art museums in the last 20 years, making museums more crowded.
- Another consequence has been museums becoming more like 'infotainment' attractions and less like the temples of art they once were.

Some artists, such as the American-based German Hans Haacke, have made works that are critical of the connections between culture and big business. His 1985 work, *MetroMobilitan*, commented on the connection between the Mobil Oil company's involvement with the South African apartheid regime and, what was alleged in the light of this, the company's hypocritical sponsorship of an exhibition of Nigerian art.

The role of art museums has become broader. They were once places that simply exhibited objects of cultural significance for our interest and appreciation; now many have other purposes. As venues which attract large numbers of visitors, national governments and regional authorities have recognized the potential of art to generate economic growth. The Bilbao Guggenheim in Spain and Britain's Tate Liverpool, the Lowry Centre in Manchester and Baltic Centre in Gateshead have all been established not only to promote wider cultural appreciation, but to attract visitors to these regions as part of an economic regeneration and enhancement plan.

While many museums have changed their character in the last few years, they are still institutions that display works of art and retain the 'cultural authority' to maintain and even create canonical art, about which we spoke in Section 1 of this chapter. We want to conclude by returning to a question with which we began this book: What is art?

> Please turn to Plate 11, Carl Andre's *Equivalent VIII*. How do we know this is a work of art?

We do not usually think of bricks as a medium for art. But to answer the above question, you might feel that because the artist arranged them as a work of art, they must be just that. In addition, you might think this is a work of art because you have been told it is and because it is reproduced in books about art (like this one). And you might know that it has considerable financial value, which means that it is art and not simply bricks (the work cost the Tate Gallery in London far more than the price of the bricks themselves). However, perhaps the most persuasive reason for categorizing *Equivalent VIII* as art is that to see it you have to visit an art museum. In other words, a pile of bricks in a builder's yard is a pile of bricks, but a pile of bricks in an art museum is art (you might want to look at the Institutional Theory of Art in Chapter 04, p. 80–83).

Rather differently, but no less significantly, New York's MoMA has a gallery that displays designed and mass-produced objects thought to be the best examples of their type. Tables, chairs, lamps, watches and even a helicopter are exhibited and labelled just like sculptures or paintings. Their original purpose denied because they are now museum exhibits, they become works of art simply to be looked at. Whether we contemplate a

wristwatch in the same way we would a painting is debatable yet the fact remains that its inclusion in a museum collection has given it artistic status.

Conclusion

To close this chapter we might make some final points about museology and the presentation of art.

It is clear that in more recent times the roles, purposes and values of museums and exhibition spaces have changed and been redefined through time, culture and circumstance. Furthermore, we must understand that no display of art or artefacts is neutral or value-free – curatorial perceptions and other influences also play a strategic role (compare the 'white-cube' method of presentation with more traditional displays). In addition, architecture (whatever its period, style, construction or date) is part of this value-forming experience.

In our own time, Postmodernism (see Chapter 04) places greater importance on how you, the viewer, respond to what you see; therefore the context or environment in which this encounter takes place is increasingly important. But in the end, as well as obviously seeing the images and works themselves, visiting any museum or gallery space should provide you with narratives of art history or ways of interpretation.

Suggestions for further reading

Emma Barker, *Contemporary Cultures of Display*, Yale University Press, New Haven & London, in association with The Open University, 1999.

Carol Duncan, *Civilizing Rituals: Inside Public Art Museums*, Routledge, London, 1995.

Reesa Greenberg, Sandy Nairne, Bruce Ferguson (editors), *Thinking About Exhibitions*, Routledge, London, 1996.

Paula Marincola (editor), *What Makes a Great Exhibition?* University of the Arts, Philadelphia Exhibitions Initiative, Philadelphia, 2007.

Kylie Message, *New Museums and the Making of Culture*, Berg Publishers, Oxford and New York, 2007.

Griselda Pollock, *Encounters in a Virtual Feminist Museum*, Routledge, London and New York, 2007.

James Putnam, *Art and Artifact: The Museum as Medium*, Thames and Hudson, London, 2001.

Donald Preziosi and Claire Farrago (editors), *Grasping the World. The Idea of the Museum*, Ashgate, 2004.

Karsten Schubert, *The Curator's Egg: The Evolution of the Museum Concept from the French Revolution to the Present Day*, One-Off Press, 2000.

06

categorizing the history of art

In this chapter you will learn:
- different ways of classifying art periods and styles
- one possible chronology used in relation to Western art practice
- about the hierarchy of genres; what it was and how it influenced the status of images and art making
- about different painting materials and techniques and how some of these were used to create various aesthetic effects
- about different kinds and forms of art historical information.

Section 1 Art periods and styles

It has been said that historians create history; what we know and understand about the past usually depends on what we are told. There is then no such thing as neutral or detached history because the ideas and opinions of historians, like those of everyone else, are influenced by their interests, values and view of the world. Besides, it would be impossible to record everything. For instance, imagine trying to record all that happened one day last week. You might simply rely on memory or ask other people, use a diary, read old newspapers or other documents. Yet however much you researched, you would never be able to cover everything. What was included would depend on the information gathered and what you chose to consider. In trying to make sense of the past, we select, order and arrange known information by categorizing and classifying things in some sort of sequence. In other words, we limit the scope of history to political, social or economic issues, or by focusing on individual countries, periods, people or sometimes on personal experiences. Inevitably, this leads to simplification, but if we did not do this, we would never have any clear awareness of our past. Like history in general, histories of art develop in this way.

Overall, art history is organized around *periods* and *styles*. A period is a span of time and can relate to an established historical era, such as the Renaissance. Figure 1 (p. 6) is an example of a painting made during this period. However, a period might be specifically created to distinguish developments in art, as with the term Baroque. Plate 1 illustrates a work from this period.

Style

Style is to do with the distinctive appearance of works of art. Specific features of a work can be individually seen or, more usually, in combination, so that altogether they are classified as a particular style. Plate 7 is described as Impressionist not only because it was displayed in a show we know as an Impressionist exhibition, but also because it has visual characteristics we identify as Impressionist:

- the light colours, rapid application of paint and visible brushstrokes
- the cropped composition as if we are in the boat with the women
- the relatively small canvas, and so forth.

Styles and periods

Nevertheless, the distinctions between a period and a style are not always clear-cut. The term Baroque can be used to mean a period of time, essentially the seventeenth century in Europe, but it is also used to identify a painting style characterized by:

- flamboyant and often colourful compositions
- an interest in representing movement
- theatrical effects created by exaggerated gestures and dramatic lighting.

Plate 1 illustrates some of these features and we could say that it is a Baroque painting in style, as well as being of the Baroque period. Often, names originally given to periods also describe styles and vice versa. For example, Figure 2 (p. 9) would be classified as Pre-Raphaelite in style but you might also talk about it as a painting from the period of the Pre-Raphaelites; Figure 1 (p. 6) was painted during the Renaissance but we could also categorize it as early Renaissance in style.

Over time, art history has established certain approaches to classification. For instance, the Western interpretation of Chinese art has nearly always been in relation to the ruling families or dynasties of China, from the Shang and Chou before the birth of Christ, to the Manchu who ruled from the seventeenth century to the early twentieth century. Studies of Central and South American art often explore and classify according to civilizations such as Toltec, Maya, Mixtec, Inca and Aztec, some existing at the same time but in different geographical regions. Both of these are very useful ways of organizing information and ideas but we should remember that methods of presentation do influence our awareness and understanding. For example, if the reign of various dynasties in China is used as an organizing principle for an account of Chinese art, we might reasonably think that such rulers were particularly influential in art's development. We might conclude that artistic changes reflected dynastic ones or were in some other way closely connected. On the other hand, if a history of Chinese art was presented as a study of landscape subjects, animal images and representations of the human figure across all historical periods, we might be persuaded that Chinese rulers were less important to the development of art than the ambitions of artists themselves to evolve new subjects and styles. In short, we should be aware that different ways of categorizing art history might lead to varying interpretations, or at least ones which may emphasize different aspects to the subject and its understanding.

Periods

Western art history is usually divided into periods customarily associated with significant changes in artistic style. The history of painting, for example, might go back to the caves of Lascaux but it is not until the fourteenth century that painting is considered a culturally important activity. From this point onwards, the periods of Western painting are typically categorized as follows:

- *c.* 1300– *c.* 1400 Medieval
- *c.* 1400– *c.* 1600 Renaissance
- *c.* 1600– *c.* 1750 Baroque
- *c.* 1750– *c.* 1960s Modern
- *c.* 1960s + Postmodern

While this sort of broad categorization oversimplifies, it does distinguish the main periods, though telling us very little about style. However, even general classifications such as these can influence the way we think about and understand art. For instance, the period described as 'Modern' spans over 200 years and includes many different styles and types of painting, encompassing both Plates 9 and 5. This category is used in some major surveys such as E. H. Gombrich's *The Story of Art* and H. W. Janson's *The History of Art* and might suggest that, since both works of art are classed as Modern, Vigée-Lebrun's portrait is in some way related to Rothko's painting. Taken at face value, this categorization seems wrong. As well as being quite different in appearance, Vigée-Lebrun was working in France and Rothko in New York City, with over 150 years separating both paintings. It would seem, therefore, that the classification 'Modern' is more a convenience of organization than a useful art historical label.

Consequently, in order to categorize more effectively, we might further subdivide such broad periods like 'Modern'. Rothko's painting is usually classified as Abstract Expressionist; Vigée-Lebrun's was made during a period when the Rococo style was challenged by the more fashionable Neoclassicism. The label Abstract Expressionism (a style, not a period) links Rothko with other Abstract Expressionist painters like Jackson Pollock, but to some extent it also describes the painting. Rothko's *Untitled* (Plate 5) is abstract – having no obvious likeness to the world as we see it – and is also expressionist because it communicates something of the artist's emotions and feelings. Nonetheless, comparing Rothko's work with a contemporary canvas by Pollock, for example, one of his drip paintings, demonstrates

that the term Abstract Expressionist can be used for paintings of quite different appearance.

Vigée-Lebrun's painting (Plate 9) is more difficult to define as a particular style. It has few of the characteristics we associate with either Rococo or Neoclassicism and, while we might describe it as naturalistic, this term is not very helpful because it describes many paintings from the fifteenth century onwards. Therefore, it might be more useful to classify her picture in terms of the period it was made: it is a product of the Enlightenment, sometimes known as the Age of Reason. Of course, if we do classify Rothko's painting as a style and Vigée-Lebrun's in relation to its historical period, we may be suggesting a certain interpretation or emphasis. In this case, that Rothko's work is best seen in terms of its abstract and expressive qualities while the historical context of Vigée-Lebrun's picture is more important. In closing, this example should again alert us to the different ways of categorizing art history and the particular interpretations that can follow.

Genres

Another way to classify art works is by subject matter. This is classification by genre, a French word meaning 'type' or 'kind'. For example, the genre of Plate 2 is landscape, Plate 9 that of portraiture, and Figure 4 (p.33), according to its title, mythological.

With the rise of art academies in the seventeenth and eighteenth centuries, a painting's genre became an important method of classification. Some genres were thought to be more significant than others, resulting in subjects being ranked in order of importance. This **hierarchy of genres** was based on the belief that inventiveness and intellect were essential to 'great' painting. It was argued that such qualities were best demonstrated in history subjects – narrative representations from history, literature, the Bible, mythology, etc. Such themes required artists to group figures in a variety of (action) poses, so telling a story which demonstrated skill, imagination and inventiveness. Additionally, by choosing subjects from history and literature, artists also proved their scholarship and intellect. Subjects such as still life and landscape were considered less important because they only copied seen reality, thus needing little imagination and intellect. As a result, these subjects were considered less important in the hierarchy of genres. Portraits and scenes from everyday life (known as genre paintings) held a

middle position. For instance, the status of the sitter suggested the importance of some portraits, while genre painting, which often demanded figure groupings in various poses and the communication of a story, illustrated ordinary life and was not as important as the exploits of historic, biblical, mythological and literary characters.

However, during the nineteenth century, the hierarchy of genres established by academies was challenged. In France, for example, the Impressionists, whose subjects were almost exclusively landscapes and everyday life (see Plate 7), organized their own shows independently of the hierarchical Salon exhibitions (Figure 4, p.33 is an example of a Salon painting). By the twentieth century, subject matter was no longer used to measure a painting's importance and in more recent times many works of art cannot even be classified in terms of genre at all (see Plate 14).

Chronology

Art history is often presented as a chronology of periods and styles so that we can understand how one might lead to another, perhaps influencing the next as if there was a continuous development. The sixteenth-century artist and art historian Giorgio Vasari not only saw things in this way but also believed that the art of his own time was actually an improvement on that which had preceded it. It is possible that a chronological approach might lead to a view like Vasari's, but this can be a misleading way of understanding art. For example, the style and subject of Hunt's *Light of the World* (Figure 2, p.9) might be seen as a development of painting like that of Caravaggio (Plate 1), but whether Hunt's painting is a development or even in some way superior to Caravaggio's is a matter of opinion and personal taste rather than art historical certainty. On the other hand, the appearance of Picasso's *Les Demoiselles d'Avignon* (Figure 5, p.63) is strikingly different from anything that preceded it in Western art, so there would seem little value in locating it in a chronological framework. Conversely, knowing what had gone before might be important simply because it seems to have no precedents and so its significance may be because of its innovation.

In the end, it is necessary to organize art history in one way or another so that we can understand a complex discipline, but we should appreciate that the way it is organized influences our understanding of it. With this in mind, the following timeline is

intended to help you chronologically locate the artists, paintings and art historians/writers mentioned in this book and identify the art historical periods, styles, genres, painting techniques and ideas with which they are usually associated.

A chronology of examples

1300	Medieval Renaissance	Cimabue Giotto		tempera fresco
1400		Masaccio *Virgin and Child* (Figure 1) Lorenzo Ghiberti Filippo Brunelleschi	Cennino Cennini *The Craftsman's Handbook* Leon Battista Alberti *Della Pittura*	oil glaze
1450		Paolo Uccello Filippo Lippi Sandro Botticelli Domenico Ghirlandaio		
1500		Albrecht Dürer Leonardo da Vinci Raphael Michelangelo Titian		oil paint
1550	Mannerism Baroque	El Greco *Christ Driving the Traders from the Temple* (Plate 3)	Giorgio Vasari *The Lives of the Artists*	
1600		Caravaggio *The Supper at Emmaus* (Plate 1) Diego Velazquez Peter Paul Rubens	Karel van Mander *The Painter's Book*	
1650		Rembrandt Charles LeBrun	French Royal Academy founded	
1700	 Modern	Joshua Reynolds	Alexander Baumgarten Immanuel Kant	

1750		Elizabeth Vigée-Lebrun *Self Portrait in a Straw Hat* (Plate 9)	Edmund Burke *A Philosophical Enquiry into the Origins of Our Ideas of the Sublime and the Beautiful* Wilhelm Wackenrode	oil paint	water-colour
1800		Francisco Goya Joseph Mallord William Turner	Glyptothek, Munich opened National Gallery, London opened		
1850	Pre-Raphaelite				

Arts and Crafts Movement | Gustave Courbet

William Holman Hunt *The Light of the World* (Figure 2) | | | |
1870		William-Adolphe Bougurereau *The Birth of Venus* (Figure 4)			
	Impressionism	Edouard Manet Berthe Morisot *A Summer's Day* (Plate 7) Edgar Degas Pierre Auguste Renoir			
1880		Marie Bashkirtseff Vincent van Gogh Georges Seurat			
1890		Michael Ancher Ejnar Nielsen Christian Krohg Edvard Munch *The Sick Child* (Plate 8) Paul Gauguin Paul Cézanne *The Grounds of the*			

		Chateau Noir (Plate 2) Henri de Toulouse Lautrec			oil paint
1900	Cubism	Henri Matisse			
		Pablo Picasso *Les Demoiselles d'Avignon* (Figure 5) Georges Braque	Wilhelm Worringer *Abstraction and Empathy*	collage	
1910		Marcel Duchamp Ammedeo Modigliani David Bomberg Walter Sickert	Roger Fry Clive Bell Antonio Gramsci		
1920		Isaac Brodsky *Lenin in Smolny* (Plate 6)			
1930		Grant Wood *American Gothic* (Plate 4) William Staite Murray *Persian Garden* (Figure 3)	Museum of Modern Art (MoMA), New York opened Walter Benjamin 'The Work of Art in the Age of Mechanical Reproduction'		
1940			Frederick Antal Francis Klingender Arnold Hauser		
	Abstract Expressionism		Erwin Panofsky		
1950		Jackson Pollock Mark Rothko *Untitled* (Plate 5) David Smith Francis Bacon			acrylic
	Pop Art				
1960		Andy Warhol Roy Lichtenstein	Clement Greenberg		new media

				collage	oil painting	acrylic	new media
	Minimalism	Peter Blake David Hockney Richard Hamilton	*Modernist Painting*				
		Donald Judd *Untitled* (Plate 10) Carl Andre *Equivalent VIII* (Plate 11)	Thomas Kuhn *The Structure of Scientific Revolutions*				
	Postmodern		John Berger *Ways of Seeing*				
1970		Robert Smithson *Spiral Jetty* (Plate 12) Jimoh Buraimoh *Animals* (Plates 15 & 16) Jimoh Beuys	Brian O'Doherty *Inside the White Cube* Roland Barthes Jean-François Lyotard				
1980		Hans Haacke	Jean Baudrillard *Simulacra and Simulation* Arthur Danto Musée d'Orsay opened				
1990		Jeff Koons Damien Hirst *Isolated Element Swimming in the Same Direction for the Purpose of Understanding* (Plate 13) Tracey Emin *Everyone I Have Slept With 1963–1995* (Plate 14)	Sainsbury Wing, National Gallery, London opened Carol Duncan *Civilizing Rituals: Inside Public Art Museums*				
2000		Carsten Höller	Tate Modern opened	↓	↓	↓	↓

Section 2 Painting materials and techniques

Materials and techniques contribute to the appearance of works of art and affect the way we respond to them. In painting, each type of paint has its own characteristics. For example, oil paint can be mixed to a relatively thick consistency, allowing the artist to create effects using brushstrokes (see Plate 8), whereas tempera paint is thinner and traditionally applied to a semi-absorbent surface, resulting in a flat appearance (see Figure 1, p. 6). Consequently, we respond differently to Munch's painting than to Masaccio's not only because of its dissimilar subject, composition and colour range, but also because of its distinctive surface characteristics. The serene effect of Masaccio's painting is partly achieved by using smooth areas of paint and sharp, clear edges to represent objects. In contrast, Munch's painting has highly visible, loosely applied brushstrokes which contribute to the emotion of the subject.

However, some paints are versatile enough to create a range of effects. For example, compare the use of oil paint in Plate 1 with that in Plate 7. You might find it useful to note some of the differences that you see when exploring the differing application of paint.

In addition to materials and techniques contributing to the aesthetic look and subsequent meaning of works of art, they can be studied in a technical and scientific way. Knowing exactly how paintings were made is essential for conservation and restoration departments of art museums which are equipped with stereo microscopes, infrared and X-ray photography, and staffed by technicians, chemists and art experts.

In Western painting, four main types of paint have been used since the early fifteenth century: tempera, oil, watercolour and acrylic.

All paint is made up of three parts:

- pigment (the colour in a powdered or granulated form)
- medium (which binds the powdered pigment)
- thinner or vehicle (which dilutes the paint so that it can be applied).

The paint is applied to a **support** or surface; traditionally this is wood, canvas or paper. Although each artist will have her or his own distinct ways of using materials, there are some general similarities which can help us to gain a greater awareness of works of art.

Tempera

Tempera paint (Figure 11, p. 131) is pigment mixed with egg yolk and diluted with water. It was usually applied to wooden panels (1) with linen glued to the surface to cover faults or joins (2) and then coated with layers of gesso (a mixture of chalk, glue and water), providing a smooth and semi-absorbent painting surface (3). Tempera was the most common medium for easel paintings until the fifteenth century. Sometimes the artist would make a full size drawing, known as a **cartoon** (4), and transfer this to the panel by pricking holes along the lines of the drawing and tapping a cloth bag filled with a mixture of chalk and charcoal so that the powder passes through the holes and transfers to the panel (**pouncing**) (5). Since tempera paint dried quickly on the gesso surface, it was impossible to blend the colour. Therefore, the paint was applied in areas, with detail and effects of light and shade added over the top in fine lines (**hatching**). Water-resistant when dry and with no need of varnish to protect it, tempera paintings were usually polished with a soft cloth to create a satiny finish (6).

Oil paint

Oil paint is pigment mixed with vegetable oil extracted from nuts and seeds and diluted with more oil and/or turpentine. In European art, the earliest use of oils was as translucent layers (glazes) over a first coat of tempera or oil. In the earliest examples of oil glaze painting (Figure 12, p. 132), the support was wood (1) prepared as for tempera painting (2–3). The main areas of the composition were blocked in (4) with detail and variations of tone added in various intensities of colour (5).

During the sixteenth century, oil painting (Figure 13, p. 133) gradually replaced tempera as the principal medium of painting, at which time canvas stretched across a wooden frame (stretcher) came to be used as the support (1). The canvas was primed with an oily paste to create a **ground** on which to paint (2) and then often covered with an overall tone of colour (**imprimatura**), either before or after the composition was drawn (3). Tonal variations were established in thin paint (4) and then glazes and/or thicker paint applied to create the desired effects (5). Artists usually worked from dark to light, applying white last of all.

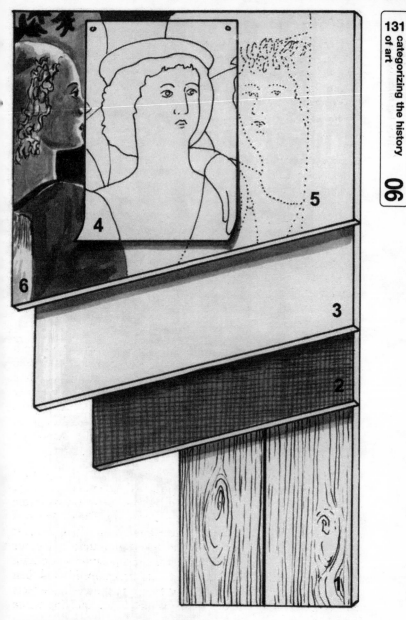

figure 11 technique of tempera painting

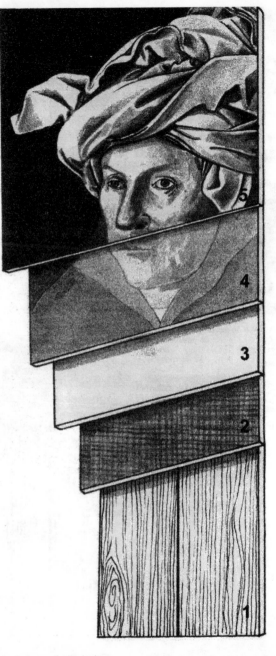

figure 12 technique of oil glazing

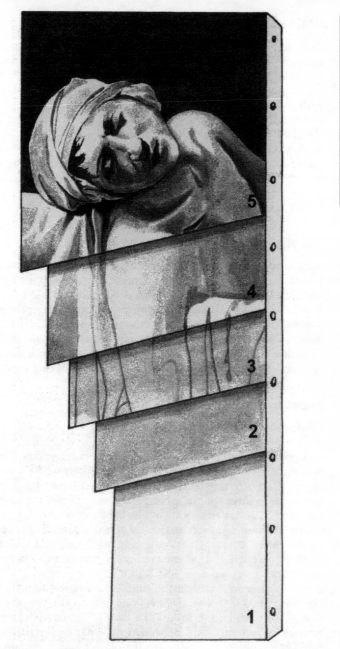

figure 13 technique of oil painting

Watercolour

Although originally used for drawing and sketching, watercolour (Figure 14, p. 135) became accepted as a medium for finished paintings at the end of the eighteenth century. Watercolour is a transparent paint made from pigment mixed with gum arabic (the sap from the acacia tree), diluted with water and applied to a thick, textured paper (1). The artist sketched the composition (2) and then applied paint in thin **washes**, the lightest first and then building layers of colour to create darker areas. The fewer layers, the lighter the tones or colours; more layers would create darker tones or colours. White areas were sometimes left unpainted (3). Details would be added last (4).

Acrylic

Acrylic paint (Figure 15, p. 136) has been marketed since the 1950s. Pigments mixed with a synthetic resin related to plastic and thinned with water are quick drying and do not discolour. Acrylics can be applied to almost any support, primed or unprimed (1). Thinned with water, translucent effects are possible but applied more thickly acrylics are opaque. Textured or **painterly** effects can be achieved as well as smooth flat areas (2). Straight edges can be obtained by using masking tape (3).

Fresco

While not a painting medium but rather a method, fresco (Figure 16, p. 137) was used for wall painting. Pigment mixed with water was applied to fresh (fresco) plaster which acted as the binder (or medium). Sometimes detail was added on dry plaster (*secco fresco*) using pigment mixed with egg. Frescoes are usually large paintings and so had to be meticulously planned. Many assistants would be used to mix and lay plaster, prepare colour and carry materials up the scaffolding necessary for the artist to paint the wall. The wall itself (1) had to be carefully prepared, first covered in a rough coat of plaster (*trullisatio*) (2), then a slightly smoother coat (*arriccio*) (3), and then a plaster mix with more sand (*arenato*) on to which the composition was drawn (4). Sections of a final layer of plaster (*intonaco*) were laid to follow the lines of the composition; the amount of *intonaco* laid depended on what the artist thought could be completed in a day, for the plaster had to remain fresh

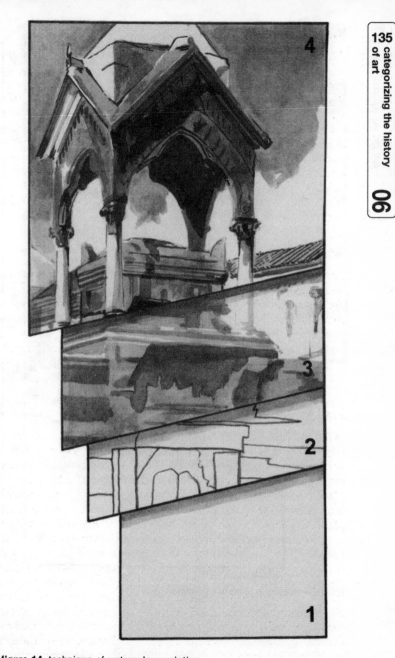

figure 14 technique of watercolour painting

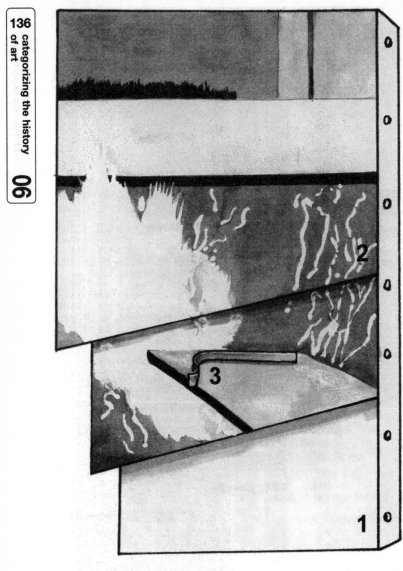

figure 15 technique of acrylic painting

figure 16 technique of fresco painting

while painting (5). As with tempera painting, a cartoon (6) was pounced on to the surface and then the paint applied (7). In frescoes, the chemical bond between surface layers and pigment is often far stronger and more durable than would be the case if dry plaster was simply painted over, as with some surviving (and earlier) wall paintings.

Section 3 Finding out more: what to look for

For the interested reader, there are many sources of information available both on art and art history. Sometimes the sheer amount can be bewildering, prompting the question: 'Will this particular book, magazine or Internet site provide me with the kind of information I'm looking for?' The following does not pretend to be comprehensive but will help you to start finding out what types of material are available.

General surveys of the history of art

These can provide good, general introductions to art history, artists, periods and styles but they tend to be large format, relatively expensive and, inevitably, their focus is broader than the monograph or museum catalogue. For example, H. W. Janson's *A History of Art* (Thames and Hudson, 2001) presents a survey from prehistoric cave painting to art of the present day; Hugh Honour and John Fleming's *A World History of Art* (Laurence King, 2002) takes a wider geographical view and not only deals with important art historical concepts such as the evolution of academic theory and the notion of art for art's sake, but also includes extracts from art historical documents; E. H. Gombrich's *The Story of Art* (Phaidon Press Ltd, 1995), originally written, Gombrich claimed, 'for readers in their teens', is less factual than either Janson's or Honour and Fleming's books yet still gives a readable overview.

The point has been made throughout this book that authors will always present art history in a particular way, adopting an approach which establishes their point of view. This probably happens to a lesser extent in general surveys of art history than in books about more specialized topics, but it is worth being aware that no writer can be entirely objective.

Moreover, many general surveys tend to emphasize the Western canon (see Chapter 01) and either omit or make only passing reference to non-Western art. The same can be said for gender issues, and it is worth asking for the latest edition or reprint of a particular survey as many have responded to contemporary discussions about Eurocentric and gender-biased history by adding to the original text.

Monographs

Literally a 'single study', these are usually books on individual artists or groups of artists who may have similar or related interests. They can be either general or specialized in approach and, with the recent upswing of interest in the visual arts, writers and publishers are taking more of an interest in this format because it offers readers a considerable amount of information, usually in a fairly economic and flexible way. The range and number of monograph studies is vast. For instance, those on individual artists can be biographical, such as John Richardson's *A Life of Picasso* (Jonathan Cape, Vol. 1, 1991; Vol. 2, 1996), or thematic, like Albert Alhadeff's *The Raft of the Medusa. Géricault, Art, and Race* (Prestel, 2002), or academic, as with Felix Thürlemann's *Robert Campin. A Monograph and Survey of Work* (Prestel, 2002). However, please bear in mind that by their very nature, monographs will be mainly concerned with a defined or specific area and will not necessarily provide a broader context with other artists, periods or styles.

Museum or collection catalogues

Whether available in book format, DVD/CD or the Internet, these publications can be invaluable sources of information, particularly if you are exploring specific images or a series of works in a particular collection. Catalogues come in various forms, either as shorter souvenir guides or visitor books, such as *Treasures of the Hood Museum of Art, Dartmouth College* (Hudson Hills Press, 1985), or as complete surveys of art held in any particular collection or museum, such as *The National Gallery, London. Complete Illustrated Catalogue on CD-ROM* (National Gallery, 1997). In addition to offering information on the art itself and sometimes the display format (see Chapter 05), they frequently explain the origins and history of the museum or gallery and even the approach taken by curators to extending, conserving and developing the collection.

Exhibition catalogues

These are usually published to accompany a specific and temporary exhibition (see Chapter 05) which may be single-sited or touring several venues, perhaps in different countries. Sometimes they have a single author, as with Paul Hayes Tucker's catalogue for *Monet in the '90s* (Yale University Press, 1989), an exhibition shown in Boston, Chicago and London. In other cases, there may be a team of art historians, curators and critics who have prepared essays and articles for the occasion, as in *Dada* (an exhibition held in Paris, Washington and New York in 2005–6) in which different authors contributed to the catalogue.

Increasingly, catalogues are more like books rather than a list of works with a few notes of explanation. Indeed, with some catalogues the list of exhibits is considered so unimportant, it is left to a back page. Catalogues should provide up-to-date information, usually incorporating the most recent academic research; more recently they have rivalled monographs as the principal source of material about art and artists.

Reference books

There is a wide range of possibilities for art reference material, either in hard copy or online. At the time of writing, *Macmillans Dictionary of Art* has established itself as a key source, covering art, architecture and conservation as well as basic biographical material. However, the cost of stocking all 38 volumes may limit the institutions which hold it. More accessible dictionaries and reference books are available, such as *The Penguin Dictionary of Art and Artists* (Penguin, 1997), *The HarperCollins Dictionary of Art Terms and Techniques* (HarperCollins, 1995), and *Hall's Dictionary of Subjects and Symbols in Art* (John Murray, 1989). The J. Paul Getty Museum in Los Angeles publishes a series of reference books with titles such as *Saints in Art, Nature and its Symbols*, and *Artists Techniques and Materials*. There are also various books that reprint essays, articles and fragments of writing by artists and critics which may also classify as art historical reference. These include Charles Harrison and Paul Wood's *Art in Theory* series (Blackwell, 1992 and later) and Donald Preziosi's *The Art of Art History* (Oxford University Press, 1998). Such publications are both interesting and useful for understanding art – they provide primary source material in an accessible format.

Books about the history of art

More recently, the discipline of art history has become a subject of study in its own right, as this book illustrates. The term used for this is 'historiography'. For example, Eric Fernie's *Art History and Its Methods: A Critical Anthology* (Phaidon, 1995), not only provides extracts of some well-known texts by past and present art historians, but also includes commentary and summaries on the entries themselves.

A number of publications exist that examine what art history is about and the way art historians operate: Louise Schneider Adams's *The Methodologies of Art* (Westview, 1996), John Armstrong's *The Intimate Philosophy of Art* (Penguin, 2000), Anne D'Alleva's *Methods and Theories of Art History* (Laurence King, 2005), Jonathan Harris's *The New Art History: A Critical Introduction* (Routledge, 2001), *Art History. The Key Concepts* (Routledge, 2006), and Grant Pooke and Diana Newall's *Art History. The Basics* (Routledge, 2008). There have also been a number of publications about art historians themselves; to date, among the most accessible are *Key Writers on Art*, edited by Chris Murray (Routledge, 2003) and Diarmuid Costello and Jonathan Vickery's *Art: Key Contemporary Thinkers* (Berg, 2007).

Auction catalogues

These can be excellent sources of information about specific artists and their work when the work finds its way on to the market for re-sale or disposal. The best examples will provide comprehensive descriptions of the works (including physical condition), as well as place of origin and the history of ownership (**provenance**).

Magazines and periodicals

There is a wide choice of English-language magazines and periodicals in the UK and US markets, ranging from the general to the highly specialist. Some large bookshops or those in major museums can be used for checking out the format and coverage of magazines before you buy. However, some publications, such as *Art History*, the journal of the British Association of Art Historians, are only available by subscription, although university and art college libraries may carry this and other periodicals. Specialist libraries may have the *Art Index*, which

lists published articles under subjects and categories, and sometimes it may be possible to use the inter-library loan system to track down back copies if you are looking for a particular article or review.

Surfing the net

There are thousands of websites on art and art history. Art museums and galleries, publishers and specialist bookshops continually update their sites; other sites provide encyclopaedic information about art, for instance, www.artcyclopedia.com, www.artincontext.org and www.archive.com. Some other useful websites are: www.arthistory.about.com, http://witcombe.sbc.edu/ARTHLinks.html, www.artlex.com, an index of terms that link to definitions, examples, etc., www.chart.ac.uk/vlib/index.html, which links to history of art image resources, collections and websites on artists, architects, periods, art museums, etc., www.metmuseum.org/toah/splash.htm, providing art history timelines and thematic essays, www.icom.museum/vlmp, which provides links to major art museums, as does www.saatchi-gallery.co.uk along with other useful links. You may also find non-art sites which will give you links to art-related sites.

Newspapers

Both daily and weekend papers offer varying amounts of visual arts copy, usually as gallery or exhibition reviews. Art critics are paid to have an informed view on the subject; be guided by the credentials of the writer and your own developing sense of what makes a critical and balanced evaluation.

Suggestions for further reading

Hugh Honour and John Fleming, *A World History of Art*, Laurence King Publishing, London, 2002.

Martin Kemp, *The Oxford History of Western Art*, Oxford University Press, 2002.

Fred S. Kleiner and Christin J. Mamiya, *Gardner's Art Through the Ages. The Western Perspective* (two volumes), Thomson Wadsworth, Belmont, CA, 2006.

Ralph Mayer, *The HarperCollins Concise Dictionary of Terms and Techniques*, HarperCollins, London and New York, 1995.

taking it further

Where to take art history from here

This book is only a beginning. It has introduced some of the basic ideas associated with art history and given you a foundation for developing your interest. This section offers some suggestions about how you might do this. It also suggests where you can go to find out more and provides some useful information on museums and galleries and the types of collections they hold. Finally, a relevant and practical glossary of various key words and terms is included for easy reference.

Study

There are many and various courses in art history that you can pursue. On the one hand, organized academic courses at universities and colleges provide significant engagement with the subject. They usually require full-time study and range from full degree courses in the history of art to individual modules within courses. However, there are also some part-time courses that are as academically rigorous as the full-time ones. Sometimes run by universities and colleges, these can often lead to academic credit or a degree qualification. On the other hand, there are many courses which might be classified as 'recreational' where there is no academic qualification for which to aim. Universities, colleges, departments of further education and community education centres might run these, but institutions such as art museums and auction houses might also organize them. These might be quite short in length, such as a few days, or once a week for a couple of months.

As well as courses, there are numerous public talks and lectures, ranging from those organized in art museums to those given less formally at local art group meetings, for example. Of course you can study with no formal structure or guidance; it may be simply to develop an interest, and this may centre on reading about art and visiting art museums.

Books and other published material

There is a wealth of published material about art and art history. We have suggested some ideas for reading at the end of each chapter and in Section 3 of Chapter 06. To pursue your interest, visit bookshops and libraries to see what is available. There are specialist art bookshops and museum shops which are often a good source. Do not forget the Internet; typing art or art history into an online bookshop such as Amazon will probably give you too many choices; you might be advised to be more precise in your search.

Art museums and galleries

At the centre of all art historical interest and investigation is direct engagement with works of art. On the whole, you will only be able to experience this in art museums and galleries. The following list provides a brief guide to some museums in the United Kingdom, the United States, and some major museums in other countries. It does not claim to be anywhere near comprehensive but it will give you a start. Websites follow addresses.

United Kingdom

London

Courtauld Institute Galleries
Somerset House, Strand,
London WC2R 0RN
www.courtauld.ac.uk
Rated as one of the top places to study art history, the Courtauld has its own collection of Impressionist and Post Impressionist works, as well as Old Master paintings by artists such as Rubens, Bruegel, Tiepolo, and Claude Lorraine.

Estorick Collection of Modern Italian Art
39a Canonbury Square,
London N1 2AN
www.estorickcollection.com

The collection was formed by Eric and Salome Estorick and first opened to the public in 1998. It holds a range of Futurist works by Italian artists such as Severini, Russolo and Boccioni, in addition to works by de Chirico, Modigliani and Morandi.

Institute of Contemporary Arts (ICA)
The Mall,
London SW1Y 5AH
www.ica.org.uk

The ICA describes itself as a 'public playground for presenting challenging work across the arts' and as an innovative forum for new ways of thinking about culture. True to its claim, the ICA showcases new work in a diverse range of media, including film, performance, and video. It also offers an expansive educational and talks programme open to members and the general public.

National Gallery
Trafalgar Square,
London WC2N 5DN
www.nationalgallery.org.uk

A comprehensive collection of paintings from the early Italian 'primitives', through the Renaissance to about 1900. There are some outstanding works, including Masaccio's *Virgin and Child* (Figure 1, p. 6), Caravaggio's *The Supper at Emmaus* (Plate 1), El Greco's *Christ Driving the Traders from the Temple* (Plate 3), Vigée LeBrun's *Self Portrait in a Straw Hat* (Plate 9), Morisot's *Summer's Day* (Plate 7) and Cézanne's *The Grounds of the Château Noir* (Plate 2). See Figures 6 and 7, p. 97. The Gallery also has numerous temporary exhibitions.

Royal Academy of Arts
Burlington House, Piccadilly,
London W1J 0BD
www.royalacademy.org.uk

The RA is a major venue for touring and international exhibitions, as well as for private collections, especially in recent years. The RA showcased the work of Young British Artists (yBas) in the 1997 *Sensation* Exhibition and has since staged major shows covering French, Chinese, Middle Eastern and Aztec art.

Saatchi Gallery
Duke of York HQ
Sloane Square, Chelsea,
London
www.saatchi-gallery.co.uk
Opened in the Spring of 2003, the Saatchi Gallery uses the Edwardian architecture and design of the former county hall offices and committee rooms to showcase both established and new artists. It features many items of Brit Art from its owner's permanent collection, including works by Tracey Emin, Jake and Dinos Chapman, Damien Hirst, Chris Ofili, Marc Quinn, and Jenny Saville.

The Serpentine Gallery
Kensington Gardens,
London W2 3XA
www.serpentinegallery.org
The Serpentine is one of the most elegant and understated art venues in London. Since its major renovation in 1998, it has staged some notable retrospectives, including exhibitions by artists such as Dan Flavin, Jane and Louise Wilson, Gilbert & George and Cindy Sherman.

Tate Britain
Millbank,
London SW1P 4RG
www.tate.org.uk
A changing display of the national collection of British art, from Tudor and Stuart paintings to the present day, and a series of temporary exhibitions throughout the year. The Clore Gallery houses the work of J. M. W. Turner.

Tate Modern
Bankside,
London SE1 9TG
www.tate.org.uk
A converted electricity power station, Tate Modern provides a dramatic setting for twentieth and twenty-first century art. The gallery space devoted to the permanent collection covers two floors and shows work thematically: Nude/Action/Body; History/Memory/Society; Landscape/Matter/Environment/ and Still Life/Object/Real Life. This re-ordering of the collection was designed not only to make the work more accessible, by

encouraging comparisons between genres, media and styles, but also to question some of the conventional chronologies and narratives of 'art history'. The collection includes Rothko's *Untitled* (Plate 5), Munch's *The Sick Child* (Plate 8) and Andre's *Equivalent VIII* (Plate 11). There are numerous temporary exhibitions, including installations in the gigantic Turbine Hall.

Victoria and Albert Museum
Cromwell Road, South Kensington,
London SW7 2RL
www.vam.ac.uk
A museum of applied and decorative arts with some important paintings, including Raphael's tapestry cartoons and works by John Constable.

Outside London
Birmingham
The Barber Institute of Fine Arts
University of Birmingham,
Birmingham B15 2TS
www.barber.org.uk
A small but excellent collection of paintings, including work by Giovanni Bellini, Gainsborough and Degas.

Birmingham Museum and Art Gallery
Chamberlain Square,
Birmingham B3 3DH
www.bmag.org.uk
A major regional collection from Old Masters to modern works.

Cambridge
Fitzwilliam Museum
Trumpington Street,
Cambridge
CB2 1RB
www.fitzmuseum.com.ac.uk
A major collection of principally Old Master works, with a few British twentieth-century paintings.

Edinburgh
National Gallery of Scotland
The Mound,
Edinburgh EH2 2EL
www.nationalgalleries.org
A major collection of Old Master works, with some later nineteenth-century French paintings, principally canvases by Gauguin.

Liverpool
Tate Gallery
Albert Dock,
Liverpool L3 4BB
www.tate.org.uk
A converted warehouse which shows changing displays of the Tate's collection and also loan exhibitions.

Manchester
Manchester City Art Gallery
Moseley Street
Manchester M2 3JL
www.manchestergalleries.org
A Victorian gallery with a new extension. The collection is varied with some outstanding Pre-Raphaelite paintings.

Milton Keynes
Milton Keynes Gallery (MKG)
900 Midsummer Boulevard,
Milton Keynes MK9 3QA
www.mk-g.org
The city's new contemporary art gallery is committed to bringing art to new audiences and features 8–10 free exhibitions per year with an expanding arts' education programme of talks and interviews.

Oxford
Ashmolean Museum
Beaumont Street,
Oxford OX1 2PH
www.ashmolean.org
The Ashmolean is credited as Britain's first public museum – having opened for business in 1633. Its permanent collection includes Old Master drawings and paintings by artists such as Uccello, Titian, Picasso, and Matisse.

United States

Boston, Massachusetts
Museum of Fine Arts
Huntington Avenue,
Boston, MA 02115
www.mfa.org
This is one of the best collections of paintings in the country, with a particularly good selection of nineteenth-century French art, including Gauguin's famous *Where do we come from? What are we? Where are we going?*

Buffalo, New York
Albright-Knox Art Gallery
1285 Elmwood Avenue,
Buffalo, NY 14222
www.albrightknox.org
Whilst there are examples from the nineteenth century and earlier, this is a gallery in which most of the major movements of the twentieth century are represented. The gallery is perhaps best known for its collection of paintings by the Abstract Expressionist painter Clyfford Still.

Chicago, Illinois
The Art Institute of Chicago
111 South Michigan Avenue,
Chicago, IL 60603
www.artic.edu
The Art Institute houses a vast collection of world art. Its most famous paintings are Seurat's *A Sunday Afternoon on the Island of La Grande Jatte* and Grant Wood's *American Gothic* (Plate 4).

Los Angeles, California
The Getty Center
1200 Getty Center Drive,
Los Angeles, CA 90049
www.getty.edu
Apart from the spectacle of architect Richard Meier's complex of shining white buildings seen against the mountains and sea, the Getty Center holds a collection of principally Italian and French art, including Van Gogh's very expensive *Irises*.

Marfa, Texas
Chianti Foundation
PO Box 1135,
Marfa, TX 79843
www.chianti.org
Although you can only visit Donald Judd's 400-acre 'museum'
on a two-hour tour (for which you do not need to book since it
is free), the new and converted buildings, desert landscape and
large-scale Land installations, notably Judd's own work (see
Plate 10), are spectacular.

New Haven, Connecticut
Yale University Art Gallery
1111 Chapel Street,
New Haven, CT 06520
www.artgallery.yale.edu
Yale has one of the best collections of early Italian art but
displays only part of it at any one time. To make up for this,
there is a fascinating collection of twentieth-century art that
includes work by Futurist, Dada, and Cubist artists. Many of
these works were purchased in Europe by the collector
Katherine S. Dreier and bequeathed to Yale in 1941.

New York
Metropolitan Museum of Art
5th Avenue at 82nd Street,
New York, NY 10028
www.metmuseum.org
Gallery upon gallery of canonical paintings, from early Italian
and Flemish to French, British, German, Spanish and American.
The 'Met' is so big that its thousands of visitors never seem to
get in each other's way (except in the museum shop!).

Museum of Modern Art
11 West 53rd Street, between 5th and 6th Avenues,
New York, NY 10019
www.moma.org
An unrivalled collection of twentieth-century art displayed
chronologically so that the visitor follows MoMA's own
interpretation of 'the story of modern art'. In just about every
gallery there is a canonical painting (see Figure 5, p. 63) but the
museum is nearly always crowded which does not contribute to
contemplative viewing.

Solomon R. Guggenheim Museum
1071 5th Avenue between 88th and 89th Streets,
New York, NY 10128
www.guggenheim.org
Although the museum has a large collection of twentieth-century art, much of it abstract, it tends to show temporary exhibitions and only selections from the permanent collection. Frank Lloyd Wright's building, as much if not more than the paintings, is the attraction for many visitors.

Philadelphia, Pennsylvania
Philadelphia Museum of Art
26th Street and Benjamin Franklin Parkway,
Philadelphia, PA 19130
www.philamuseum.org
The principal and arguably most important works of art in the Philadelphia Museum are the Old Master paintings in the John G. Johnson collection and the twentieth-century modernist works in the Gallatin and Arensberg collections. Walter and Louise Arensberg were the patrons of Marcel Duchamp and thanks to them, the museum holds the most complete collection of his work.

Pittsburgh, Pennsylvania
The Andy Warhol Museum
117 Sandusky Street,
Pittsburgh, PA 15212
www.warhol.org
Although for most of his career Warhol worked in New York, he was born in Pittsburgh to Czechoslovakian parents in 1928 and it was the city of his birth which commemorated his achievements. Campbell's soup, Coca Cola, Brillo pads, Marilyn Monroe and Chairman Mao, were variously 'translated' into art by Warhol and his museum in Pittsburgh celebrates them all.

San Francisco, California
San Francisco Museum of Modern Art
151 Third Street,
San Francisco, CA 94103
www.sfmoma.org
The spectacle of Mario Botta's Postmodern building threatens to overshadow the art on display but there are enough Matisses, Mondrians, and Rauschenbergs to hold their own.

Washington, D.C.
National Gallery of Art
6th Street at Constitution Avenue NW
Washington, D.C. 20565
www.nga.gov
In short, one of the best collections of European and American painting from the thirteenth century to the present day.

Australia

Canberra
National Gallery of Art
King Edward Terrace, Parkes Place,
Canberra, ACT 2601
www.nga.gov.au

Sydney
Art Gallery of New South Wales
Art Gallery Road, The Domain,
Sydney, NSW 2000
www.artgallery.nsw.gov.au

Austria

Vienna
Kunsthistorisches Museum
Burgring 5,
A-1010 Wien
www.khm.at/home/home/E.html

Belgium

Brussels
Musées Royaux des Beaux-Arts – Musée d'Art Ancien Musée d'Art Moderne
Rue de la Régence 3,
B-1000 Brussels
www.fine-arts-museum.be
See Figure 8, p. 100

Canada

Ottawa
National Gallery of Canada
380 Sussex Drive, PO Box 427, Station A,
Ottawa, Ontario K1N 9N4
www.nationalgallery.ca

Czech Republic

Prague
Sternberg Palace (Šternbersky Palác)
Hradčanské námesti 15
Praha 1-Hradcany
Tel: 420 224 810 758

Denmark

Copenhagen
Ny Carlsberg Glyptotek
Dantes Plads 7,
1555 Kobenhaven V
www.glyptoteket.dk

France

Paris
Musée du Louvre
Rue de Rivoli,
75001 Paris
www.louvre.fr
The 'New Louvre' was opened in 1993 which doubled the space of the existing museum, itself already vast. The transparent pyramid entrance has become something of a tourist attraction, as has the Greek sculpture known as the *Venus de Milo* and Leonardo's *Mona Lisa*. But the Louvre has so much more, some of it outlandishly large, such as David's *Coronation of Joséphine*, and some small and easily overlooked images, such as Vermeer's *Lacemaker*.

Musée National d'Art Moderne, Centre Georges Pompidou
Place Georges Pompidou,
75191, Paris
www.centrepompidou.fr
On the 4th and 5th levels of Richard Rogers' and Renzo Piano's
'high-tech' building, the history of twentieth-century art is
chronicled in spacious galleries. In front of the Pompidou Centre,
with its entrance on the rue Rambuteau, the studio of the
modernist sculptor Constantin Brancusi has been reconstructed.

Musée d'Orsay
62 rue de Lille,
75345 Paris
www.musee-orsay.fr
The former railway station Gare d'Orsay was transformed into a
museum of art in 1986. The collections trace French culture from
the 2nd Republic in 1848 to the outbreak of the First World War
in 1914. On the ground floor, Salon, Realist and early
Impressionist paintings illustrate the changing culture of the 2nd
Republic and 2nd Empire; on the upper level, the light galleries
display a spectacular collection of 3rd Republic Impressionist
paintings; whilst on the middle level, Symbolist paintings and
some salon works are exhibited with Art Nouveau applied art
and early modernist works. See Figure 9, p. 100.

Musée Marmottan
2 rue Louis-Boilly,
75016 Paris
www.marmottan.com
A relatively small collection dominated by Monet's late
paintings housed in new, white and serene underground galleries
sponsored by a Japanese bank.

Outside Paris

Bordeaux
Musée des Beaux-Arts
Jardin de la Mairie, 20 Cours d'Albret,
33000 Bordeaux
www.culture.gouv.fr/culture/bordeaux
The collection emphasizes late eighteenth- and nineteenth-
century painting.

CAPC Musée d'Art Contemporain
Entrepôt, 7 rue Ferrère,
33000 Bordeaux
Tel: 33 5 56 00 81 50
Art of the last 30 years.

Lille
Musée des Beaux-Arts
Le Palais des Beaux-Arts de Lille, Place de la République,
59000 Lille
www.pba-lille.fr
Includes a large collection of eighteenth- and nineteenth-century French painting.

Lyon
Musée d'Art Contemporain
81 Cité Internationale,
69006 Lyon
www.moca-lyon.org
Set in a modern building complex, the collection is of recent art and specially commissioned installations.

Nice
Le Musée d'Art Moderne et d'Art Contemporain
Promenade des Arts,
06300 Nice
www.mamac-nice.org
Modern art in a dramatic new building.

Roubaix
Musée d'Art et d'Industrie (La Piscine)
24 rue des Champs
59100 Roubaix
www.french-art.com/musees/roubaix
See Figure 10, p. 101

Rouen
Musée des Beaux-Arts
Sq. Verdrel,
76000 Rouen
www.rouen-musees.com/beaux_arts/index
The collection is centred on French art from the sixteenth to the twentieth centuries.

Germany

Berlin
Alte Nationalgalerie Kunst des 19 Jahrhunderts
Bodestrasse, 1–3,
D-10178 Berlin
www.alte-nationalgalerie.de
A collection of nineteenth-century painting and sculpture.

Neue Nationalgalerie
Berlin-Tiergarten, Potsdamer Strasse 50,
D-10785 Berlin
www.neue-nationalgalerie.de
The New National Gallery has a collection of twentieth-century
art but when there is a temporary exhibition little of it is
displayed.

Dresden
Gemäldegalerie Alter Meister
Der Zwinger, Sophienstrasse,
D-01067 Dresden
www.skd-dresden.de
A fine collection of late Renaissance and Baroque paintings,
including Giorgione's *Sleeping Venus*.

Essen
Museum Folkwang
Goethestrasse 41,
D-45128 Essen
www.museum-folkwang.de
Late nineteenth- and twentieth-century paintings housed in new,
light and spacious galleries.

Frankfurt
Frankfurt Museum für Moderne Kunst
Domstrasse 10,
D-60311 Frankfurt am Main
www.mmk-frankfurt.de
Hans Hollein's idiosyncratic building houses works by
contemporary artists such as Beuys, Nauman and de Maria.

Hamburg
Kunsthalle
Glockengiesserwall,
D-20095 Hamburg
www.hamburger-kunsthalle.de
A wide-ranging collection from early German and
Netherlandish painting to twenty-first century installations.

Köln (Cologne)
Museum Ludwig
Bischofsgarten Strasse 1,
D-50667 Köln
www.museenkoeln.de/english/museum-ludwig

München (Munich)
Alte Pinakothek
Barestrasse 27,
D-80799 München
www.pinakothek.de/alte-pinakothek/index_en
Old Master paintings from pre-Renaissance to the eighteenth century.

Neue Pinakothek/Staatsgalerie Moderne Kunst
Barestrasse 29,
D-80799 München
www.pinakothek.de/neue-pinakothek/index_en
Nineteenth-century paintings.

Stuttgart
Staatsgalerie Stuttgart
Konrad-Adenauer-Strasse 30-32,
D-70038 Stuttgart
www.stattsgalerie.de
James Stirling's architecture is a work of art in its own right. Inside, the galleries are light and airy; the collection includes some Old Master works but the modern twentieth-century works are more impressive.

Ireland

National Gallery of Ireland
Merrion Square West,
Dublin 2
www.nationalgallery.ie

Italy

Firenze (Florence)
Galleria degli Uffizi
Loggiato degli Uffizi 6,
50122 Firenze
www.uffizi.com
The best time to visit the Uffizi is December and January, otherwise it is crowded with tourists. The best Italian Renaissance painting is here, together with some examples from the Netherlands, Germany and France.

Milano (Milan)
Galleria d'Arte Moderna
Via Palestro 16,
20121 Milan
Tel: 30 02 7600 2819
There is some nineteenth-century painting in the collection but the Pavilion of Contemporary Art in the museum has an impressive display of Futurist paintings and contemporary work from the early twentieth century.

Rome
Galleria Borghese
Villa Borghese, Porta Pinciano, Via Veneto,
00197 Rome
www.galleriaborghese.it

Pinacoteca Vaticana
Viale Vaticano 165,
00120 Città Vaticana
www.mv.vatican.va/3_EN/pages/PIN/PIN_sala08_03.html
Michelangelo's Sistine Chapel ceiling, Raphael's *Stanze*, and much more.

Venezia (Venice)
Gallerie dell'Accademia
Campo della Carità,
30121 Venezia
www.gallerieaccademia.org

Japan

Tokyo
Bridgestone Bijutsukan (Bridgestone Museum of Art)
10-1 Kyobashi 1-chome, Chuo-ku,
Tokyo 104-0031
www.bridgestone-museum.gr.jp
Mainly nineteenth- and twentieth-century European and Japanese paintings.

Netherlands

Amsterdam
Rijksmuseum
Stadhouderskade 42,
1071 ZD Amsterdam
www.rijksmuseum.nl
The collection centres on Dutch seventeenth-century painting.

Stedelijk Museum
Paulus Potterstraat 13,
1071 CX Amsterdam
www.stedelijk.nl
The collection consists of art from *c.* 1850 onwards and a new
building to house this is planned. At present, the museum shows
some of this collection but much of the space is given over to
temporary exhibitions.

Van Gogh Museum
Paulus Potterstraat 7,
PO Box 75366
1070 AJ Amsterdam
www.vangoghmuseum.nl

Groningen
Groninger Museum voor Sta den Lande
Museumeiland 1,
9711 ME Groningen
www.gronigermuseum.nl
The collection of Postmodern museum buildings on an island
site is spectacular; the collection includes seventeenth-century
Dutch painting as well as works by Jeff Koons and Andy
Warhol.

Den Haag (The Hague)
Haags Gemeentemuseum
Stadhouderslaan 41,
PO Box 72,
2501 CB Den Haag
www.gemeentenmuseum.nl
Modern art from the nineteenth and twentieth centuries.

Mauritshuis
Route Vijverberg 8,
PO Box 536,
2501 Den Haag
www.mauritshuis.nl
Dutch seventeenth-century painting.

Norway

Oslo
Nasjonalgalleriet
Universitetgaten 13,
N-0164 Oslo
www.nationalmuseum.no

Russia

Moscow
Pushkin Fine Art Museum
12 Ulitsa Volkhonka,
121019 Moscow
www.museum.ru/gmii/defengl.htm

State Tretyakov Gallery
Lavrushinsky perculok 10,
Moscow
www.tretyakov.ru/English/about/shtml
A vast collection of Russian art.

St Petersburg
State Hermitage
Winter Palace, 34 Dvortovaya Naberezhaya,
St Petersburg 19000
www.hermitagemuseum.org

Spain

Bilbao
Museo Guggenheim Bilbao
Abandoibarra Et. 2,
48001 Bilbao
www.guggenheim_bilbao.es

Madrid
Museo Nacional del Prado
C/Ruiz de Alarcon 23,
28014 Madrid
www.museoprado.mcu.es

Sweden

Stockholm
Moderna Museet
Steppsholmen,
103 27 Stockholm
www.modernamuseet.se

Switzerland

Berne
Kunstmuseum
Hodlerstrasse 8–12,
CH-3000 Berne 7
www.kunstmuseumbern.ch

Zürich
Kunsthaus
Heimplatz 1
CH-8024 Zürich
www.kunsthaus.ch

glossary

This glossary is not exhaustive but includes all words and terms which are **emboldened** on their first mention in the text, as well as some other associated words and terms that may be useful. Words **emboldened** within the glossary refer to other entries.

abstract Abstract art is non-**figurative**; that is, it does not obviously refer to nature and objects in the visible world and, as such, does not depict subjects. However, it would be misleading to say that abstract art does not represent; all art represents in some way and while abstract art does not represent by imitating the visible world of objects and nature, it can represent ideas, beliefs, thoughts, opinions and so forth. Therefore, abstract art in its strictest sense does not resemble (see Plate 5).

Yet in a less strict sense, certain forms of abstract art can resemble to a degree. Nature and objects can be 'abstracted' – they can be represented in ways which do not conform to established figurative conventions of depiction (as in Plate 1). Such 'interpretations' can be regarded as abstract but might be more exactly described as 'abstracted' (see Figure 5, p. 63).

academies Dissatisfied that painting, drawing and sculpture were regarded simply as **craft** activities and that artists were thought of as mere artisans, at the end of the sixteenth century some Italian artists organized groups to promote the intellectual and creative aspects of their activities. Called academies, these groups capitalized on the rising status of artists which had begun in the fifteenth century (see **artists' status**) and by the eighteenth century academies were established throughout Europe. Some academies such as those in France, Spain and Britain benefited from royal

support, which further enhanced the status of the institutions and their members – the academicians. Academies provided places for artists to meet and work as well as being teaching institutions that promoted the styles and subjects of **academic art**. In elevating art above craft and freeing the making of art from the control of **guilds**, academies helped to promote art as an intellectual activity (a **liberal art**) rather than a manual one (a 'mechanical art'). By the nineteenth century, with the evolving ideas of artistic independence promoted by the Romantic and Realist movements, academies were challenged as the principal arbiters of taste. They were no longer seen to offer intellectual leadership in the arts but merely to provide technical training. As a result, their artistic authority and influence declined.

academy (academic art) The original use of the term academic art was simply to identify art produced by academicians (see **academies**). Such art had relatively distinctive features:

- in form, it placed drawing over colour, used carefully organized compositional arrangements, a controlled application of paint and generally championed technical competence
- in content, subjects were characterized by large-scale narratives from history, the Bible and mythology (see **history painting**), while portraits, landscapes and still life, etc. were considered of less importance (see **hierarchy of genres**).

From the nineteenth century, the term academic art began to be used in a derogatory sense to identify unimaginative and outmoded styles and subjects (see Figure 4, p. 33).

aesthetic (aesthetics, aestheticism) The philosophical study of the concepts of beauty and taste became a concern for European culture in the mid-eighteenth century. The word derived from the Greek *aesthesis*, meaning perception by the senses, and so aesthetics stressed the way in which we responded to beauty through our senses rather than intellectually.

- In the eighteenth century, thinkers such as Alexander Baumgarten, Immanuel Kant and Edmund Burke did make intellectual claims that there were universal standards of beauty to which we would all respond.
- Equally, there were claims that what was aesthetically pleasing or satisfying was dependent on the individual's sensory perception and that the condition of beauty was purely subjective.

- In the nineteenth century, another approach considered that a work of art could not be understood and appreciated independently from the social circumstances of its production, and that the viewer's perceptions were also socially conditioned. Therefore, these contextual theories interpreted beauty and taste as the products or consequences of controlling interest groups and viewpoints.

It is clear that the meanings attached to aesthetics often vary and, consequently, the word tends to be used in an inexact way to mean:

- a standard of beauty or taste, although one which does not necessarily have precise definition,

or

- a reference to the purely visual aspects of a work of art, as opposed to its historical and social contexts,

or

- our sensual response to works of art,

or

- an adjective which, imprecisely, describes a work of art's 'artistic' merit.

altarpiece A screen or set of panels, sometimes hinged so that they can be opened or closed, set above, behind or on the altar of a church. Images on such objects sometimes represented the patron saints of the church and/or the person who commissioned the work. Altarpieces could serve as both decoration and biblical instruction to an illiterate population; they also served to concentrate the devotions of the congregation.

applied art A term which is often used to identify arts such as interior design, pottery, metalwork, glass and other forms that generally have a functional or utilitarian purpose. In this sense, applied art is synonymous with design. However, the term is also frequently used as a contrast to **fine art**. In this sense, the necessity for the terms 'fine' and 'applied' seems to derive from a need to distinguish the activities of **academies** from those of **guilds**. Thus, applied art is not simply that which is functional or utilitarian (jewellery and tapestry are classed as applied arts yet they are not necessarily functional) but, arguably, art that emphasizes **craft** skills above apparent intellectual content. The term 'decorative art' is also used as an alternative to applied art; this too is imprecise since not all applied art is decorative.

artists' status The social, cultural and economic recognition given to artists was a major concern and motivation shaping the work of authors and painters such as the Italian Giorgio Vasari and the Dutchman Karel van Mander in the sixteenth century. Changes in artistic status, especially among the most gifted practitioners, were closely linked with:

- the rise of the **academies** (these institutions stressed the role of art as, in part, an intellectual undertaking, requiring considerable skill and judgement)
- the importance and prestige of the patron or commissioning body.

With the decline of the **academy** system in the late nineteenth and early twentieth centuries, perceptions of artistic status (especially on an individual basis) have been increasingly tied to critical success and the popularity of the work, either for the open market or for specific collectors and galleries. In recent times, the status of the artist has sometimes achieved that of celebrity.

avant-garde Originally, the term was used to describe nineteenth-century artists (including writers and musicians) considered to be ahead of their time in artistic practice. In its original use by the French socialist writer, Henri de St Simon, the term avant-garde associated their radical artistic practice with radical politics. By the twentieth century, the meaning of avant-garde was less precise. For critics like Clement Greenberg (see Chapter 02), avant-garde was associated with the **Modernist** practice of investigating the issues specific to the process of making art and so was distinct from politics and any social concerns. In general, the term tends to be used to identify unconventional art, especially that which seems to challenge apparently conformist and predictable art.

canon (canonical) Deriving from the Greek word for a carpenter's measuring stick, the word canon has come to signify a benchmark of quality. Historically, inclusion of a work of art in the Western canon provided the basis for judgements about artistic value and status since these were in turn established by the **academies**. More recent art history has expanded and questioned the roles and meanings of the canon and the term now tends to be used more flexibly.

- For example, some might claim Isaac Brodsky's *Lenin in Smolny* (Plate 6) has no canonical importance in relation to the evolution of **modern** or **Modernist** art. But because of its reproduction in some books and the actual historical

circumstances and actions to which it relates, it may be thought of as canonical since it communicates a particular way of looking at and understanding the role of art.

- Rothko's *Untitled* (Plate 5) is more generally regarded as canonical because it has received critical acclaim as a work of **Modernism**, it is **abstract** in form, uses flat colour and is apparently concerned to exploit the intrinsic characteristics of the medium, and so forth.

Generally speaking, where the term canon is used in art history, it still suggests some form of positive judgement or recognition of pictorial value or attributes.

cartoon Specifically, a cartoon is a full-scale preparatory design or drawing which is transferred to a support for a finished painting (see **pouncing** and Figures 11 and 16, pp. 130–1, 134 and 137–8 respectively). A well-known example is Leonardo's cartoon for the *Virgin and Child with Saints Anne and John the Baptist* in London's National Gallery.

chiaroscuro A word derived from the Italian words *chiaro* (clear) and *oscuro* (dark), meaning an extreme use of light and dark in a painting. The contrast between light and shadow helps to create a convincing illusion of reality, and often enhances the theatricality and drama of the subject (see Plate 1).

collage From the French verb *coller* (to glue or stick), collage was used to describe the technique invented by the Spanish artist Pablo Picasso in the early twentieth century, of applying fragments of paper and other materials to the surface of Cubist compositions. As well as changing the texture of the surface, collage defied conventional ways of making art and by using newspaper and wallpaper, introduced everyday objects into art production.

composition The overall arrangement of lines, colours, shapes and forms within a work of art. The 'appropriate' organization and combination of these various elements was one of the concerns of **academies** and the instruction they provided.

contrapposto From the Italian for 'placed or positioned opposite', contrapposto is used to describe the twisting of upper and lower parts of the body in different directions for both dramatic and **aesthetic** purposes. The pose was often, although not entirely, associated with the depiction of the nude (see Figure 4, p. 33). Originally developed in Classical times by Greek sculptors, contrapposto has been used throughout the history of Western art and in some styles, such as sixteenth-century Mannerism, was increasingly exaggerated.

craft With the establishment of **academies**, craft was increasingly seen as handmade artefacts without intellectual substance. Academicians encouraged this perception in order to promote the arts of painting, drawing, sculpture and architecture as **liberal** rather than manual arts. Thus, craft was seen as a lesser activity than art. In the nineteenth century, attempts were made to redress this arguably unjust hierarchy, notably by the Arts and Crafts Movement in Britain. However, it was not until the later twentieth century that the divisions between art and craft were seriously challenged. Many artists disregard the distinction between art and craft, using craft methods and materials to create art (see Plate 14).

easel painting An easel is a support on which a panel or canvas is prepared and painted. The term easel painting implies a moderately sized painting which allowed for its display in, for example, a domestic setting. Historically, **academies** influenced the size of paintings. 'Higher' **genres** such as **history painting** required large canvases and so are not generally easel paintings; 'lower' genres such as still life were produced on smaller panels and canvases, befitting the modest artistic and social value placed on their subject matter (see **hierarchy of genres**), and these tended to be easel paintings. The **Modernist** critic Clement Greenberg argued that the development of large-scale **abstract** painting and the move away from illusionistic imagery heralded the death of the conventionally sized easel painting.

Eurocentric A perspective or set of values and ideas that reflect a European or Western way of looking. The term has been used to summarize the ways artistic and cultural values more generally were imposed or exported to parts of Asia, the Far East, Africa, etc. by European countries both in pre- and post-colonial times.

figurative Used to describe a way of representing which is a **naturalistic** or realistic depiction of figures, objects, etc. The word is often used as the opposite of **abstract**.

fine art Those arts which are deemed to be essentially **aesthetic** and supposedly concerned with the intellect. Fine art includes painting, sculpture, drawing and certain forms of printmaking, forms which are to be looked at and appreciated. This is opposed to arts that are decorative and/or functional (see **applied art**). Fine art is regarded as 'higher' than applied art, appealing to ideas about aesthetics and taste, a notion endorsed and maintained by the **academies**.

genre A French word meaning 'type' which is used in two ways in art:

1 A category, or type, of subject matter (see **hierarchy of genres**).
2 A **figurative** work that supposedly depicts aspects of the everyday life of 'ordinary' people.

ground The painting surface, but specifically the primed or prepared canvas or panel, before the application of paint (see Chapter 06).

guild An association of craftspeople specializing in a specific skill. A guild Master trained apprentices for about seven years, after which time the apprentice would produce a piece to prove his or her knowledge, experience and skill. This was the 'masterpiece' for, if successful, the apprentice would become a Master. Guilds controlled the production of art until the fifteenth century when wealthy patrons began to commission work without recourse to the guild. The establishment of **academies** further eroded the decline in guild control and influence.

hatching The technique of shading with fine parallel lines. Cross-hatching is where the lines are placed across each other, often at right angles, resulting in a darker tonal effect.

hegemony A word, originally associated with the Italian Marxist, Antonio Gramsci, meaning leadership or influence. In art history, hegemony is used to indicate the influence and even control of power and politics over art.

hierarchy of genres As part of the **academies**' attempts to elevate painting from a manual to a **liberal art**, those subjects that required a degree of creativity, imagination and recourse to literary sources were given a higher status than those principally derived from observation. As a result, subjects were ranked in order of importance and prestige. **History painting** was paramount, with portrait, **genre**, landscape and still life having lesser positions in the hierarchy.

historiography of art As the term suggests, this is the study of the history of art itself. So, for example, Vasari's *Lives* (see Chapter 03) is regarded as a major (if very personalized) work of art historiography. Typically, historiographic studies look at the ways in which cultural fashions have influenced how art historians have approached the subject. For example, in the 1930s, Marxist thinking influenced a certain generation of art historians, such as Arnold Hauser, Frederick Antal and Francis Klingender.

history painting The **figurative** depiction of human life in its supposedly most admired, esteemed, uplifting and glorious manifestations. In effect, history paintings are large-scale figure compositions representing scenes from history, the Bible, mythology and literature (see **hierarchy of genres**).

iconographic (iconographical) The word icon means image. Iconography is the study of images, but specifically the study of symbols (and their origin) within images as a basis for interpreting subject matter. For example, a candle or a skull in a Dutch seventeenth-century still-life painting may represent the brevity of life, or a mirror and other luxury objects can mean the vanity of human desire. Many symbols and their meanings are based on visual conventions, although they vary from one culture to another and may change through time (see **pre-iconography**).

iconology The study of an image's meaning, with reference to its wider context and historical background (see Chapter 03 and Plate 6).

imprimatura A **wash** or thin layer of paint applied to a panel or canvas **support**, usually before the composition is drawn, to 'tone' the surface so that the artist is not working directly on to a stark white **ground**.

kitsch A German word meaning 'rubbish' but used in art history to refer to images or objects of bad taste or of no **aesthetic** value. In some contemporary, or **Postmodern** art, kitsch has been used in an ironic way.

liberal arts In the Classical Greek tradition, liberal arts were a group of subjects suitable for study. They included grammar, logic, rhetoric, arithmetic, geometry, music and astronomy. While this list varied with time, some of these subjects became the basis of university courses in the Middle Ages. Painting, sculpture and architecture were not considered liberal arts but as practical, or mechanical, arts. However, during the fifteenth century, artists, writers and patrons reacted against this tradition and gradually the visual arts were elevated to the status of liberal arts (see **academies**).

linear perspective A system of lines on a two-dimensional surface which creates the illusion of three-dimensional forms and space. The Italian architect, Filippo Brunelleschi, is credited with the discovery of linear perspective in the fifteenth century, calling it the 'legitimate construction'. Many artists and writers have discussed the geometric intricacies of linear perspective,

most famously the fifteenth-century Italian, Leon Battista Alberti, in his book *Della Pittura* (*On Painting*) (Yale, 1966).

male gaze The term first developed in relation to issues raised by feminist critics who questioned the assumptions and ideas behind images which apparently reflected male dominance in the making, commissioning and viewing of art. The male gaze refers to the way women in art are frequently presented in a particular way calculated to appeal to a predominantly male audience (see Figure 4, p. 33).

mimesis (mimetic) Used in art history to describe an approach which literally mimics reality by using a highly representational or sometimes photographic style (see Plate 6). The term was used by the Greek philosopher Plato who held that art should imitate reality.

modern (modernity, modernist, Modernism) These compounds vary in definition and scope depending on where and how they are used. They all share the common stem *modo*, which comes from the Latin for 'just now'. In art history, the terms have been subject to much discussion.

- We might say that the modern period extends from *c.* 1750 to *c.* 1960. In other words, the term modern is used to indicate a period of time when industrialization and many inventions, processes and beliefs provided the basis for material existence and outlook, and when a large part of the Western world developed and became established.

- In some ways related to this meaning, modern means of the present time, now, contemporary. We can use the term modernity in this sense: the inward experience of the contemporary or how it is felt by those who witness or live through it.

- Modernist can suggest someone or something which is of the modern period and concurs with its beliefs and traditions. However, in art, modernist can mean certain techniques, approaches, subjects and contexts which are different or even challenging from the accepted ones (see **avant-garde**).

- Sometimes used with a capital M, Modernism is used to indicate the ideas of the twentieth-century American critic, Clement Greenberg, and his belief in art's independence (or autonomy) from life (see Chapter 02 and **Postmodernism**).

museology The study of how museums, galleries and exhibition spaces more generally display their collections and how this in turn influences understanding and interpretation (see Chapter 05).

narrative art The telling of a story or series of events through visual means, hence a narrative painting.

naturalistic (naturalism) We might understand naturalism and the naturalistic in art as an attempt to portray things as they appear, not stylized, distorted or *abstracted*. Sometimes, naturalism is associated with the idea of art as 'a mirror of nature'. Realism is often used as an alternative term for naturalism although in the mid-nineteenth century, some distinctions were made. Naturalism referred to the representation of nature, sometimes accurately, sometimes in an idealized way. Some artists and critics understood realism as the representation of everyday life, especially with some sort of social comment. Thus, we might consider Hunt's *The Light of the World* (Figure 2, p. 9) as naturalistic but not realistic, because it does not depict a real event.

On the other hand, Munch's *The Sick Child* (Plate 8) may be regarded as realistic, in that it supposedly shows us an event experienced by the artist, but because of the paint application and the use of colour it is not naturalistic (see **figurative, mimetic** and **mimesis**).

oeuvre This refers to the collective work of an artist, i.e. Max Beckmann's oeuvre. It is often also used in stylistic or formalist analysis.

painterly Essentially, the representation of forms by colour and brushwork. Painterly works emphasize colour over drawing, and the medium and picture surface might even compete with the subject (see Plate 7).

paradigm The term is now used quite generally to suggest a particular approach to something; a way of looking or a set of shared assumptions. In art history, for example, we might describe a 'formalist paradigm' as one which gives emphasis to the compositional aspects of an image; a 'contextual paradigm' as one which explores the cultural background and history to an image, and so on. The term was coined by the scientist, Thomas Kuhn, whose 1962 book *The Structure of Scientific Revolutions* defined paradigm as a pattern of belief. According to his thinking, scientific history was one in which successive 'paradigm shifts' occur as scientific knowledge changes and develops. For instance, Galileo's conception of the universe and Einstein's theory of relativity were 'paradigm shifts' since both challenged pre-existing views of the physical universe.

perspective See **linear perspective**.

picture plane Although it is a plane occupied by the surface of a painting, the picture plane is a theoretical notion, conceived as

a transparent plane on or 'through' which the image exists. Since the Renaissance and the use of **linear perspective**, the picture plane has been perceived as a 'window on to reality'. **Modernists** like Clement Greenberg challenged the idea of the picture plane as something the viewer looks 'through' and emphasized the surface of a painting.

polyptych Specifically, a set of paintings on hinged panels. To describe a set of paintings as a polyptych, there would be more than two (which would be a diptych), or three (a triptych). Most commonly, this form would be used for **altarpieces**. More generally, the terms polyptych, diptych or triptych can be used for any painting done in a number of sections.

Postmodern (Postmodernism, Postmodernity)

Literally 'just after now' or after **Modernism**, the Postmodern is among the most fluid and complex concepts (see Chapter 04). Essentially, it has been described as an attitude, a state of culture or of mind, although its condition is often seen as a composite of contrary aspects such as confused, eclectic or uniform. There is limited agreement amongst commentators that some of its characteristics date to the post-war years and the early 1960s, and are possibly linked to the increasingly post-industrial nature of Western society.

- Supporters of the Postmodern see it as a cultural moment and argue that **modernist** art had reached a dead end of abstraction which few outside an elite understood. In this sense, Postmodernism can be seen as a reaction *against* Modernism. Some art historians see Marcel Duchamp's **readymades** as a key forerunner of a permissive Postmodernism.

- Others view the 1960s Pop Art of Andy Warhol and its apparent celebration of mass culture and the commodity as a **paradigm** of Postmodern art (ironic, witty, celebratory and consumer-oriented), the opposite to modernist art's alleged highbrow and serious approach.

- There is also disagreement as to whether Postmodernism is good and liberating or negative and backward looking.

In relation to art and art history, we can say that there is a more relaxed approach to questions of **aesthetic** value and the wider role and meaning of art (see Chapter 04, pp. 80–3 and the discussion of the Institutional Theory of Art as an example of Postmodern inclusiveness). The apparent confusion may be because the Western world is still in a position of transformation and we lack the historical perspective that allows greater clarity and understanding.

pounce (pouncing) Pounce is a fine mixture of chalk or white clay and charcoal in a pounce bag, a square of open mesh cloth tied at the top. It is tapped along the lines of a **cartoon** that has been perforated or punctured with a fine point. The pounce passes through these perforations leaving a line of dots on the **support** (a wall, panel or canvas). The process is called pouncing (see Figures 11 and 16, pp. 131 and 137 respectively).

pre-iconography This literally means 'before the image'. For the twentieth-century art historian Erwin Panofsky, this was the first level to exploring an image (see Chapter 03). In turn, it was divided into two parts: *factual* was a description of the shapes, lines and contours of the image; *expressional* was concerned with the tone, colour and shading of the picture. The subsequent stages to this approach were **iconography** and **iconology**. Together, these three levels were called Panofsky's **trichotomy** (three-handed).

provenance Strictly the history of ownership of a work of art. Auction houses and galleries frequently undertake authenticating the provenance of paintings and other objects. However, the word can also be used to mean the general influences upon the work of art. Therefore, in its strict sense, the provenance of Rothko's *Untitled* (Plate 5) is from the artist to the Mark Rothko Foundation to the Tate Modern, London. However, one might also say that the provenance of the painting is a series of works made by Rothko in the mid- and later 1940s culminating in a style or form of which *Untitled* is an example.

readymade In 1913, the French artist Marcel Duchamp created what he later called a 'readymade assisted' when he mounted a front bicycle fork with its wheel on to a kitchen stool painted white. By selecting objects which, he claimed, had no **aesthetic** for him and which he neither liked nor disliked but felt completely neutral about, Duchamp created a form of art that privileged imagination and concept over skill. 'Readymade assisteds' such as the *Bicycle Wheel* were objects to which Duchamp added something (for instance, he attached the bicycle fork to the stool); readymades were simply objects selected to be 'art' with no additions other than perhaps a signature. These include *Bottlerack* (a bottle drying rack bought in Paris in 1914), *In Advance of a Broken Arm* (a snow shovel bought in New York in 1915) and, notoriously, *Fountain* (a urinal signed 'R. Mutt' which was to have been exhibited in New York in 1917).

The readymade challenges assumptions about artistic creation:

- Can art be something selected by an artist rather than made by an artist?

- Does a work of art have to be a unique object made by an artist or can it be industrial and mass-produced, having, according to Duchamp, no discernable aesthetic properties?
- And if one pays a certain price for this object when bought in a shop, what reasoning makes its value significantly increase when the very same object, with only the addition of a signature, is exhibited as 'art'?

Duchamp's challenge to preconceived ideas about what art could be, what it was about, and what values it had, led some artists from the 1950s onwards to pursue these themes.

realism (realistic) See **naturalism**.

Salon An art exhibition organized by the French Royal Academy, originally at the Salon d'Apollon in the Louvre (hence the name Salon), biannually from 1737 until 1789 and then annually. It was *the* major public exhibition of art in France and reflected academic values. By the mid-nineteenth century, the Salon had become synonymous with conventional art and artists such as Courbet and the Impressionists began to challenge its hegemony.

significant form In the early years of the twentieth century, the British writer and art critic Clive Bell claimed that:

- when we look at a work of art, we always experience a distinctive **aesthetic** experience
- this aesthetic experience is the case whatever the work of art, be it a cave painting or a Michelangelo sculpture.

Bell maintained that this experience is the result of works of art all having a property, which he called significant form. Bell argued that significant form resides in the formal elements of an artwork – its lines, colours, composition, etc. However, it is not the same as beauty which is determined by pre-conditioned ideas and our own desires and responses; nor is it the aesthetic dimension of a work of art. Significant form is discerned intuitively and immediately although, Bell argued, to experience it the viewer will have to concentrate. It is the role of the critic to stress the formal characteristics of art and so lead the viewer to experience significant form. Both Bell and his friend and colleague Roger Fry believed that **narrative** painting, such as Hunt's *The Light of the World* (Figure 2, p. 9), makes the experience of significant form more difficult than a work that seems to give value to formal features, such as Cézanne's *The Grounds of the Château Noir* (Plate 2). As such, Bell's ideas are a version of formalism and prefigure Greenberg's **modernist** thinking.

sublime A term used in the eighteenth century to describe effects in nature which are awe-inspiring and overwhelming in their scale, drama or wildness. Developing ideas from as early as the first century, and the theories of philosophers such as Immanuel Kant and the painter Joshua Reynolds, in 1757 the Irish-born writer and statesman Edmund Burke wrote *A Philosophical Enquiry into the Origin of Our Ideas of the Sublime and the Beautiful* (Oxford University Press, 1990). The sublime was conceived as an **aesthetic** category, a form of beauty. Burke noted:

> *When danger or pain press too nearly, they are incapable of giving any delight, and are simply terrible; but at certain distances, and with certain modifications, they...are delightful, as we everyday experience.*

The concept of the sublime exerted a considerable influence on artists in the eighteenth and nineteenth centuries. As well as the 'taste' for wild mountain landscapes and stormy skies, painters such as the Englishman Joseph Mallord William Turner represented humankind engulfed by the apparently overwhelming power of nature. In more recent times, the American painter Mark Rothko (Plate 5) has been associated with the idea of the sublime.

support A generic word for the surface on which a painting is made. For **tempera** painting, the support was usually wood; for watercolour it was paper; for oil paint it was originally wood but after *c.* 1500 canvas stretched on a frame (stretcher) gradually became more common.

tempera Originally the word simply meant a liquid binder for powdered pigment (colour) but subsequently it was used to identify a paint made from egg yolk, pigment and water. Originating in medieval Europe, tempera was widely used for painting on wooden panels until the development of oil paint in the fifteenth century.

trichotomy Used by the art historian Erwin Panofsky, this refers to his three-fold or forked methodology (see also **pre-iconography, iconography** and **iconology**; also Chapter 03).

wash (washes) A layer of watercolour paint. Therefore, watercolour is painted in a series of layers or washes, usually working from light to dark, each wash modifying the tone and/or colour of the previous one when applied on top of it.

references

Michael Baxandall, *Painting and Experience in Fifteenth Century Italy: A primer in the Social History of Pictorial Style* (2nd edition), Oxford University Press, 1972.

John Berger, *Ways of Seeing*, Penguin, 1972.

M. Blind (translator), *The Journal of Marie Bashkirtseff*, Virago, 1985.

D. Bussel, *Sensation – Young British Artists from the Saatchi Collection*, Royal Academy of Arts in association with Thames & Hudson, 1997.

I. Crofton, *A Dictionary of Art Quotations*, Routledge, 1988.

F. Frascina, 'Realism and Ideology: an Introduction to Semiotics and Cubism' in *Primitivism, Cubism, Abstraction*, C. Harrison *et al.*, Yale University Press, 1993.

T. Garb, 'Gender and representation' in *Modernity and Modernism*, F. Frascina *et al.*, Yale University Press, 1993.

E. H. Gombrich, *The Story of Art*, 16th edition, Phaidon Press Ltd., 1995.

Clement Greenberg, Letter to the Editor of *The Nation*, reprinted in *Clement Greenberg. The Collected Essays and Criticism, Volume 2*, John O'Brian (editor), University of Chicago Press, 1986.

Clement Greenberg, 'American-Type Painting' in *Clement Greenberg. The Collected Essays and Criticism, Volume 3*, John O'Brian (editor), University of Chicago Press, 1993.

Clement Greenberg, 'Complaints of an Art Critic' in *Clement Greenberg. The Collected Essays and Criticism, Volume 4*, John O'Brian (editor), University of Chicago Press, 1993.

Malcolm Haslam, *William Staite Murray*, Crafts Council, 1984.

R. Heller, *Edvard Munch*, John Murray, 1984.

R. Hughes, *Nothing if Not Critical*, Harvill, 1990.

H. Langdon, *Art Galleries of the World*, Pallas Athene, 2002.

Sandy Nairne, *State of the Art*, Chatto and Windus, 1987.

S. Naismith and G. White Smith, *Jackson Pollock. An American Saga*, Barrie and Jenkins, 1989.

R. Parker and G. Pollock, *Old Mistresses*, HarperCollins, 1981.

G. Vasari, *Lives of the Artists*, translated by G. Bull, Penguin Books, 1975.

W. H. Wackenrode, *Outpourings from the Heart of an Art-Loving Monk*, 1797, quoted in *Relative Values*, L. Buck and P. Dodd, BBC Books, 1991.

index

Page numbers in *italics* refer to illustrations and Plate numbers.

German
German Conversation
German Grammar
German Phrasebook
German Starter Kit
German Vocabulary
Globalization
Go
Golf
Good Study Skills
Great Sex
Green Parenting
Greek
Greek Conversation
Greek Phrasebook
Growing Your Business
Guitar
Gulf Arabic
Hand Reflexology
Hausa
Herbal Medicine
Hieroglyphics
Hindi
Hindi Conversation
Hinduism
History of Ireland, The
Home PC Maintenance and
 Networking
How to DJ
How to Run a Marathon
How to Win at Casino Games
How to Win at Horse Racing
How to Win at Online Gambling
How to Win at Poker
How to Write a Blockbuster
Human Anatomy & Physiology
Hungarian
Icelandic
Improve Your French
Improve Your German
Improve Your Italian
Improve Your Spanish
Improving Your Employability
Indian Head Massage
Indonesian
Instant French
Instant German

Instant Greek
Instant Italian
Instant Japanese
Instant Portuguese
Instant Russian
Instant Spanish
Internet, The
Irish
Irish Conversation
Irish Grammar
Islam
Israeli-Palestinian Conflict, The
Italian
Italian Conversation
Italian for Homebuyers
Italian Grammar
Italian Phrasebook
Italian Starter Kit
Italian Verbs
Italian Vocabulary
Japanese
Japanese Conversation
Java
JavaScript
Jazz
Jewellery Making
Judaism
Jung
Kama Sutra, The
Keeping Aquarium Fish
Keeping Pigs
Keeping Poultry
Keeping a Rabbit
Knitting
Korean
Latin
Latin American Spanish
Latin Dictionary
Latin Grammar
Letter Writing Skills
Life at 50: For Men
Life at 50: For Women
Life Coaching
Linguistics
LINUX
Lithuanian
Magic